# 28 DAY WINTER
## A SNOWBOARDING NARRATIVE

powerHouse Books
Brooklyn, NY

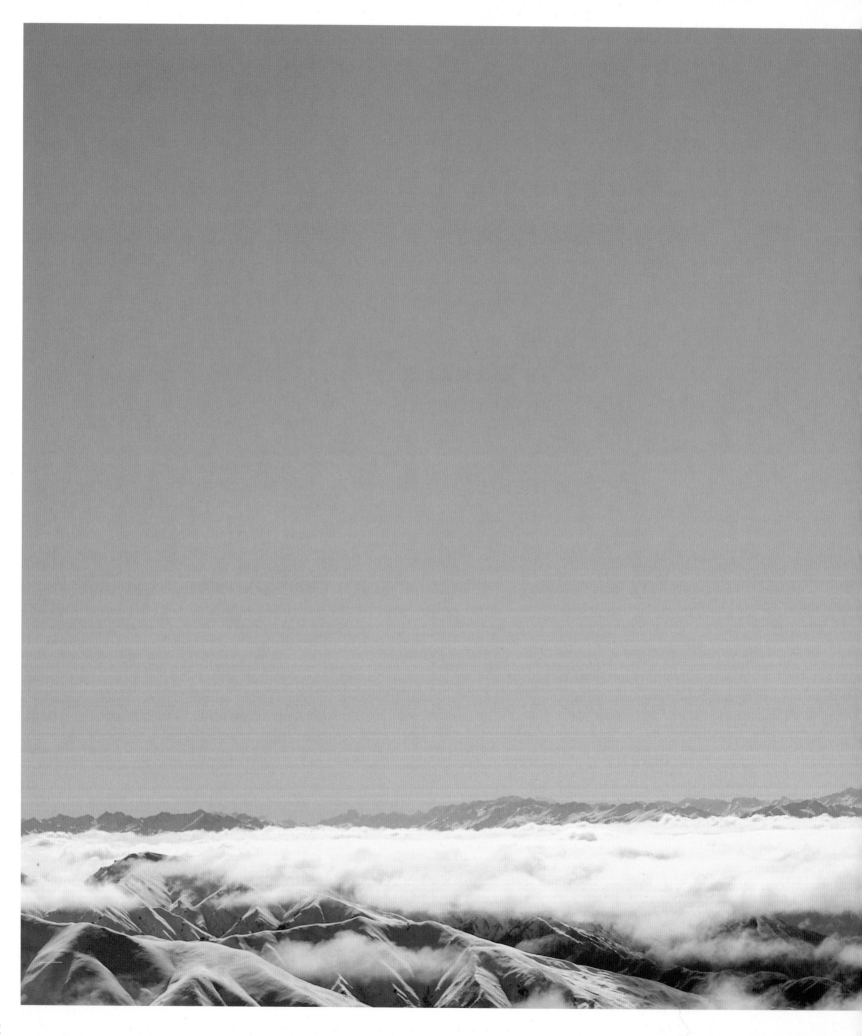

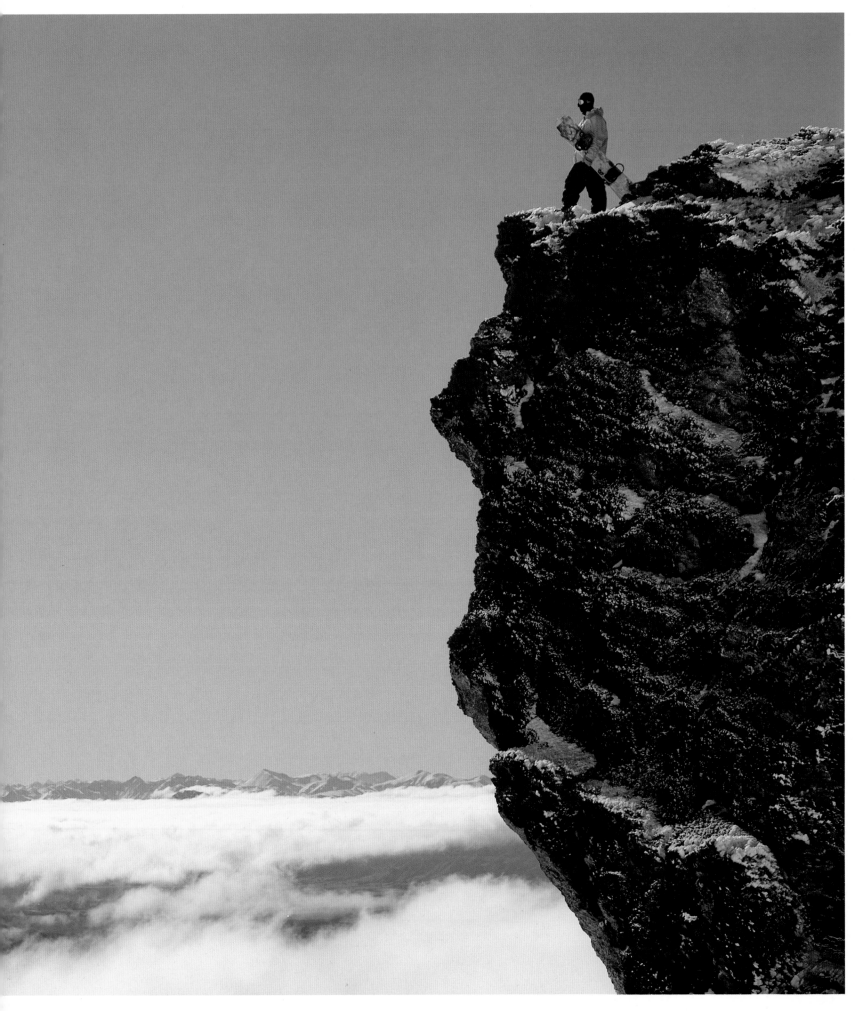

# 28 DAY WINTER

*Every year the Burton snowboard team travels south chasing snow. This book documents a specific moment in time. It captures these snowboarders pushing the limits of riding in the ultimate of conditions and thereby, inspires us all to ride.*

When I was a kid winter seemed to last forever. Cold, short, and dark Wisconsin days dragged long into a springtime that never seemed to arrive. There were those epic snow days that cancelled school, setting us free to play outside all day. But they were few and far between. Winter dominated the calendar when all we wanted was summer vacation.

When I became a snowboarder my perspective flipped and winter was never long enough. We devised tactics to extend our season at both ends of the calendar, simply to ride; early season November hikes up the partially blanketed mountains to sneak in some turns, trips to Europe to shred the glaciers in the early autumn, springtime slush sessions on the high passes that held snow, missions into the arctic circle that allowed us to ride well into May, midsummer Mt. Hood trips and the extravagance of jetting to the southern hemisphere. To us the last day of the season is simply a starting point to counting down to the first day of the next… we were never satisfied… summer simply got in the way and **winter was just never long enough.** Now I find myself wondering, what's happening to winter? In some places the harshness of winter pounds with an unpredicted chaos, and at the same time mountain ranges all over the world are nearly dry, experiencing the worst conditions in years.

*28 Day Winter* is all of the above. A middle of a blazing hot summer trip to New Zealand and Chile documented in a simple photographic narrative—three epic weeks of snowboarding with Burton's Global Team on a trip of a lifetime. Winter too long, winter too short, and in August 2006, winter condensed to 28 days. Looking back, it was a trip of epic proportions now frozen in time; images now worth cherishing as winter shows its fragility, as temperatures in New Zealand are unusually warm and snowboarders sit on edge waiting for snow to come.

Jeff Curtes/photographer

Comparisons have always been made that the southern hemi is just a little brother to the northern hemisphere, but it has never been about what is and what isn't for us. The goal has always been focusing on the mountains, the terrain, and the riding that happens on frozen crystals called "snow" that are no different from what falls from above January through April.

This focal point was unchanged during the summer of 2006, in which the Burton Snowboard Team would gather in hand-picked locations at varied times with three diverse photographers.

28 days: Adam's day care in Wanaka, sessioning Snow Park daily; Curtes hunkering down in Methven, followed by a trip to Chile to document the ladies.

My schedule you could chalk up to a little bit of everything. Starting with the heli at Methven, followed by man-made features at Snow Park with Susie's crew, back to Methven for a few days, then a resort tour around the South Island where chairlifts and parking lots were the set boundaries. To top it off, 36 hours at Hood before and after the southern hemisphere to cover Jussi and Jeremy.

Three photographers pooled together the shots after the fact, a lightbulb lit up, and this hardcover was born. But not without a great number of people all putting in just as much, or more.

Dean Blotto Gray/photographer

BLOTTO

28 days, the longest period I spent in any one location for all of 2006 (including my house). August is a strange month. I see it the same as January. I know we will be on snow the whole time. I know it's going to be busy, and I love it. Growing up we would drive three hours to Killington each fall in early October to try to get there for opening day. It would be half a trail of snow, freezing cold, and snowguns in your face the whole time, but the little jumps out of the drainage ditches made it all worth it. Back then September was spent dreaming about October, since that was when I knew I would finally get back on snow. I would skate all day, and then look at the new mags all night, wondering what board I should save up to buy. What boots? Did I pump enough gas this summer to get both? Hopefully. These days it's a dream come true. I go snowboarding 12 months a year shooting photos the whole time, and enjoy a full winter in the middle of everyone else's summer. By the time I get back, I am ready for a little springtime again in September. By October, however, I want to be back on snow again—just the same as I was when I was a kid.

I'm not a patient person, never have been. I hate lines, and waiting for anything. It may be a side effect of too much coffee, but as far as I remember it's always been this way. But August photo shoots for a month will teach you about patience. No matter what you have to get done, or how long you have to do it, there is no way to make the wind stop blowing, the sun come out, or the clouds go away. We sat for hours waiting for the sun to crack below the clouds for some of these shots. We dug through a junkyard full of waste and used oil looking for things to jib, and watched the snow blow sideways through the air so fast that someone might get blown into the next zip code if they went big enough. My patience was tested this past summer to its fullest. But as always the waiting pays off. Even if it was just a half-hour session at sunset or a single jib shot off a crane. If the shot is worth it in the end, I can't help but look back and laugh at myself for being so impatient in the first place. Every year I get a 28 day lesson in this.

These photos show everything we worked to create in that month, the snowboarding side of it. But to me they also spark all the funny times we had living as a crew together in NZ for four weeks. The soccer games behind the house, Mikkel's bed coated with jelly, Keegan's shirt getting ripped off one-handed by Mikkel, and Luke quietly instigating all of it. The nights at the backyard fire pit, and the days waiting to see the sun. But most of all I see it and think of how gross our house smelled every night from used socks and boots, wet from a day of shredding, leaned up against the electric heaters blowing a nauseating scent into the air. These photos will live on forever, and at times I think that smell in those rented houses will too. Sorry.

Adam Moran/photographer

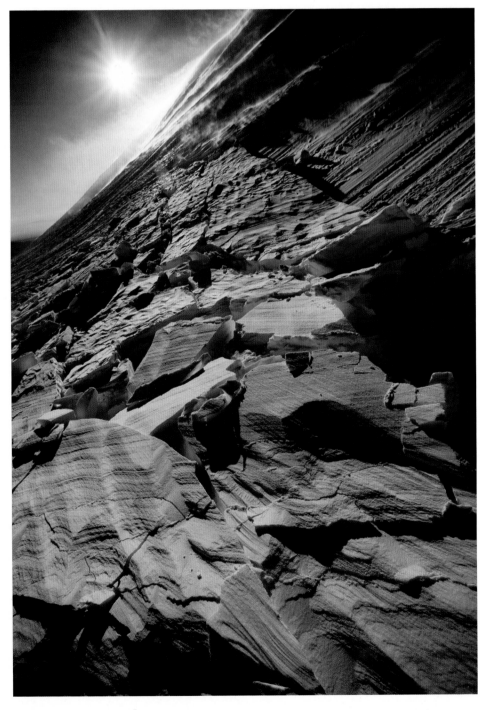

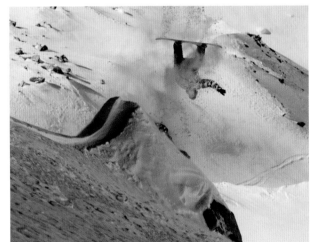

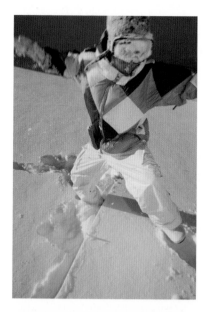

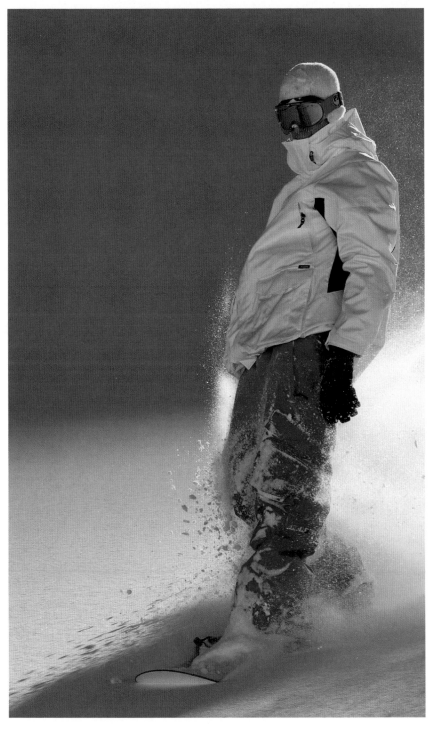

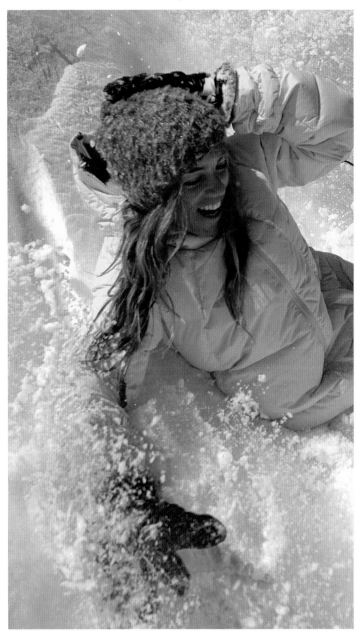

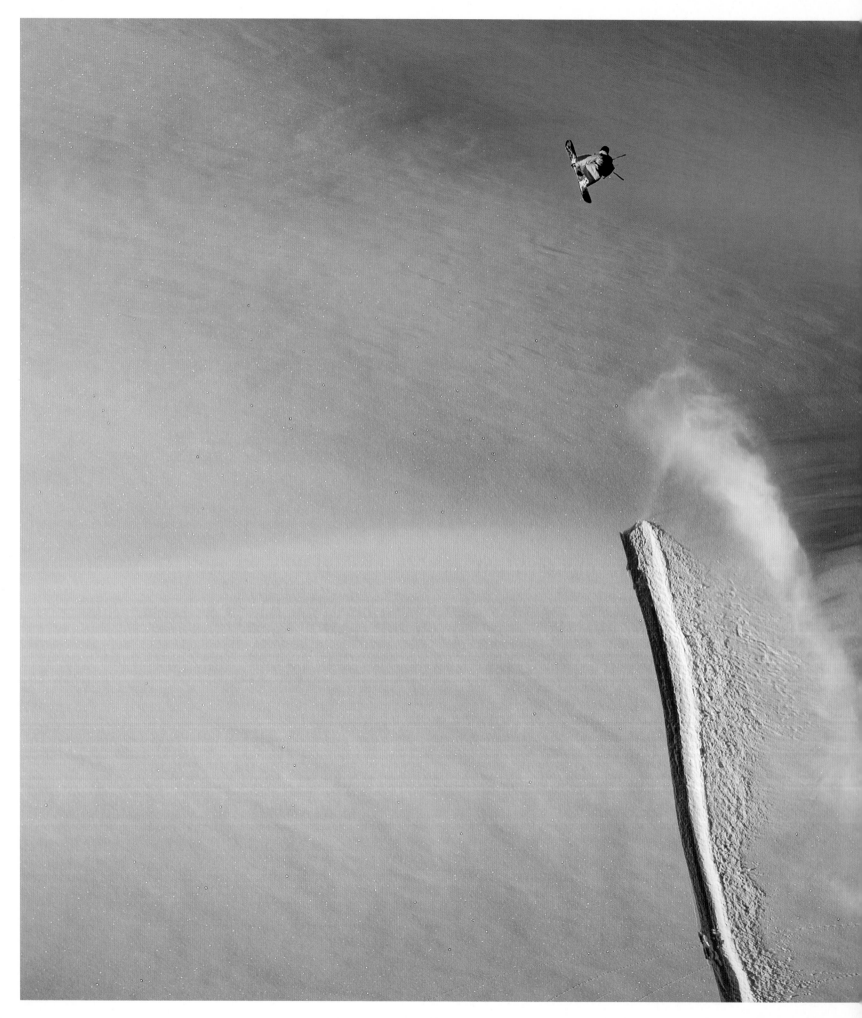

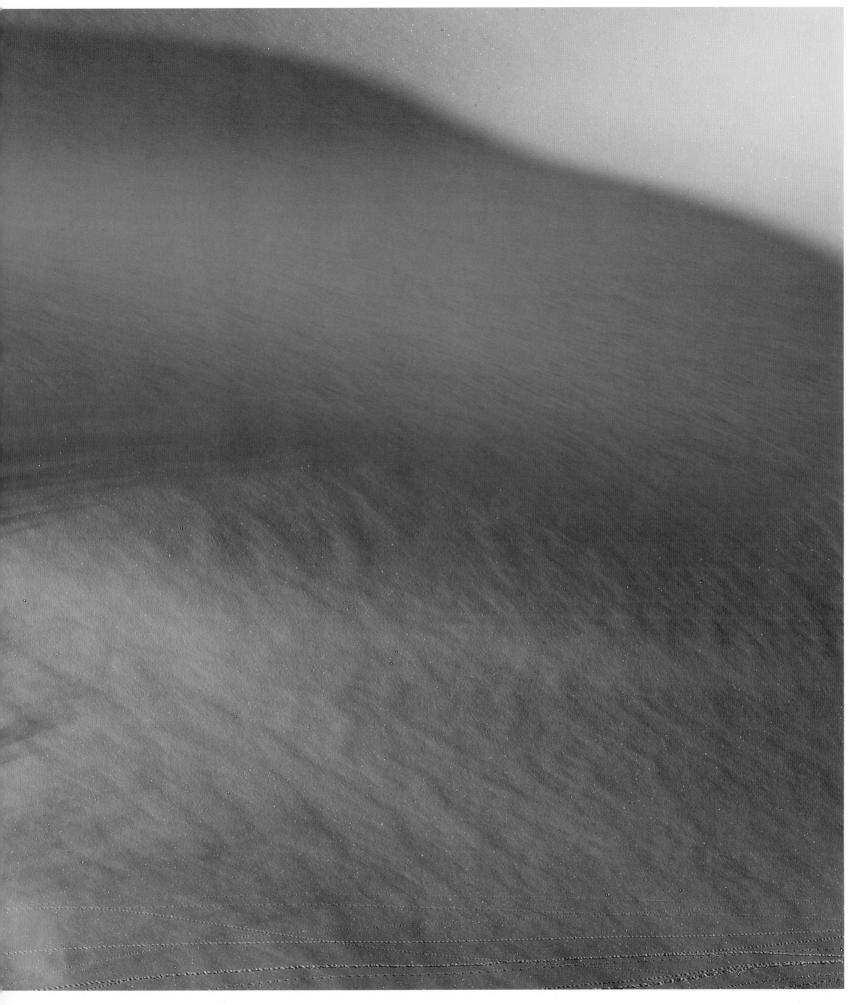

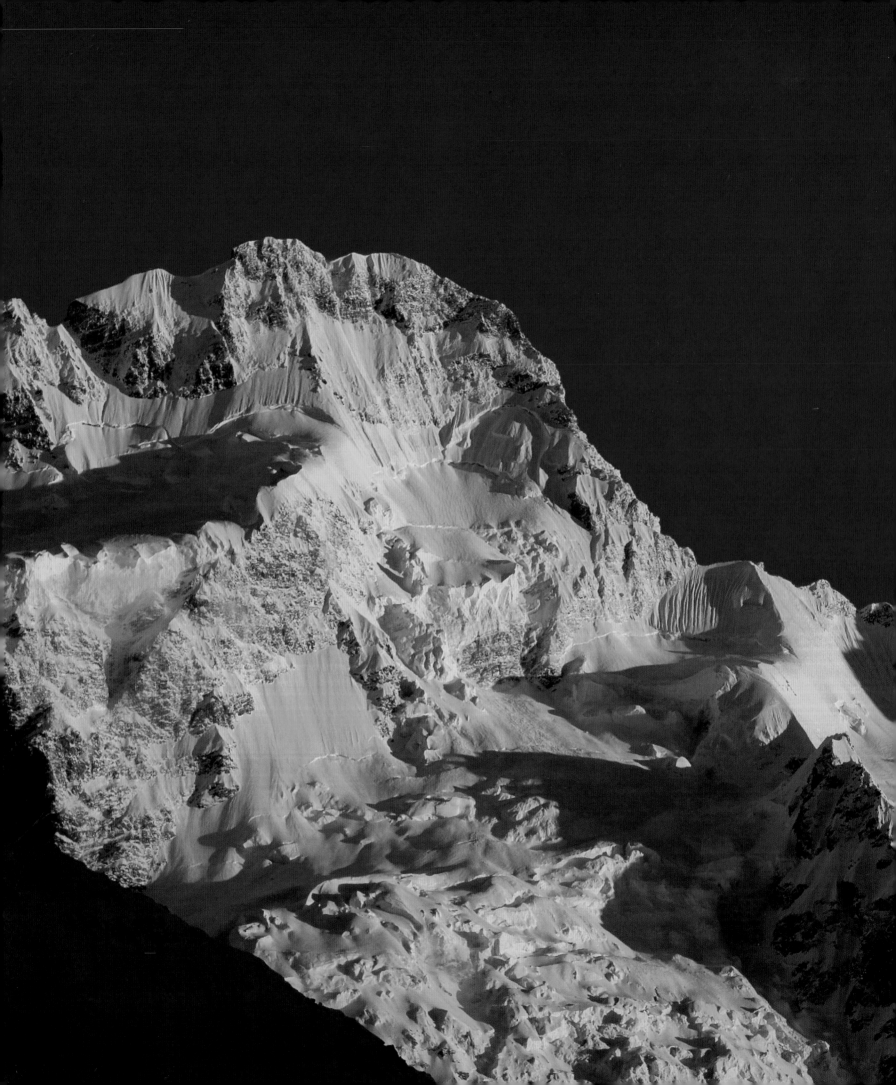

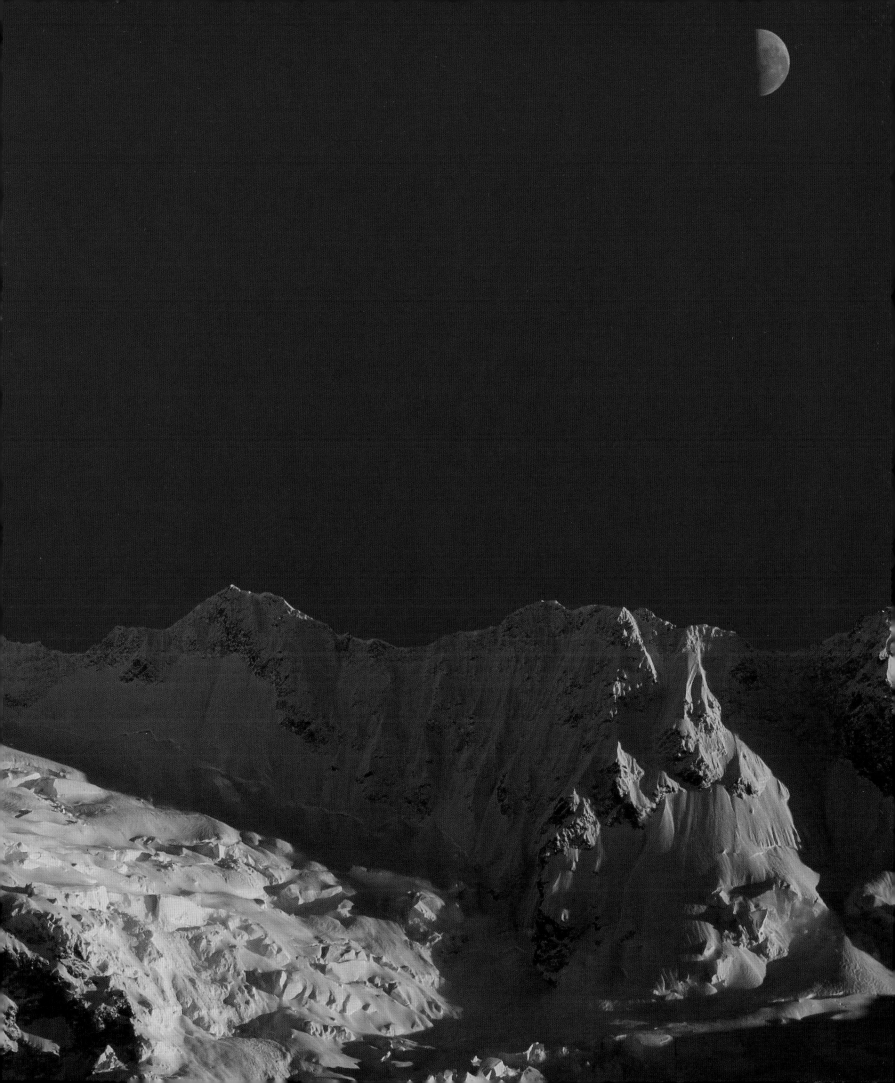

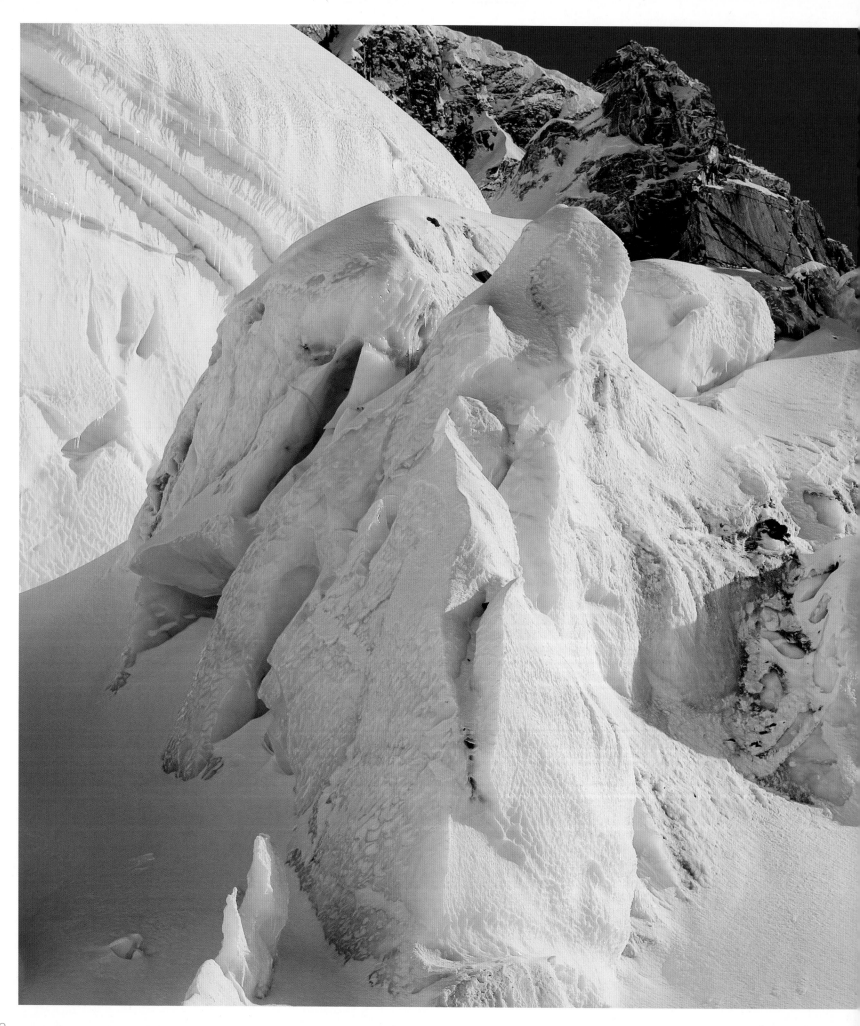

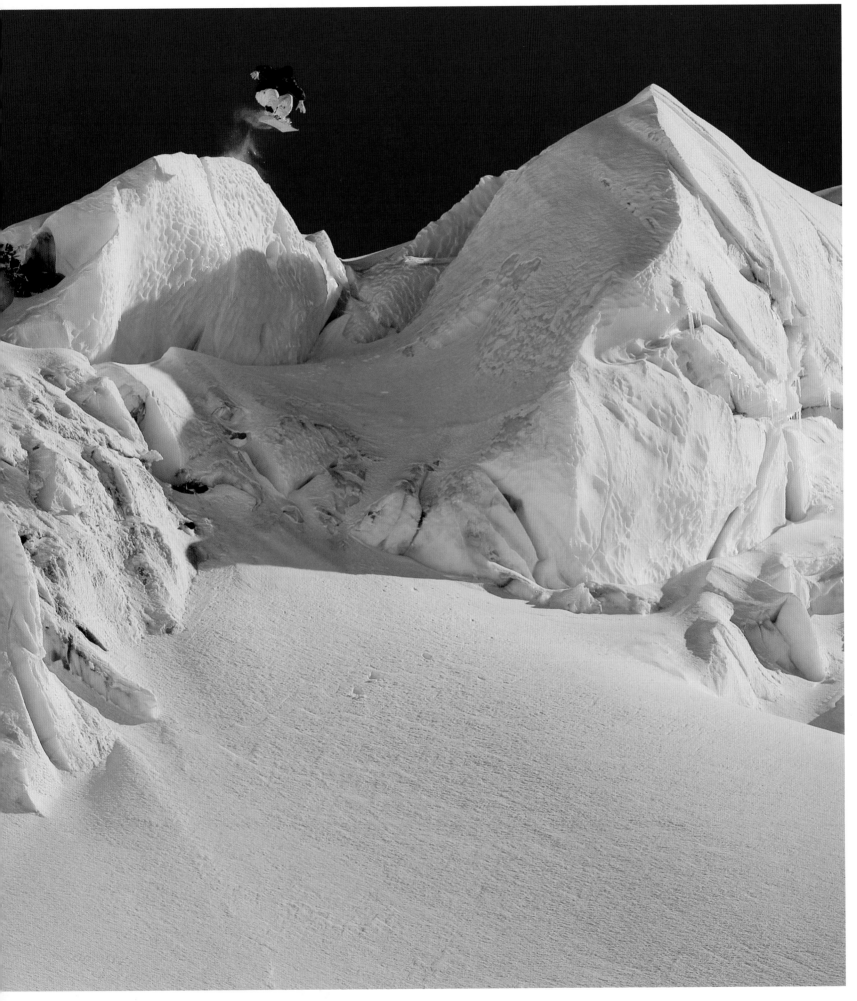

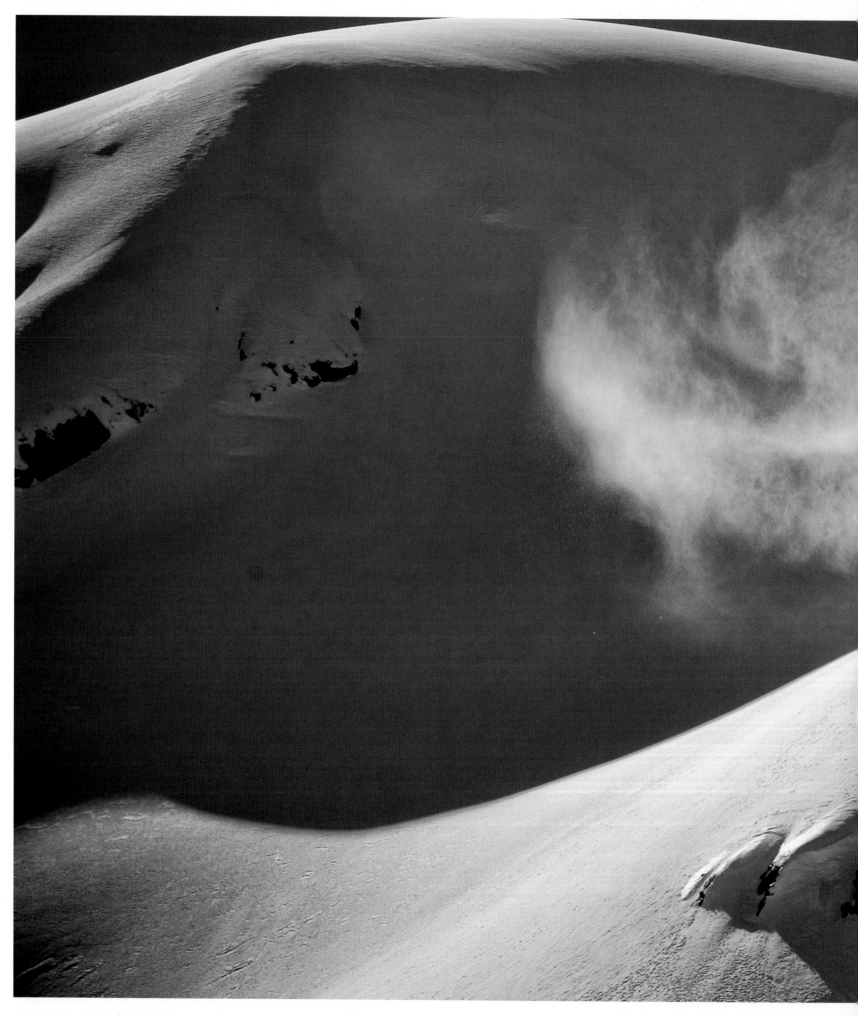

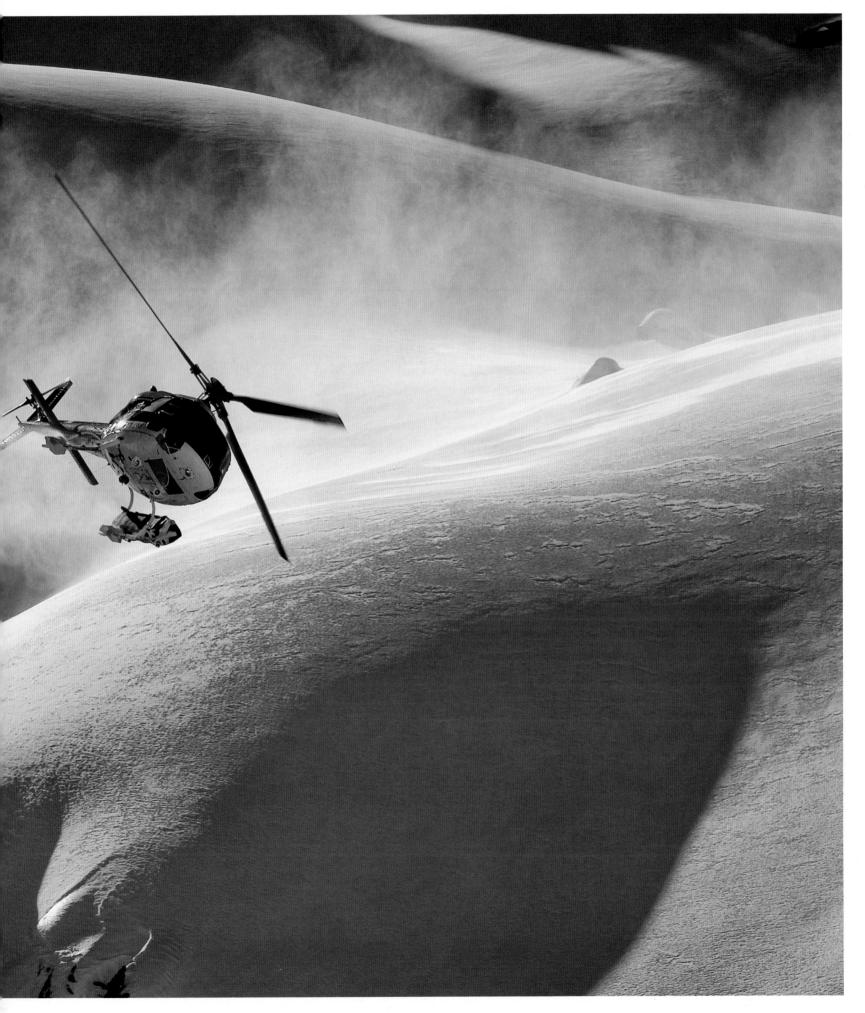

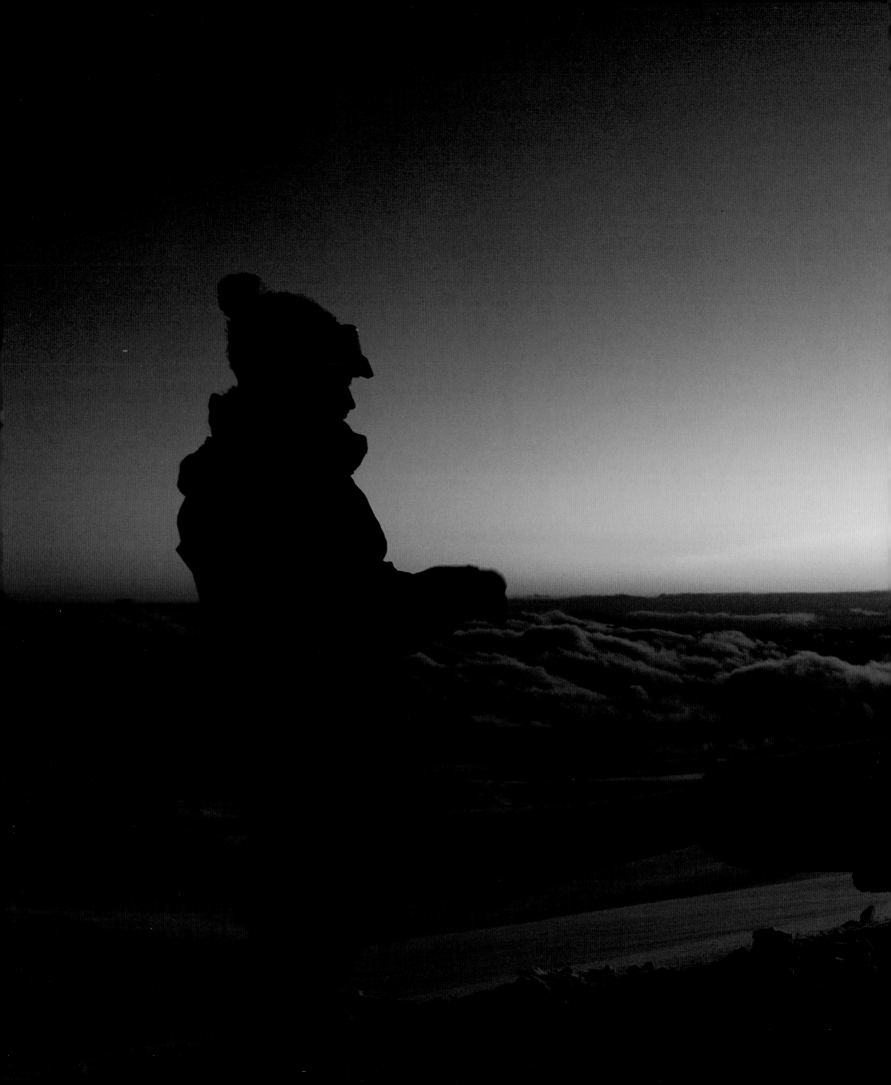

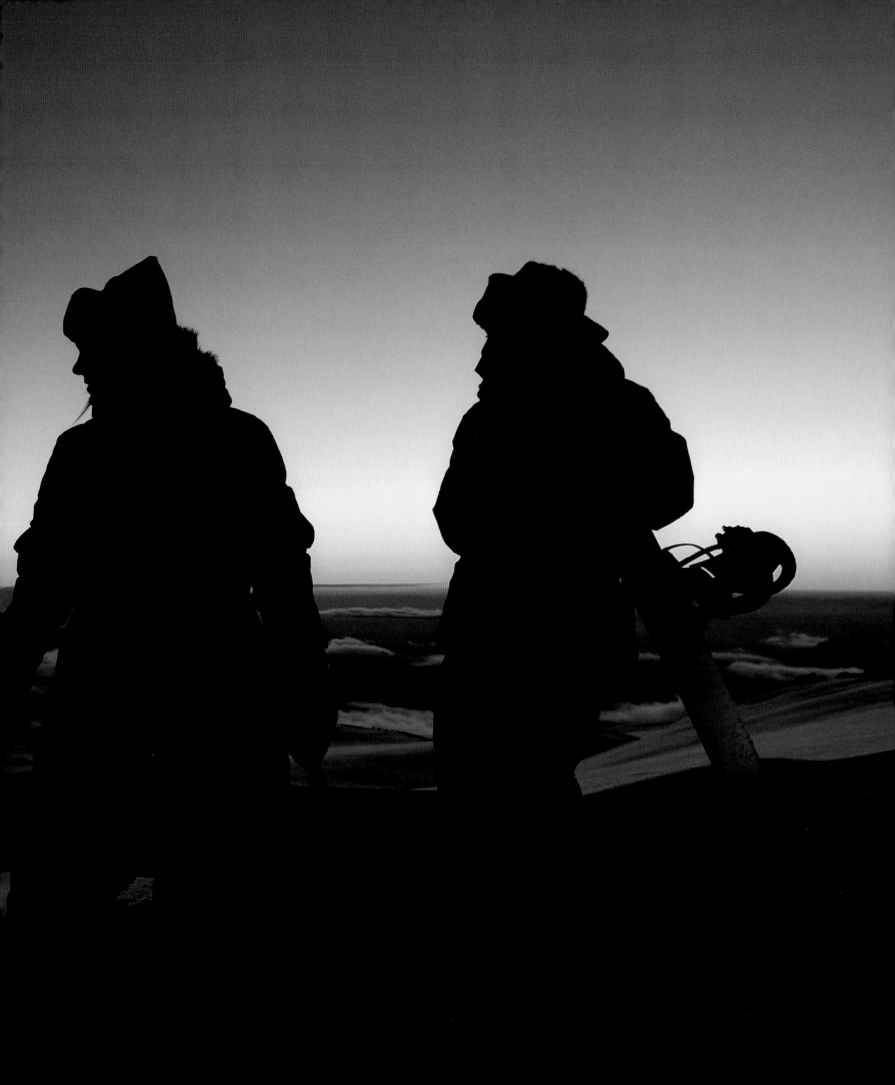

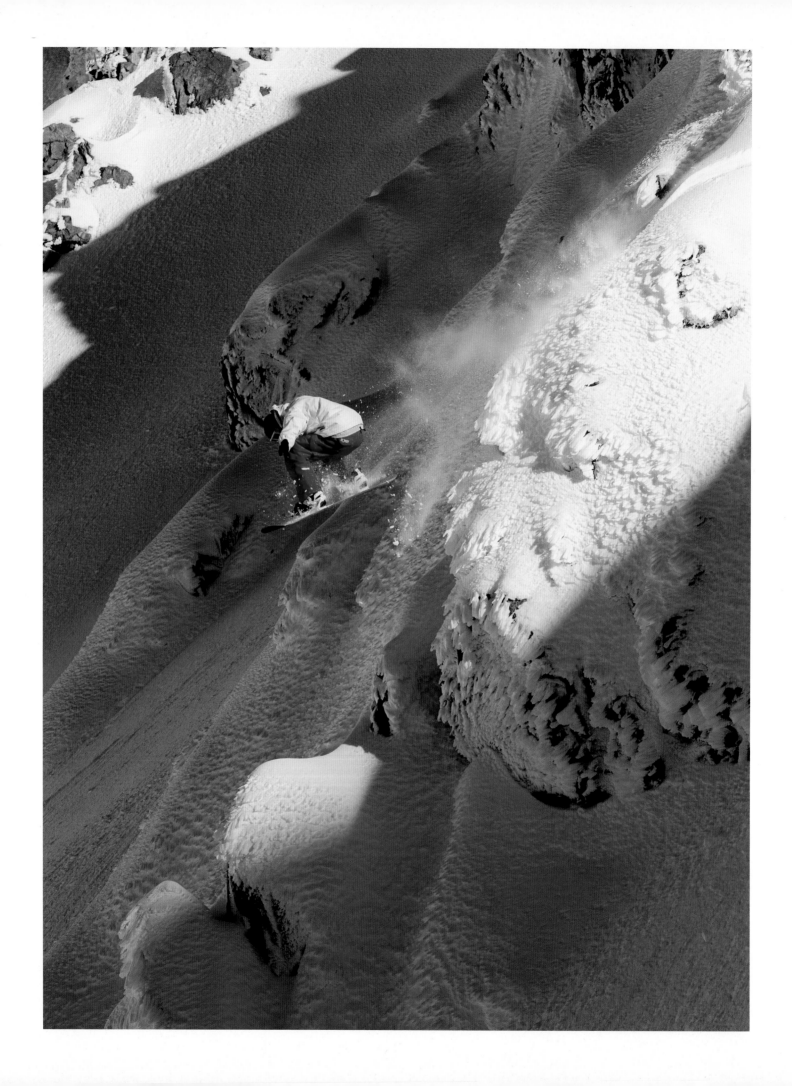

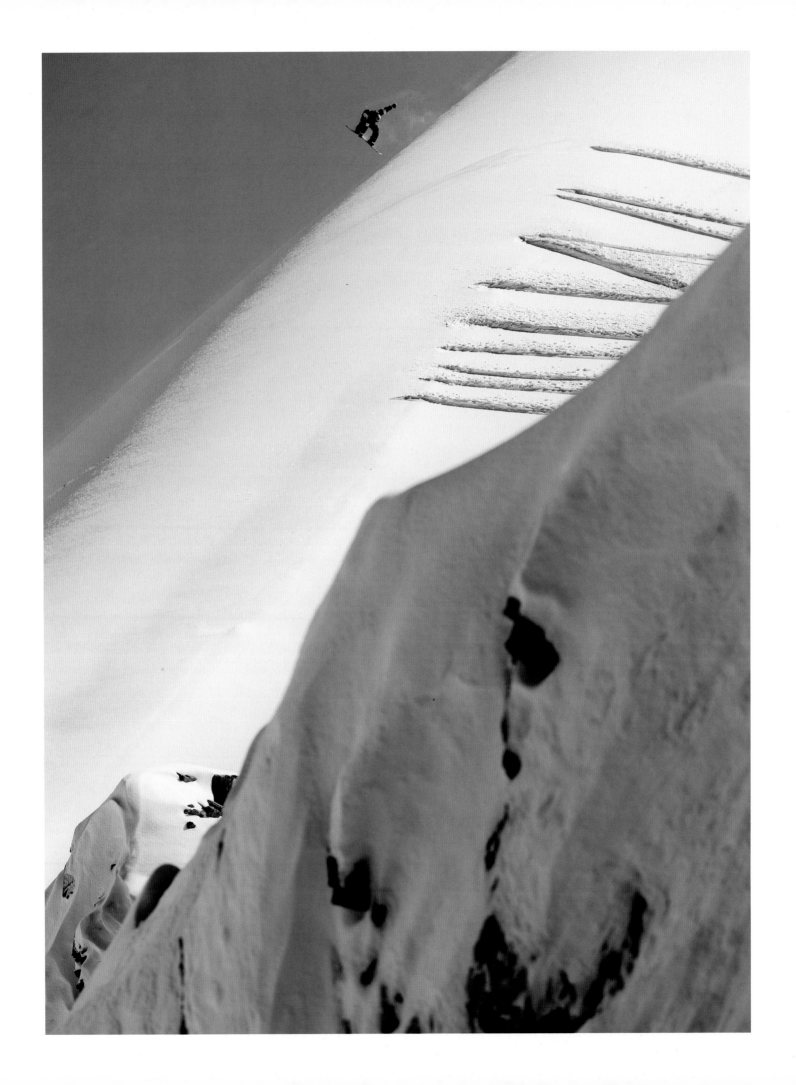

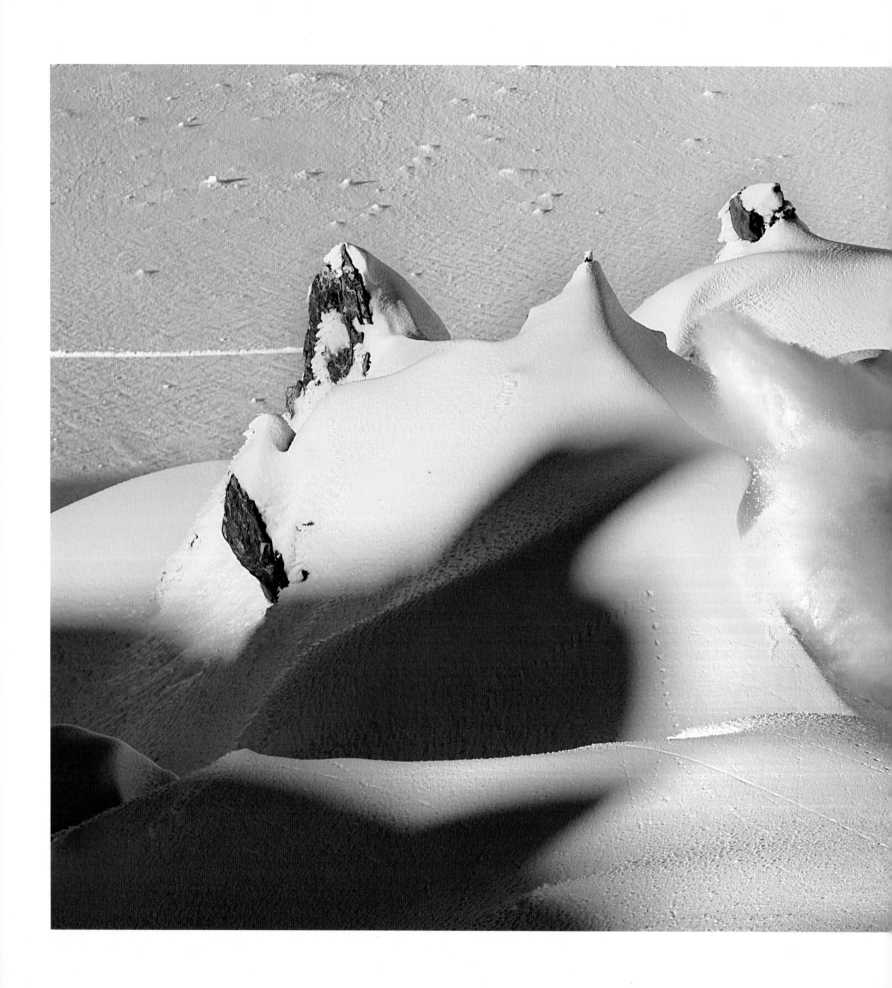

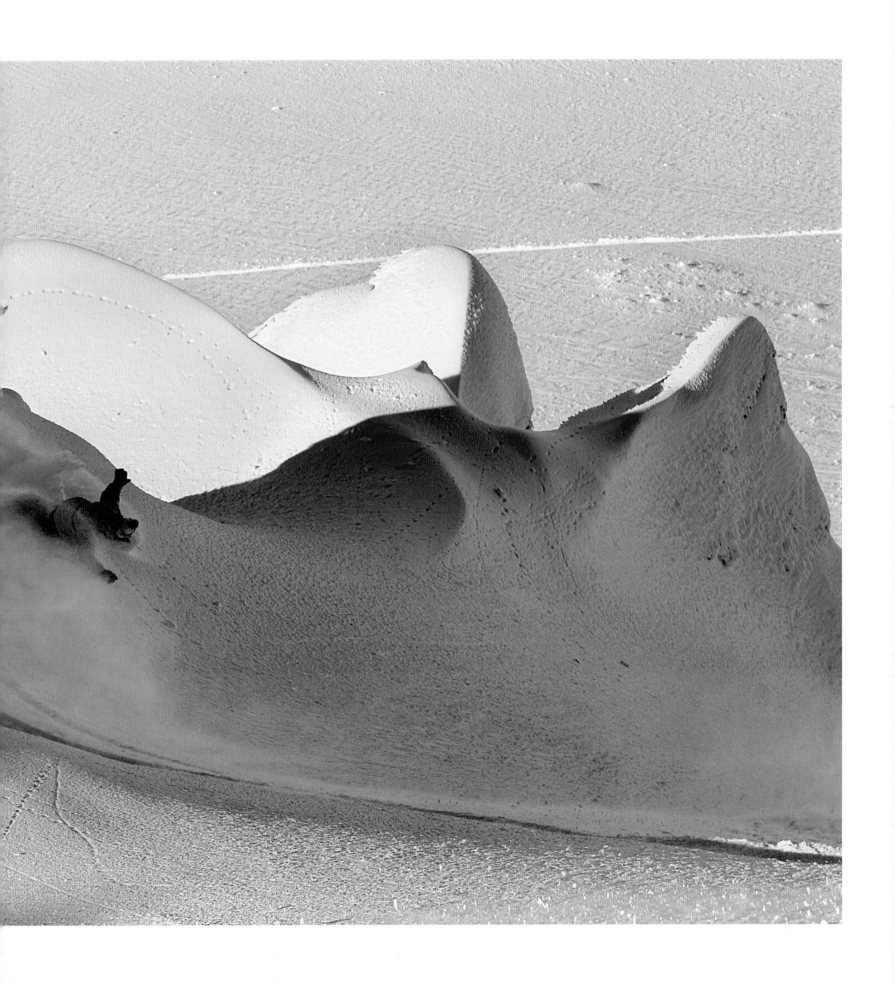

23

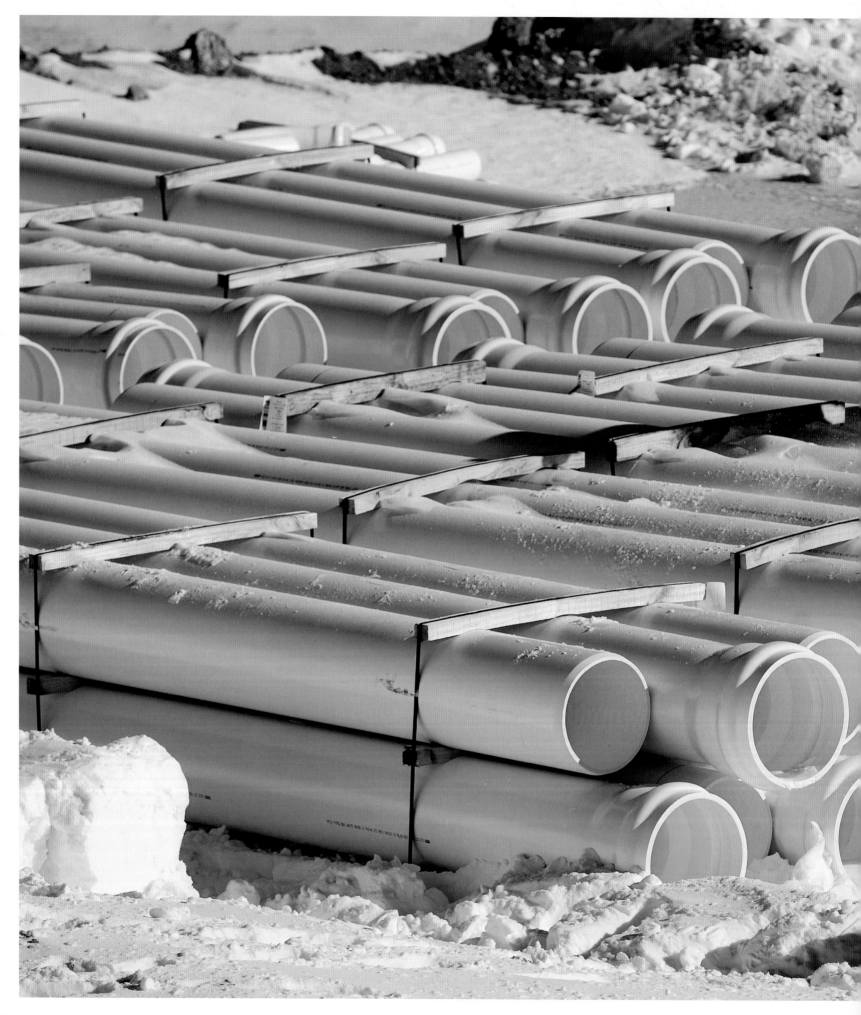

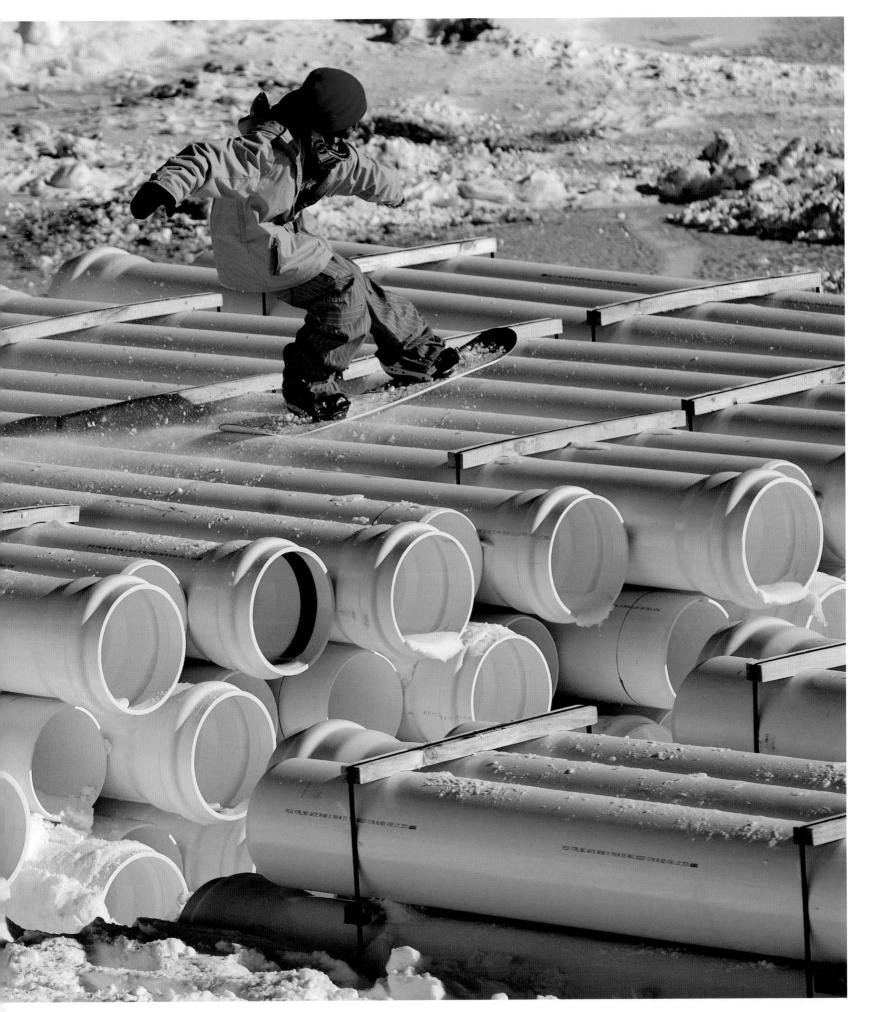

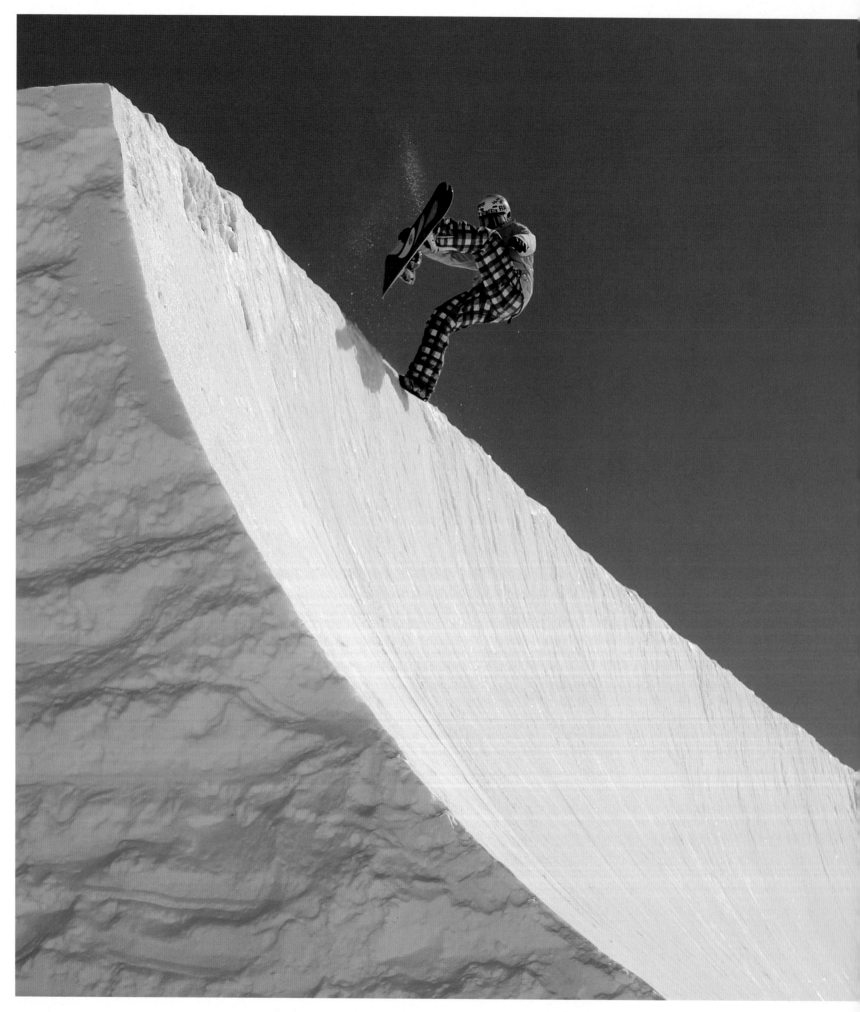

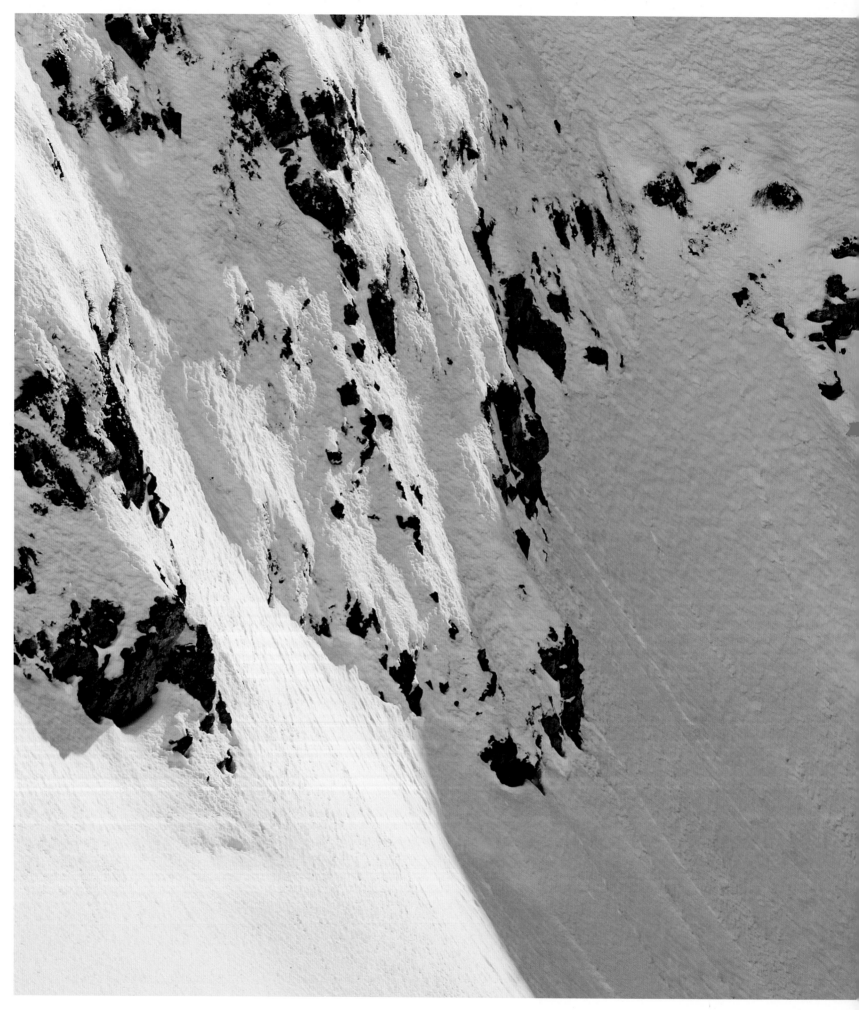

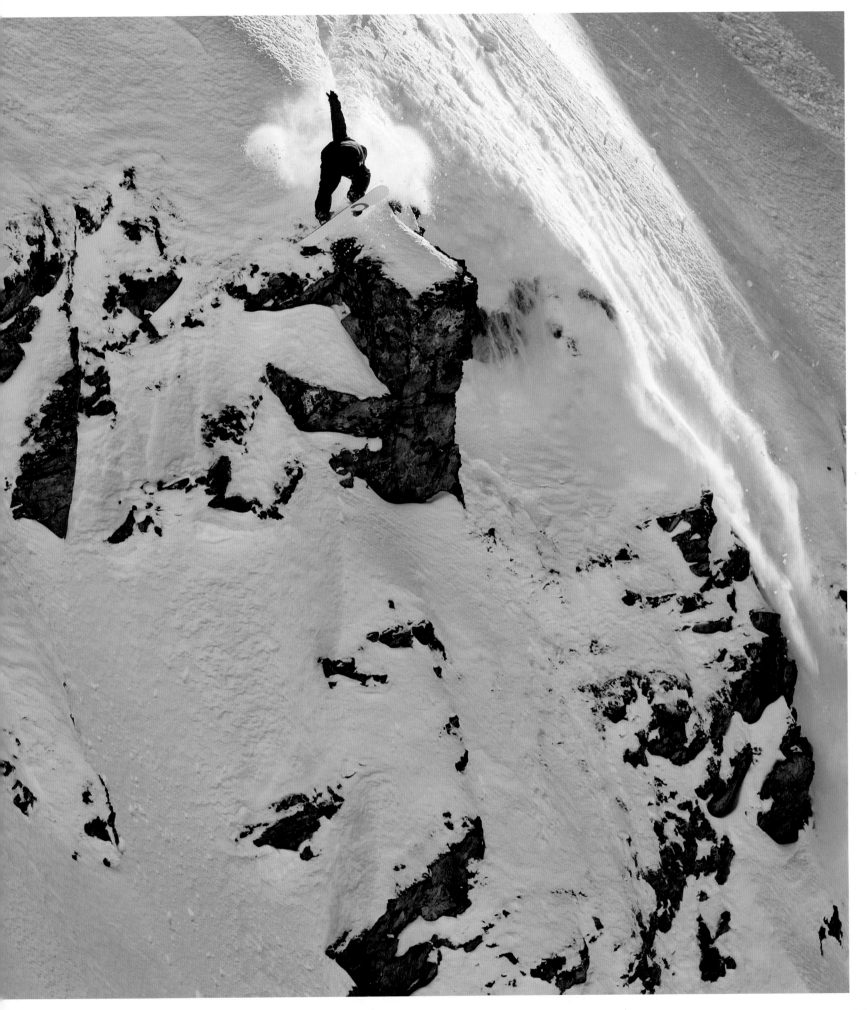

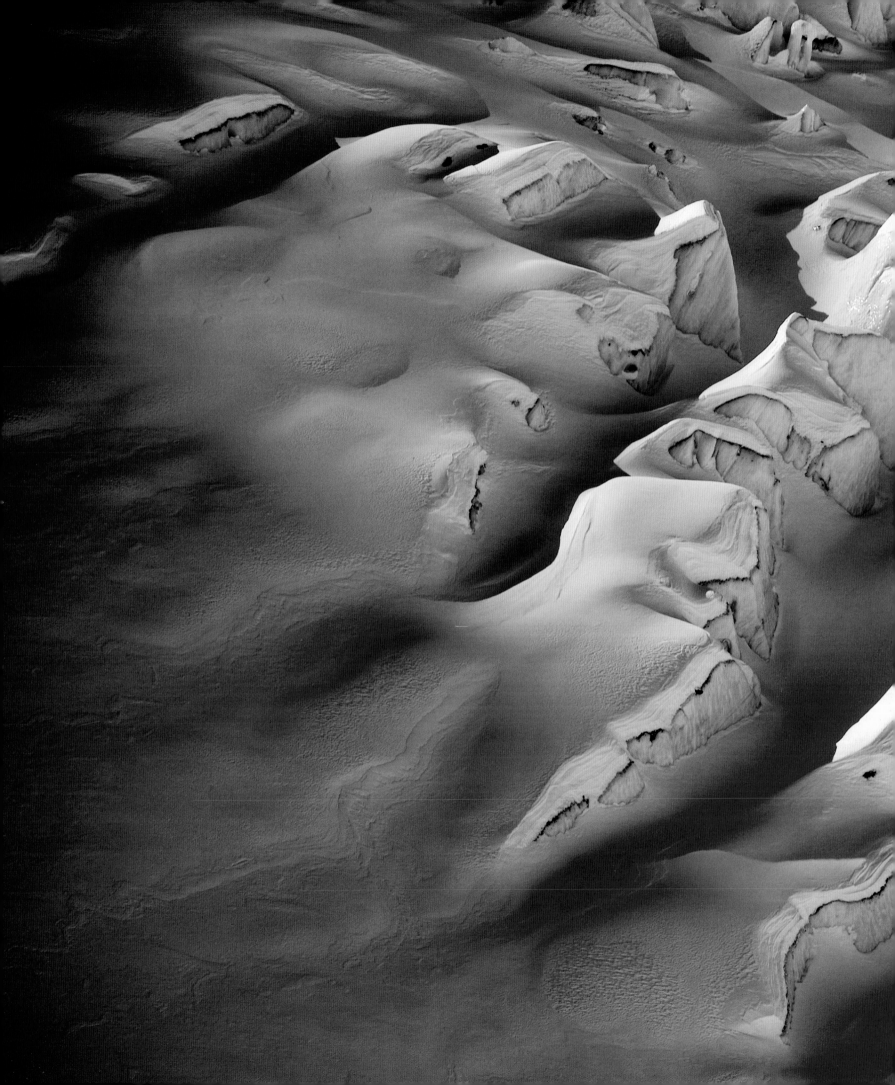

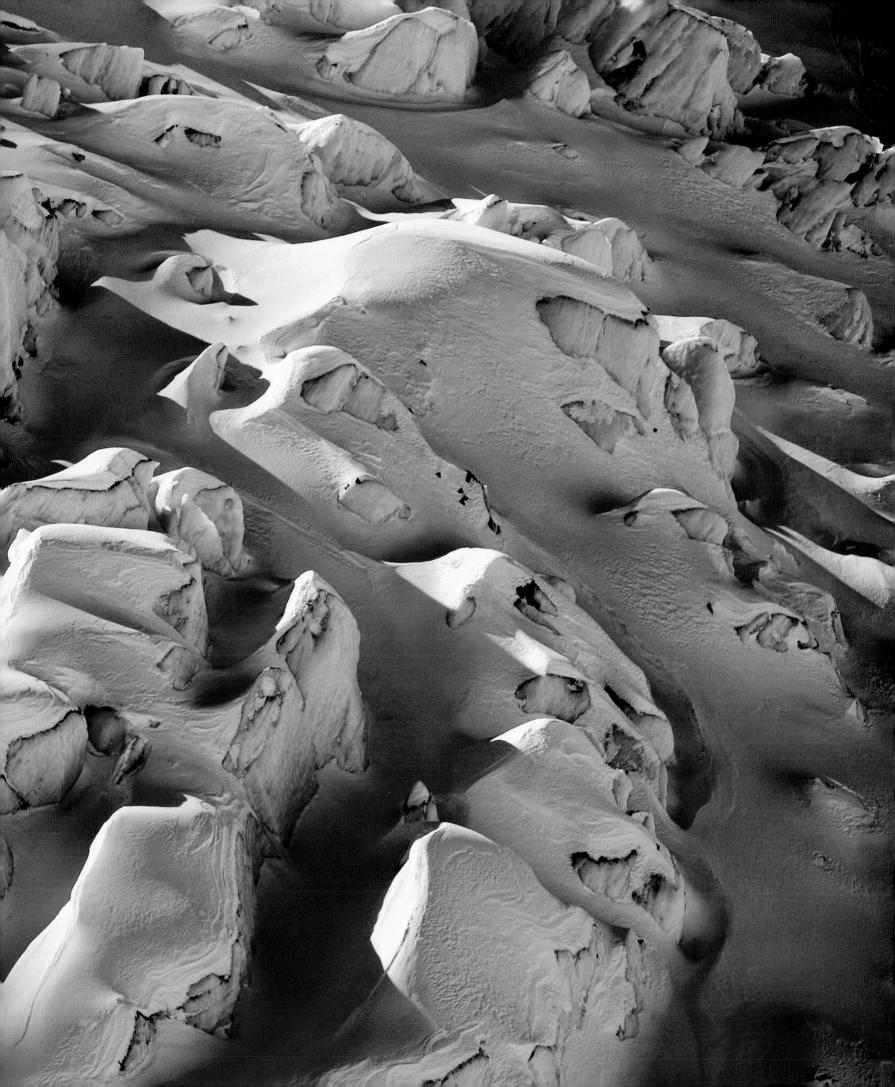

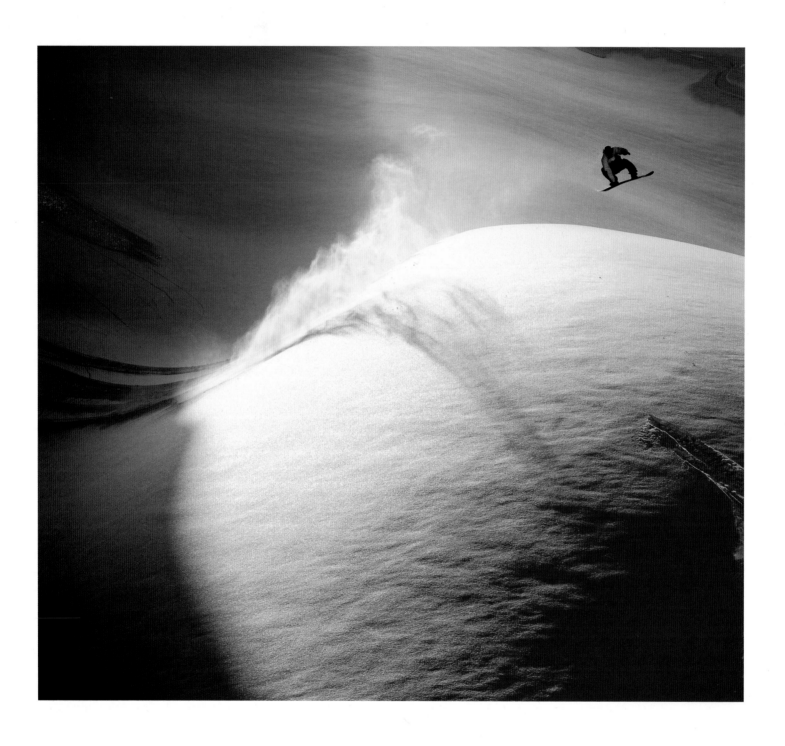

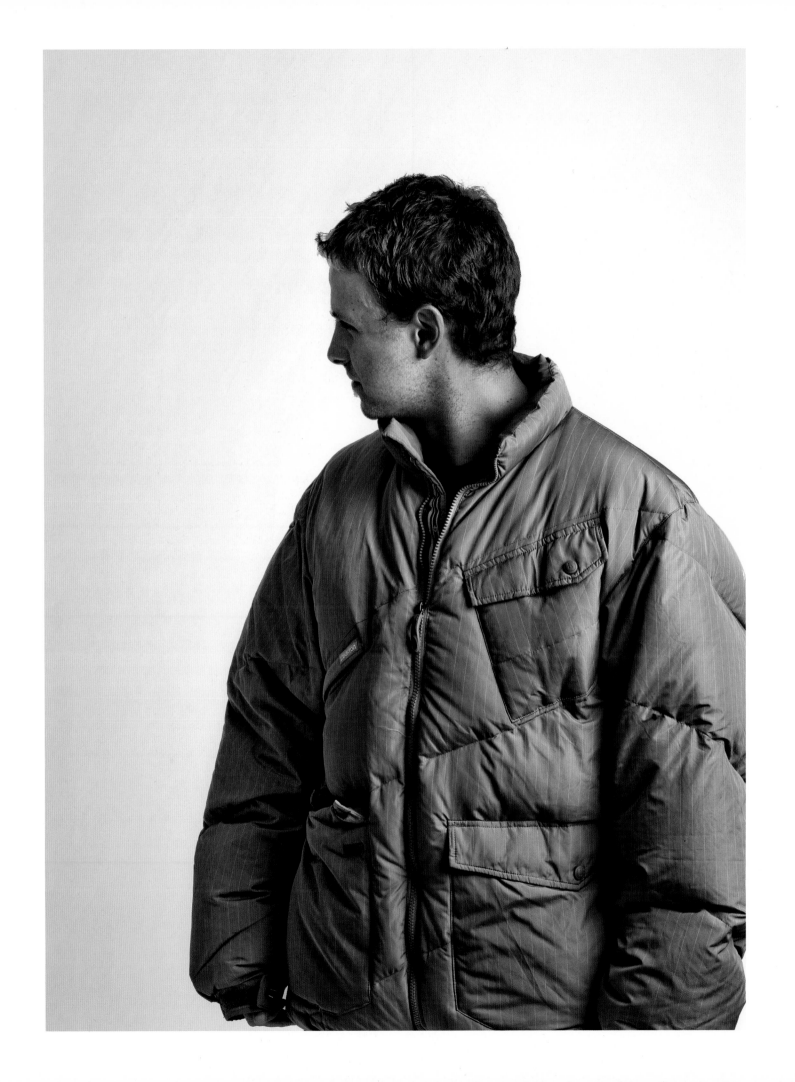

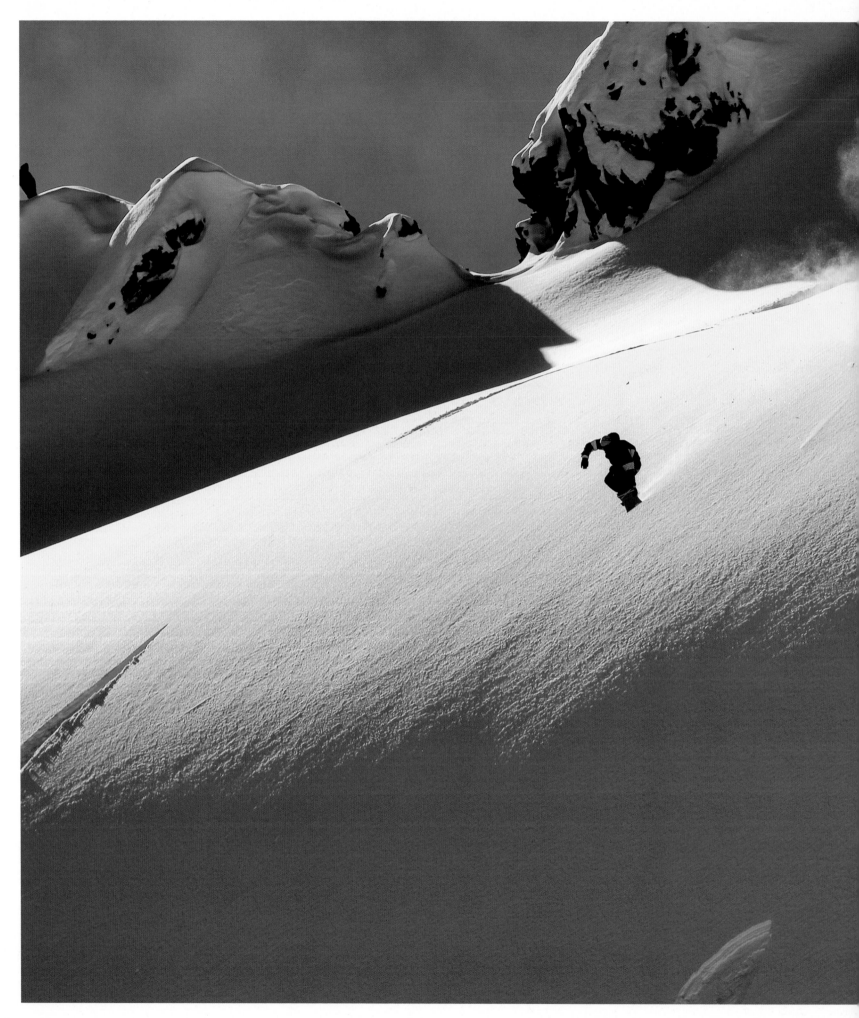

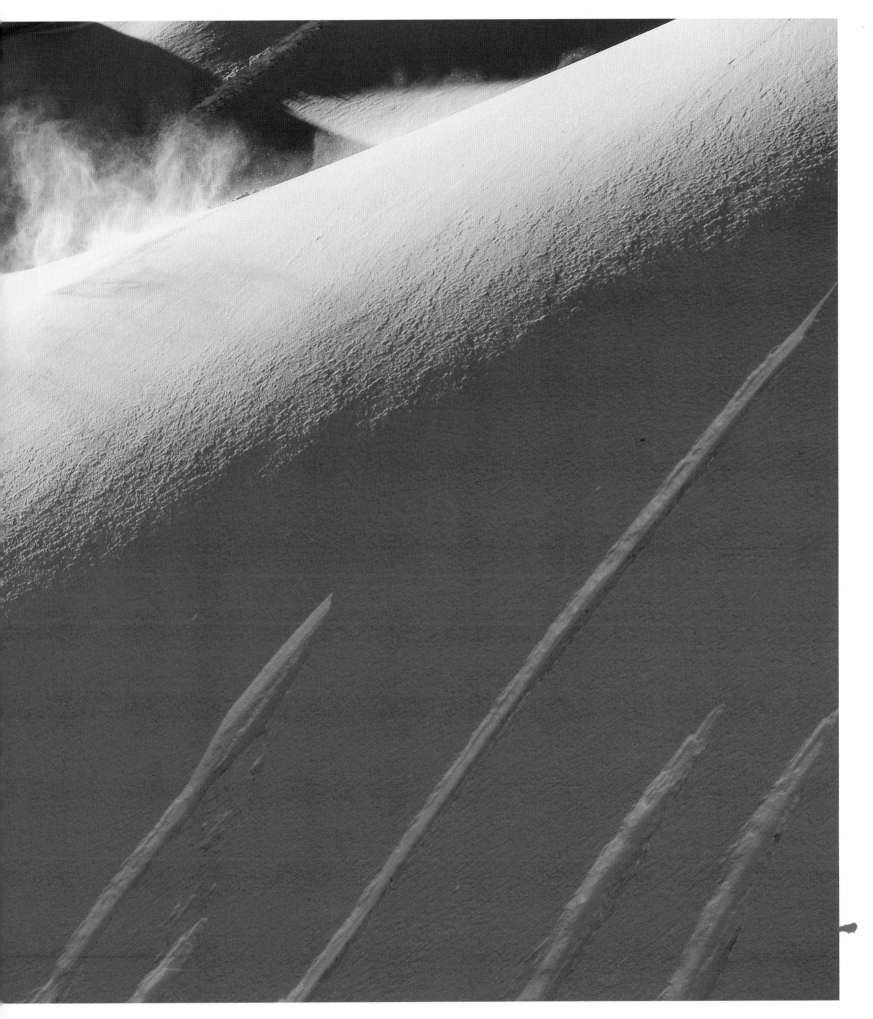

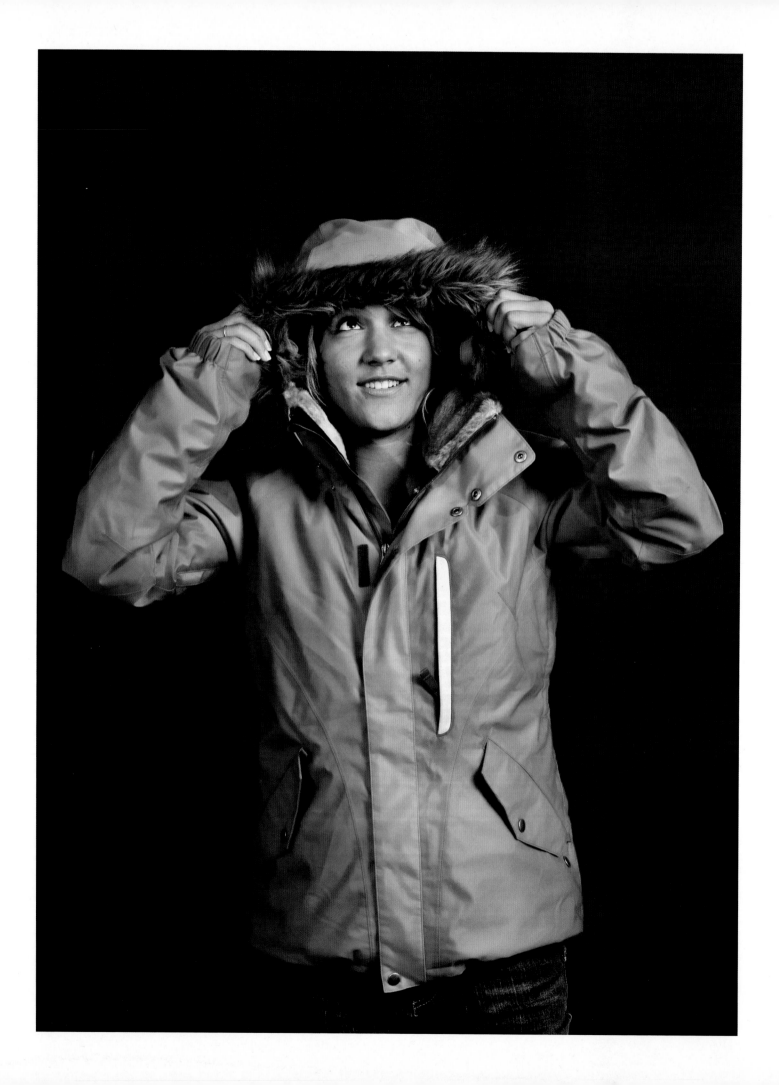

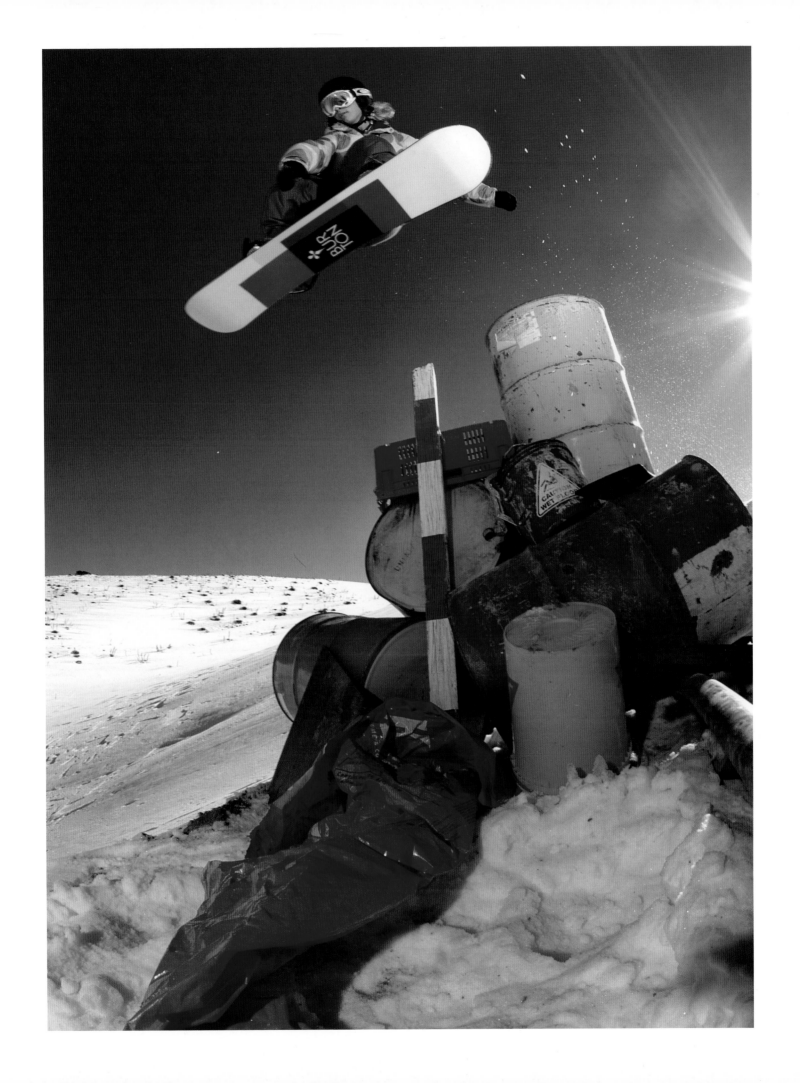

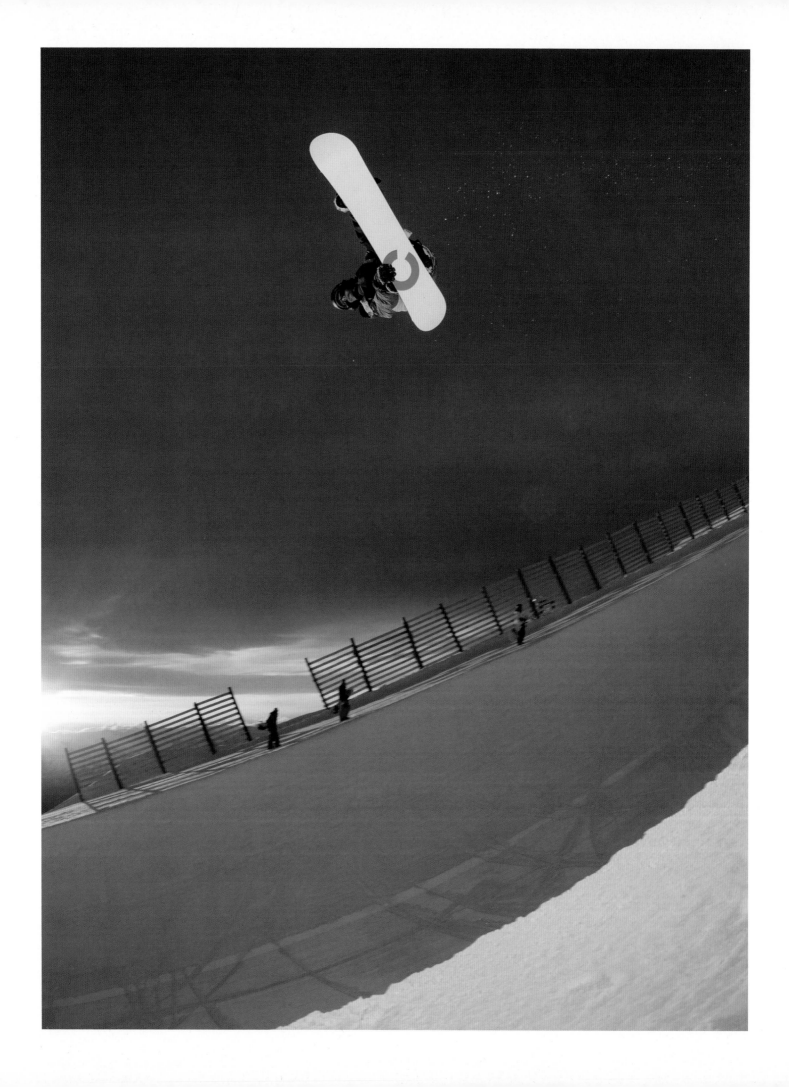

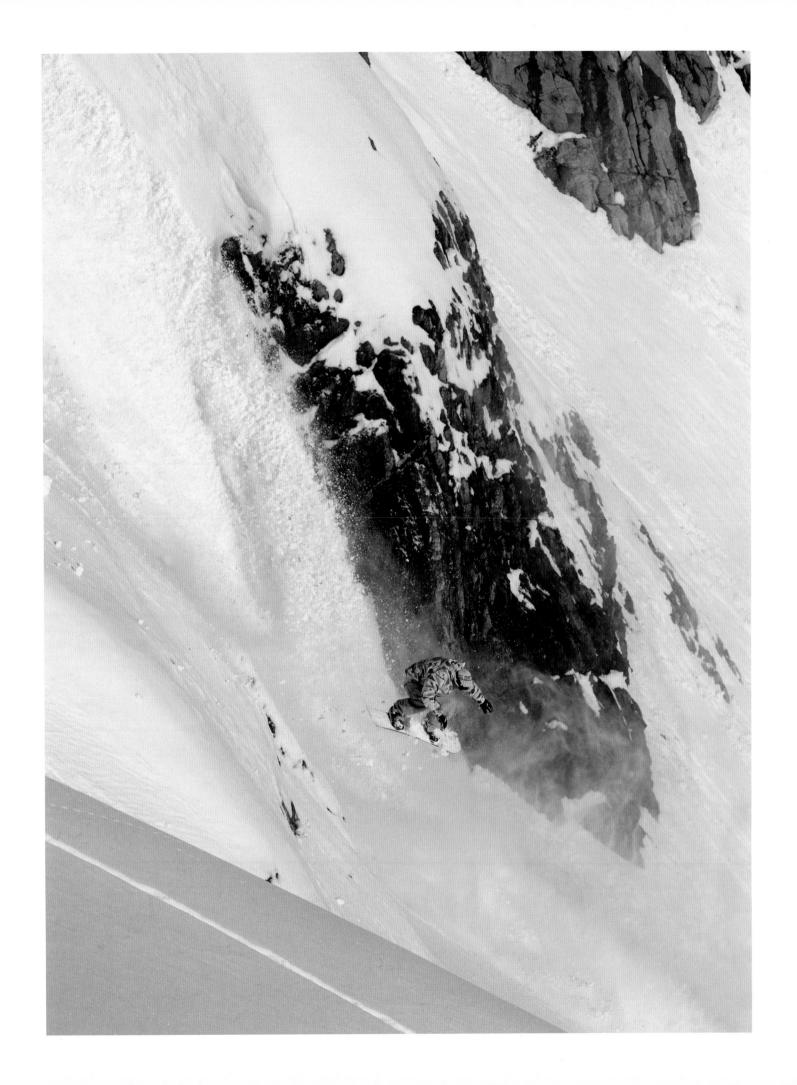

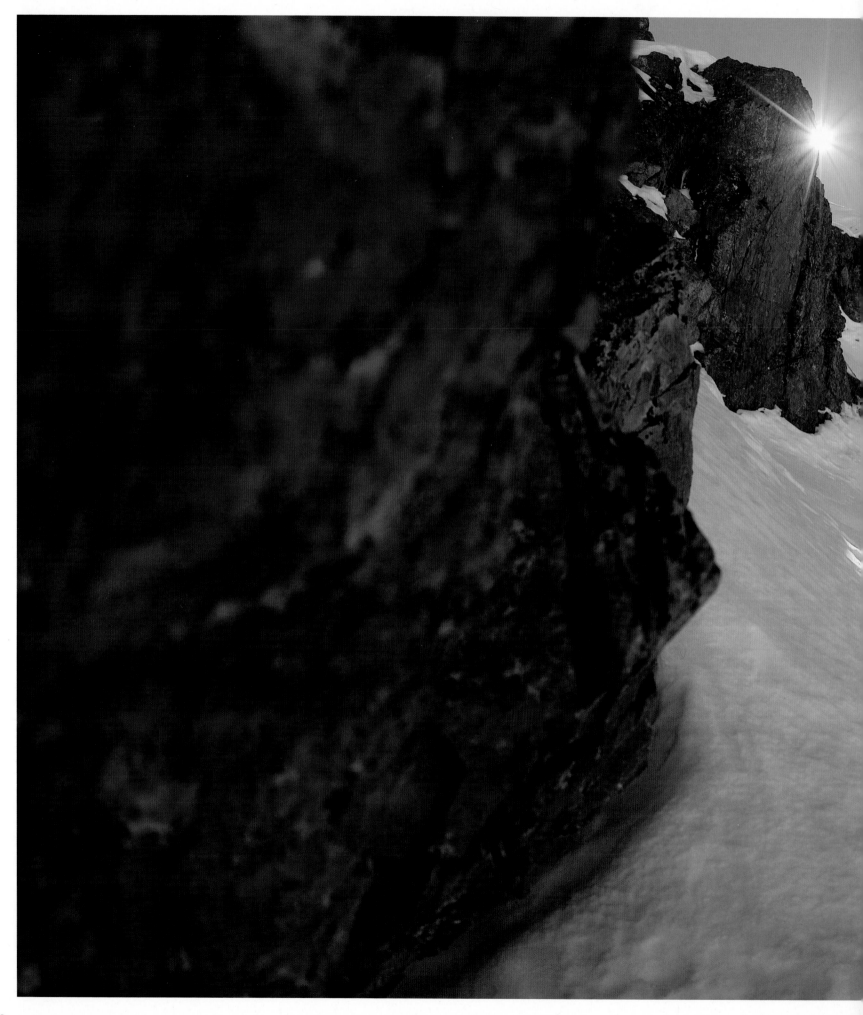

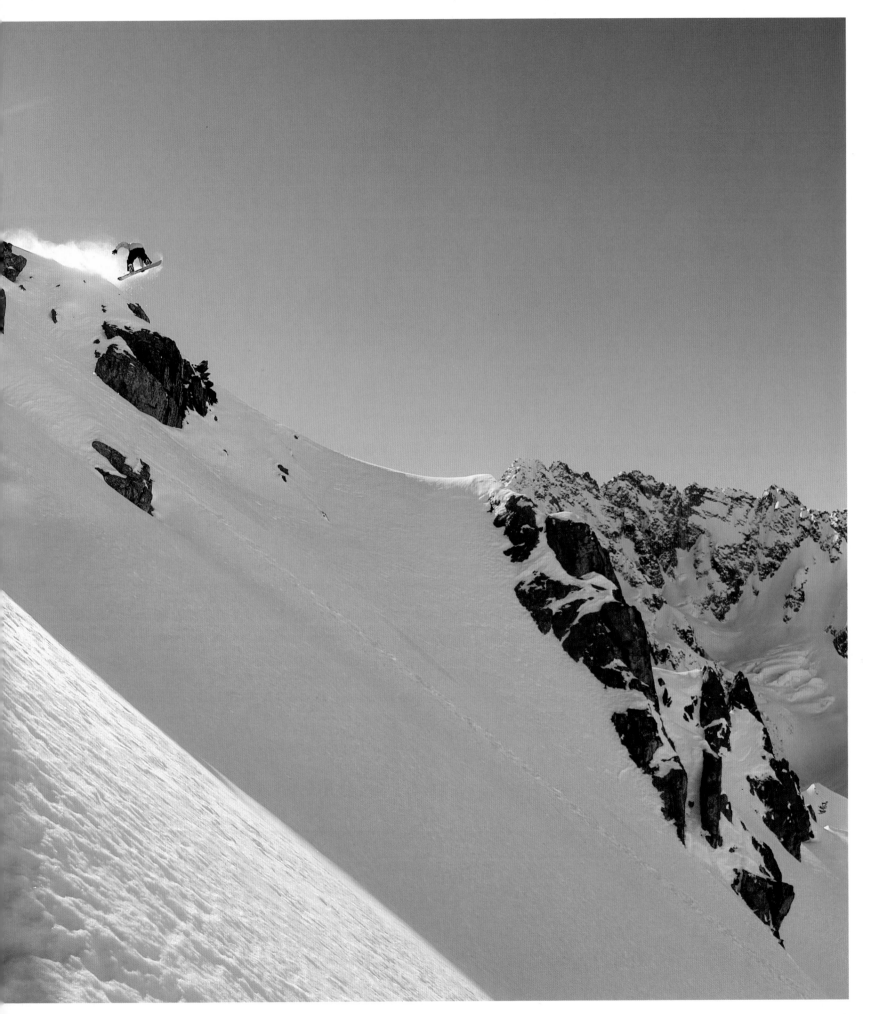

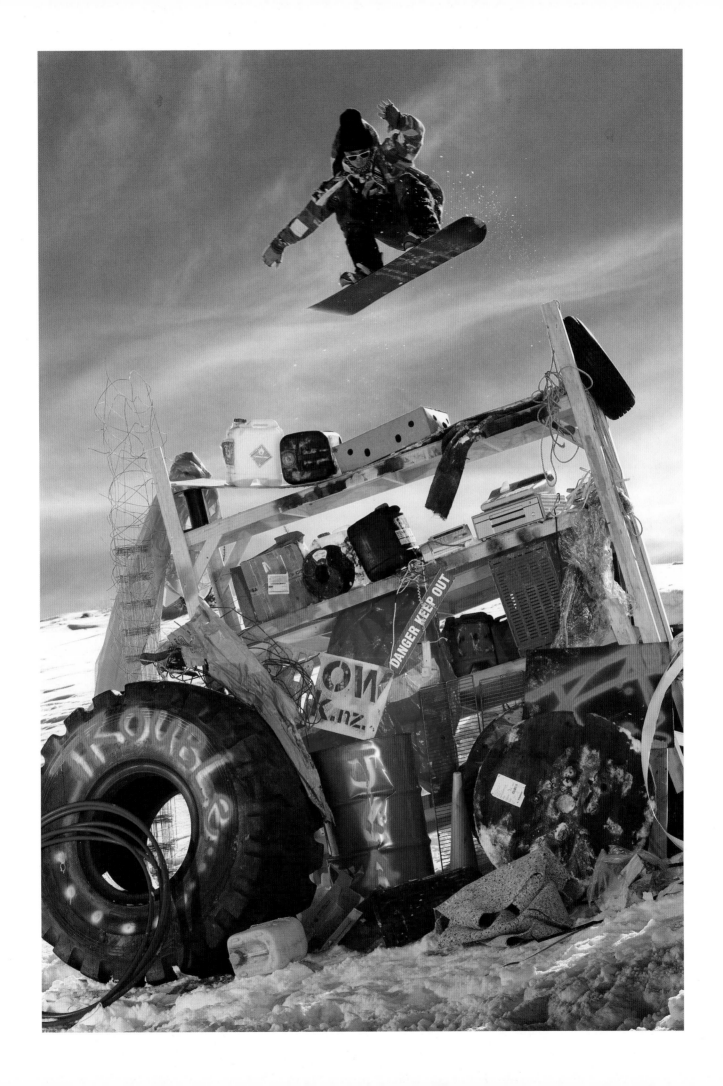

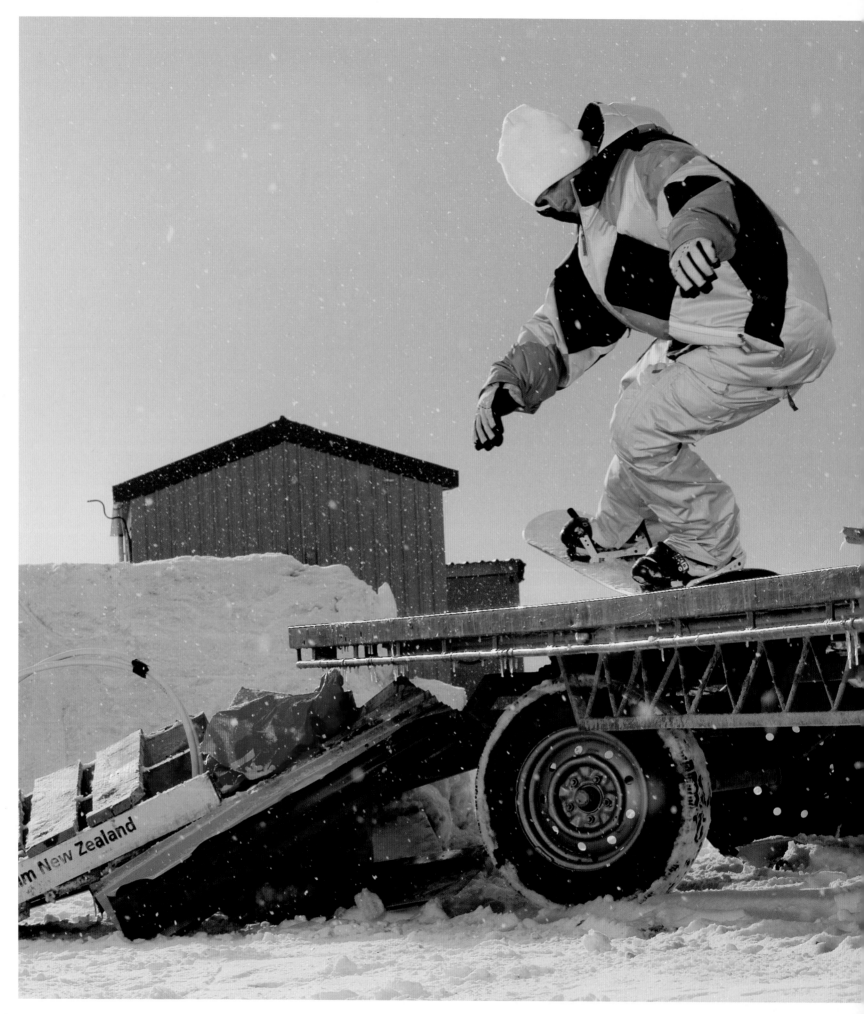

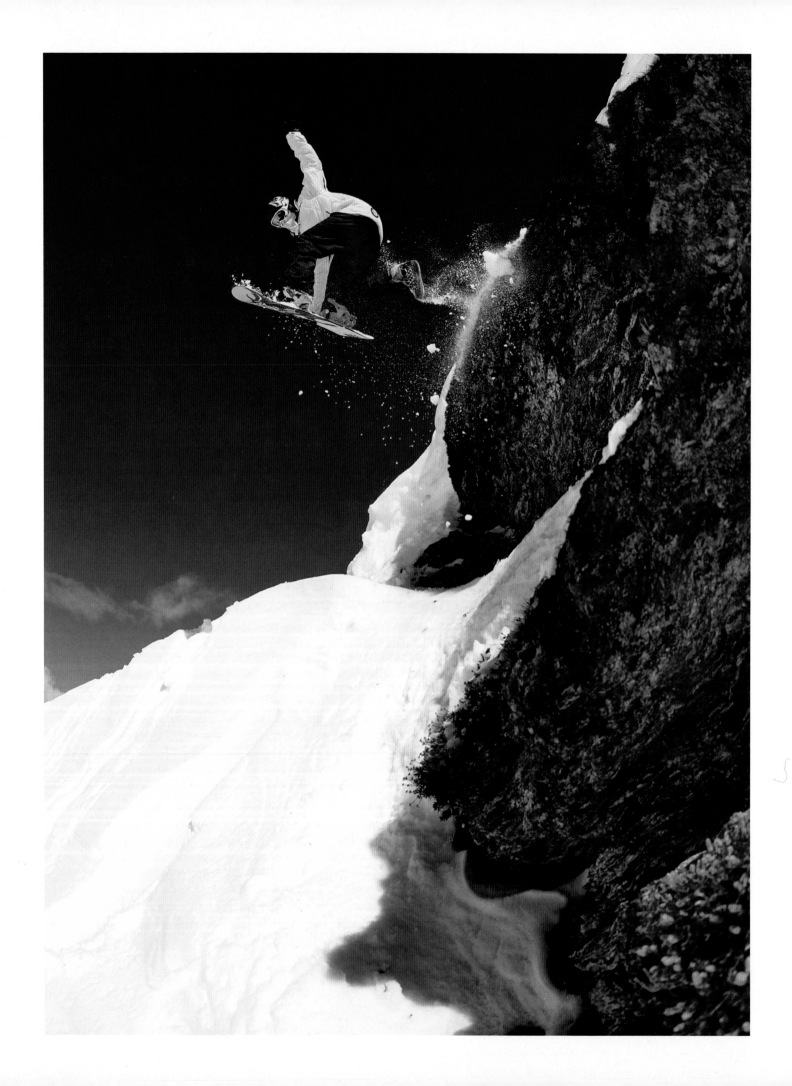

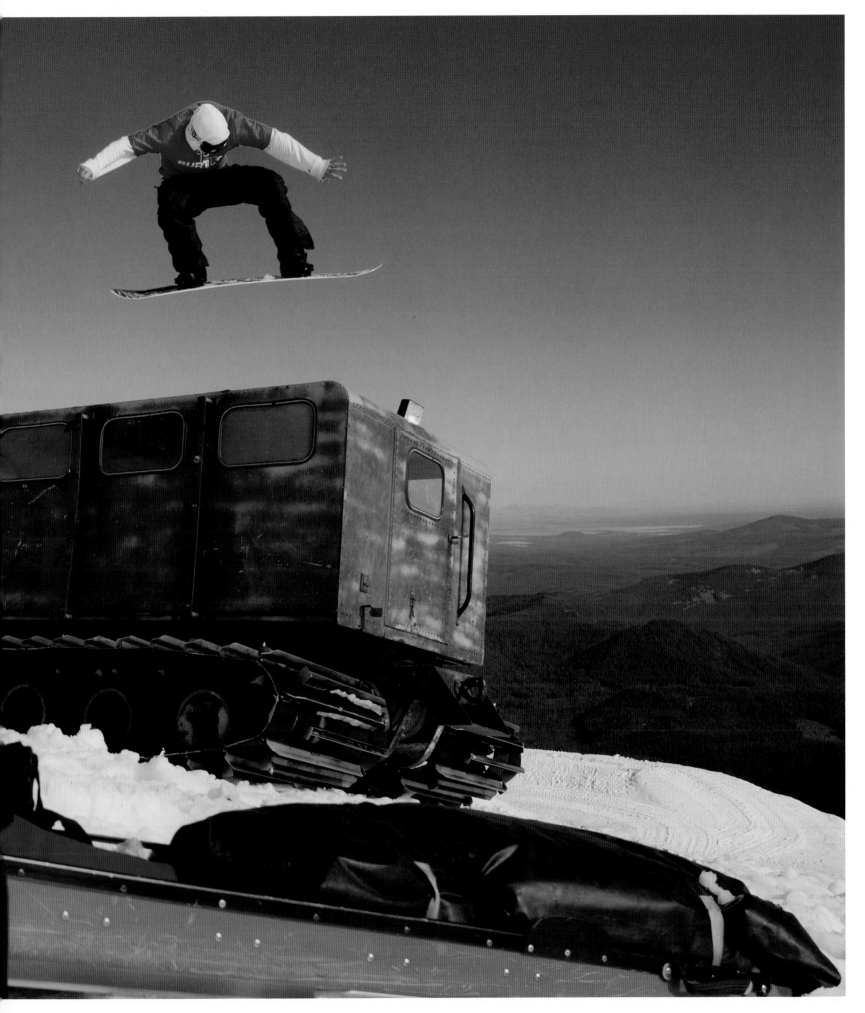

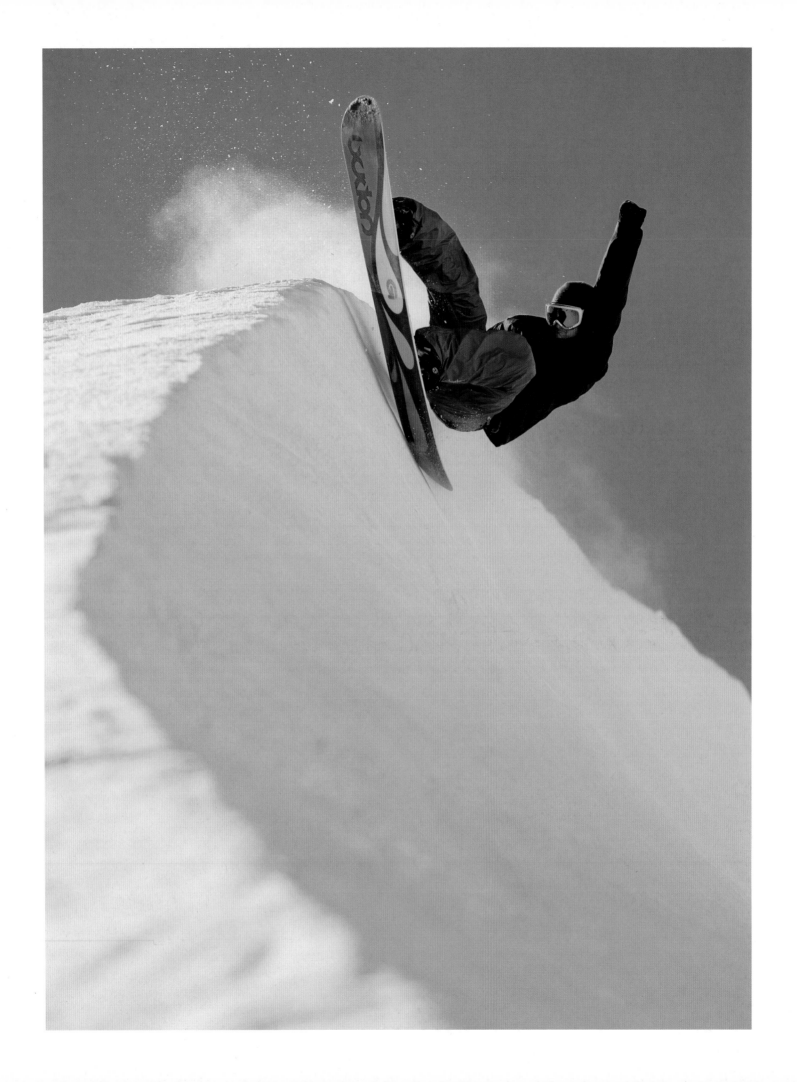

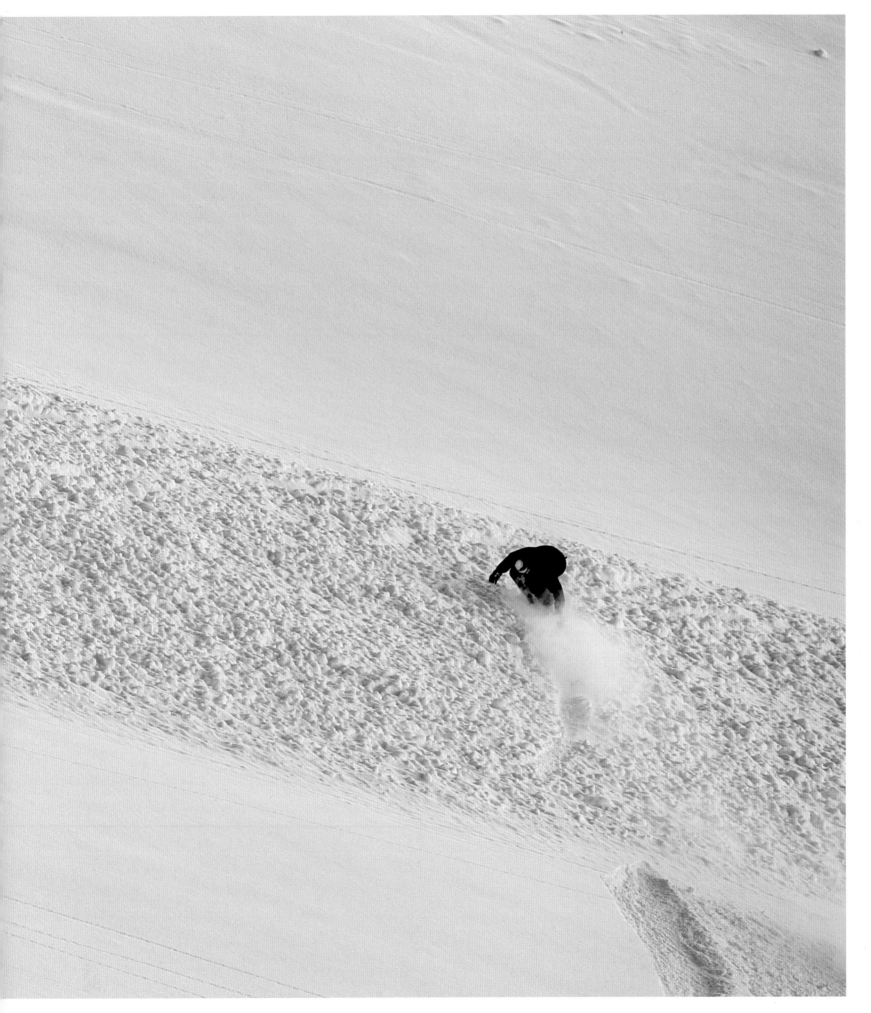

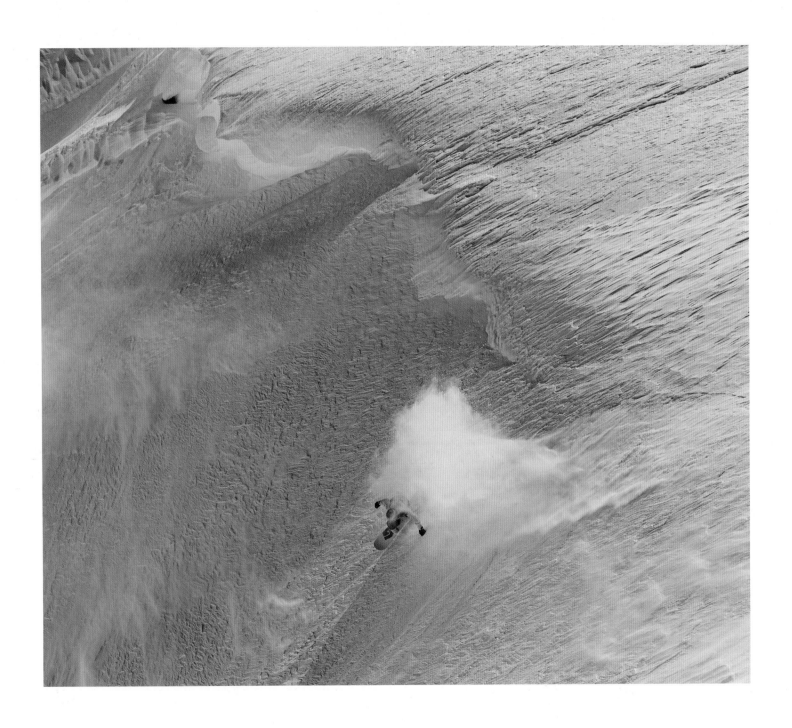

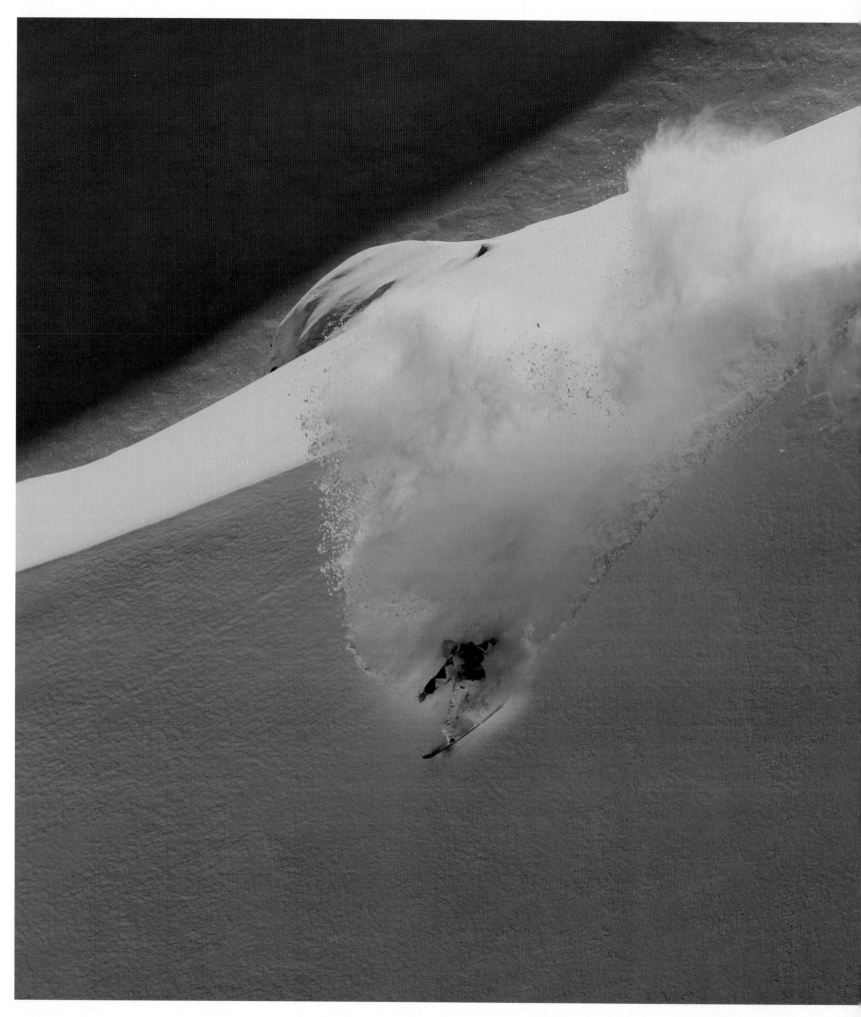

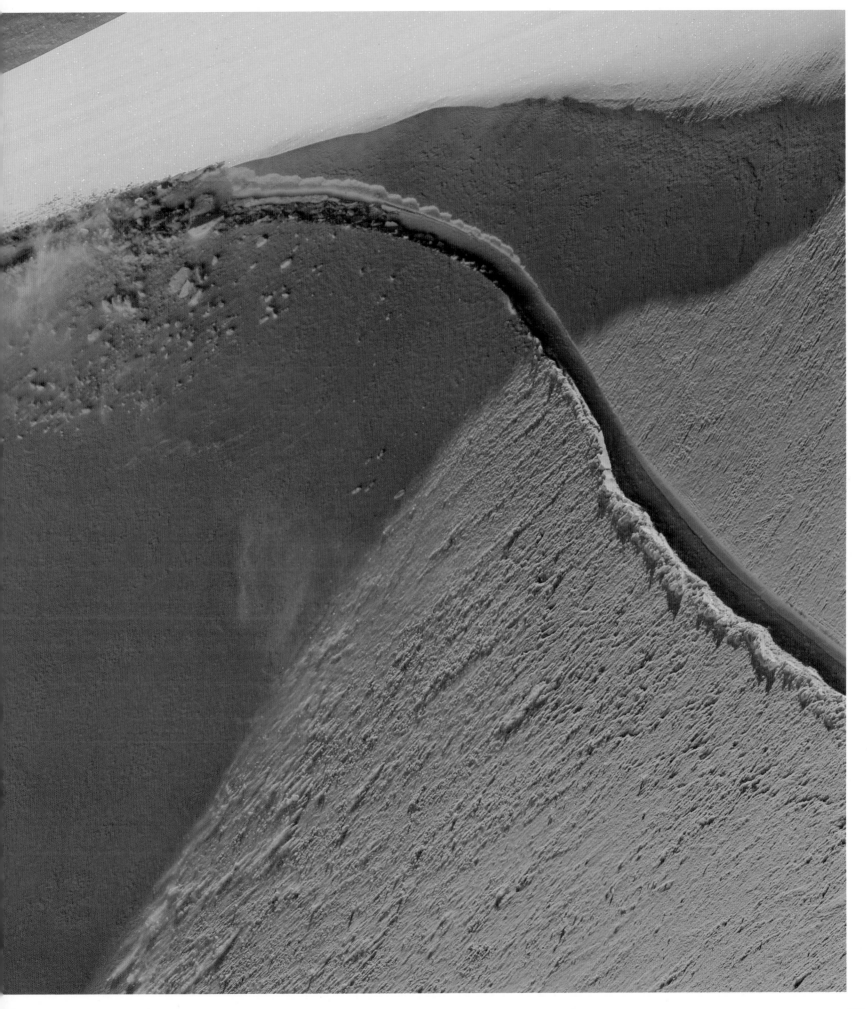

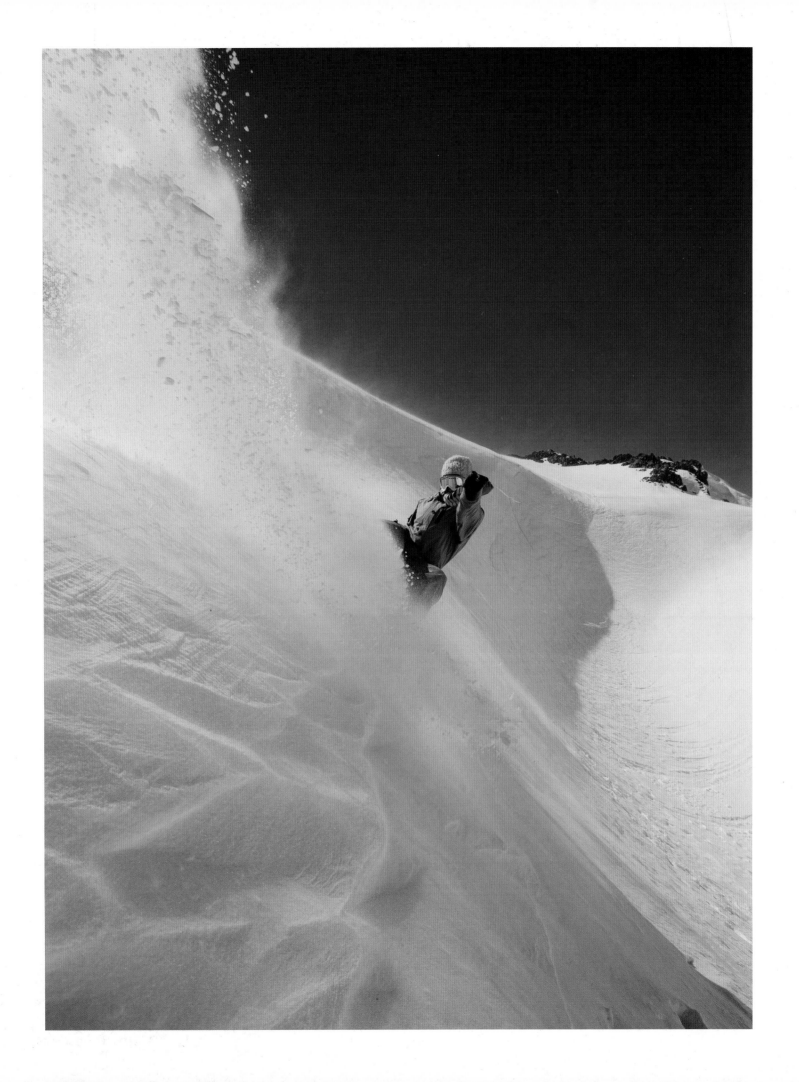

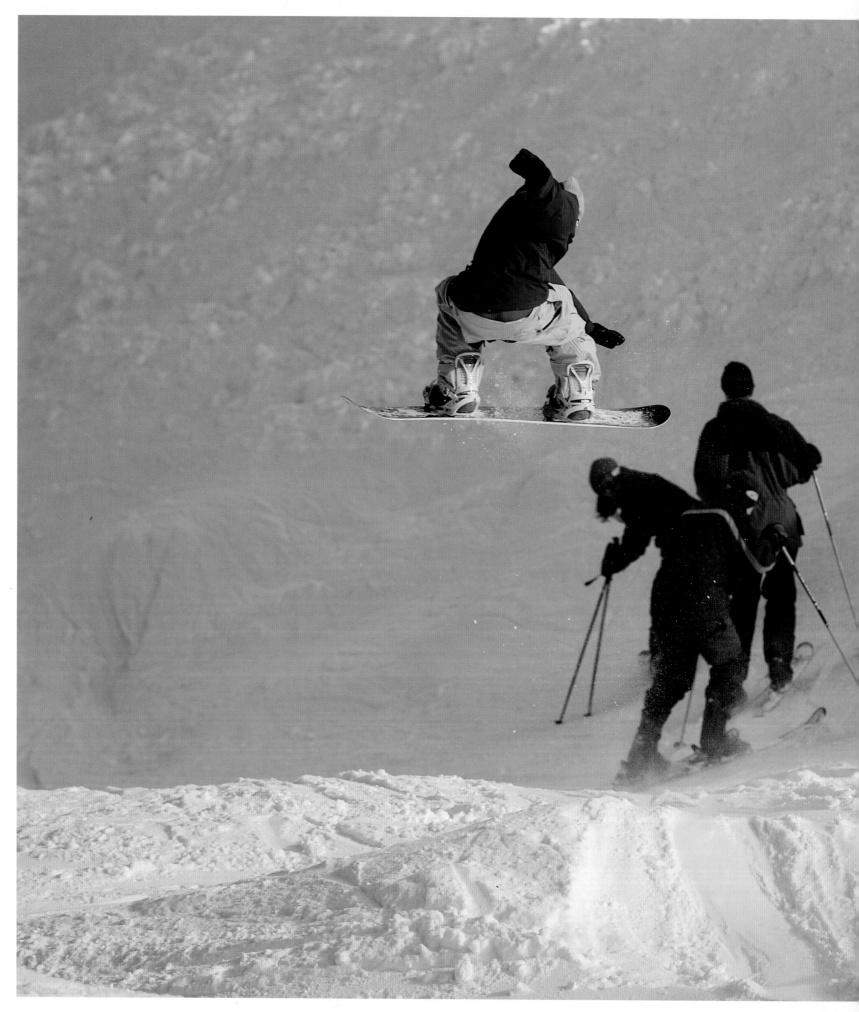

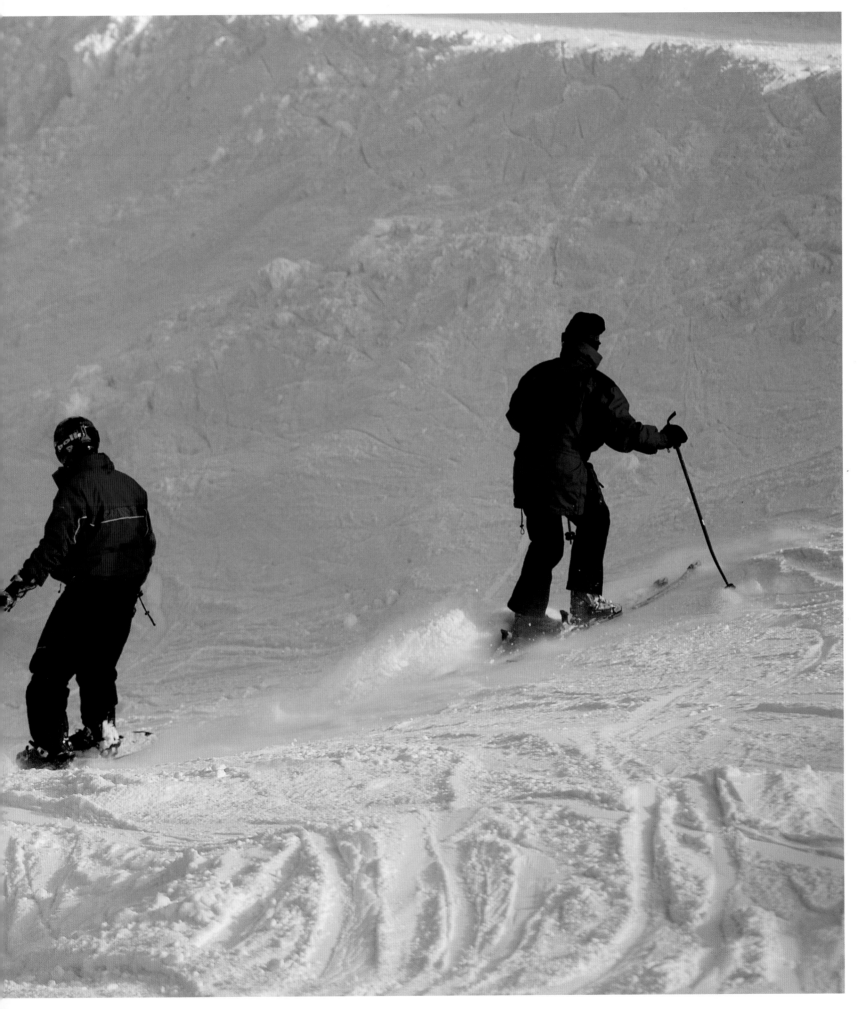

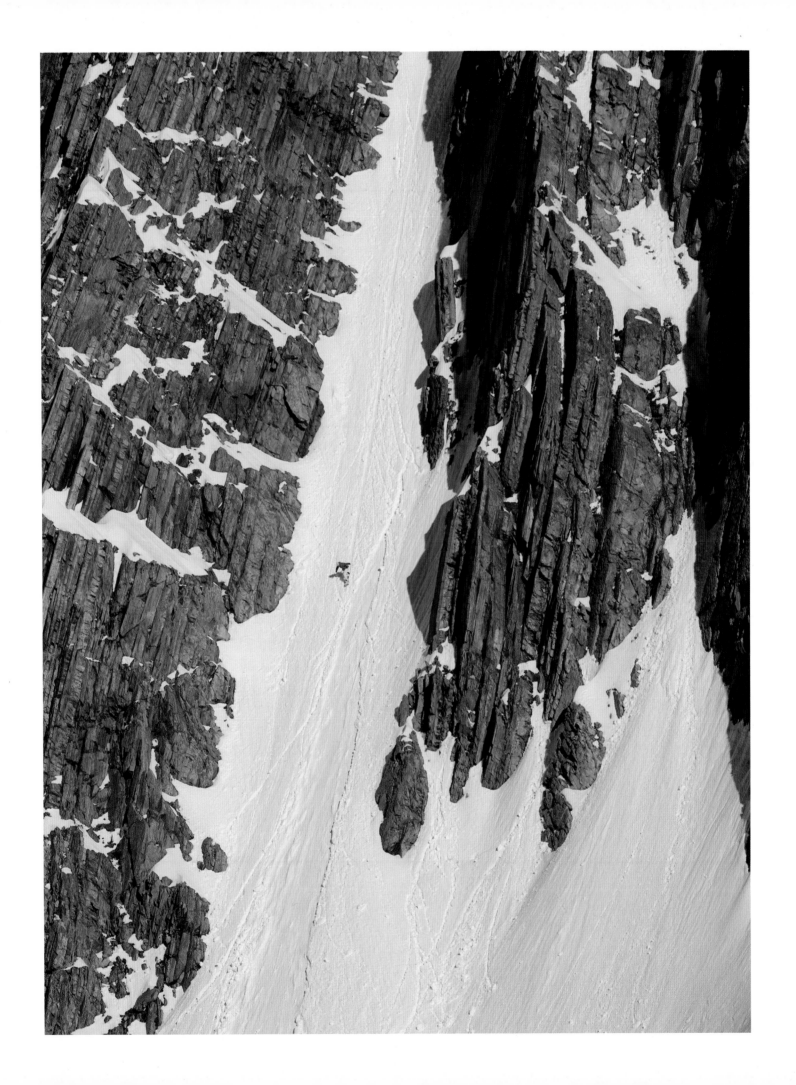

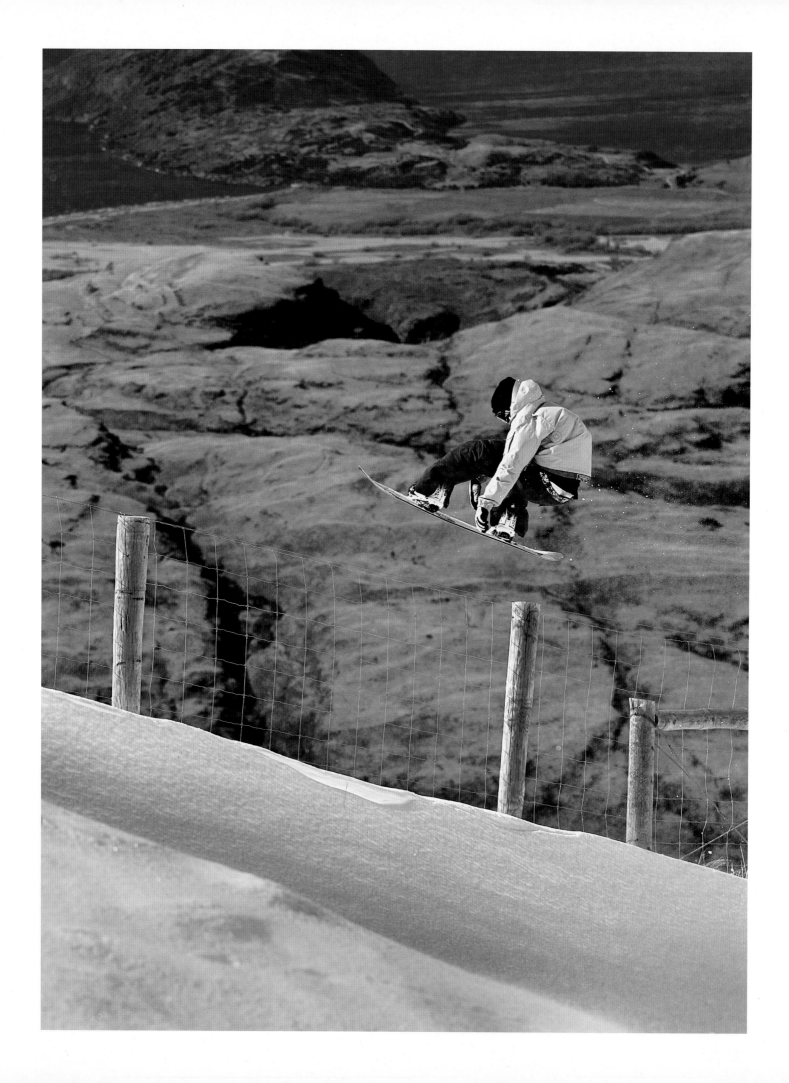

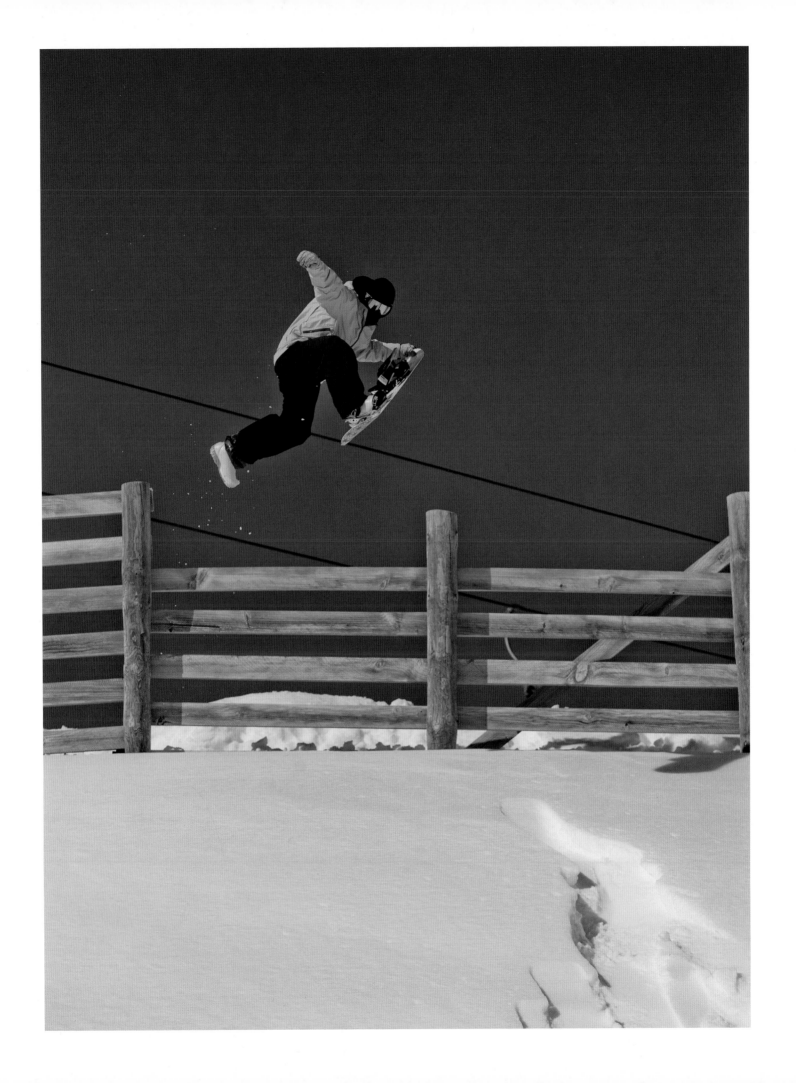

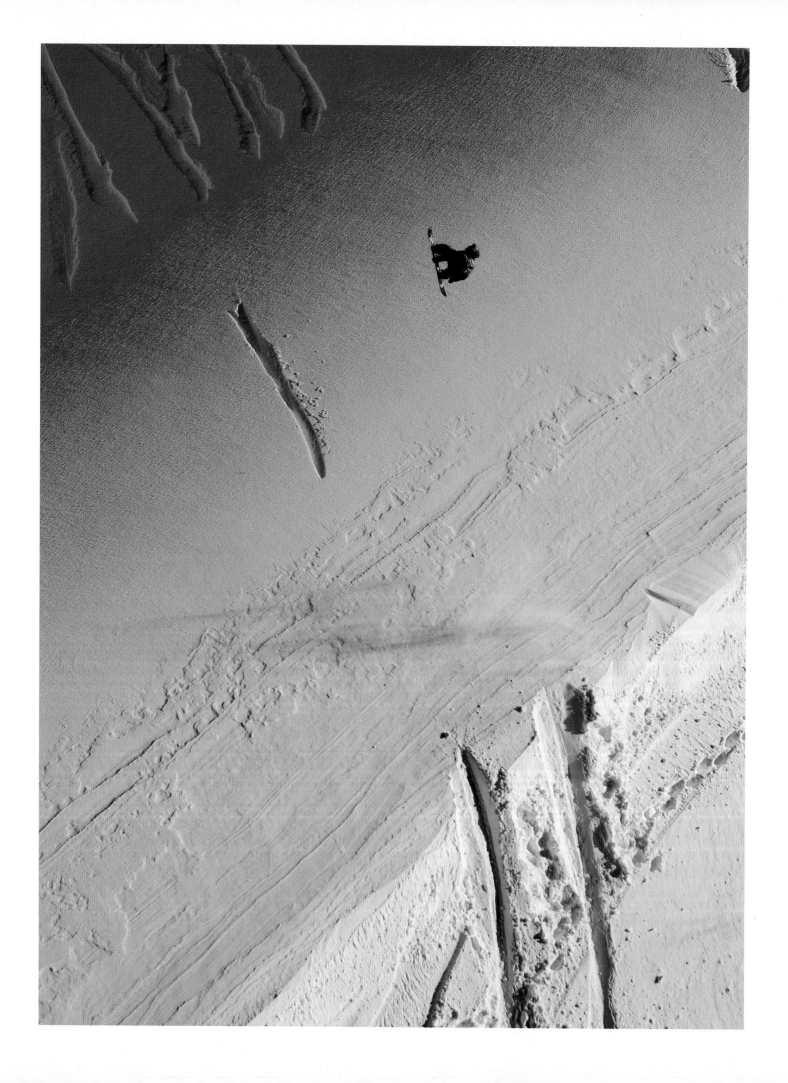

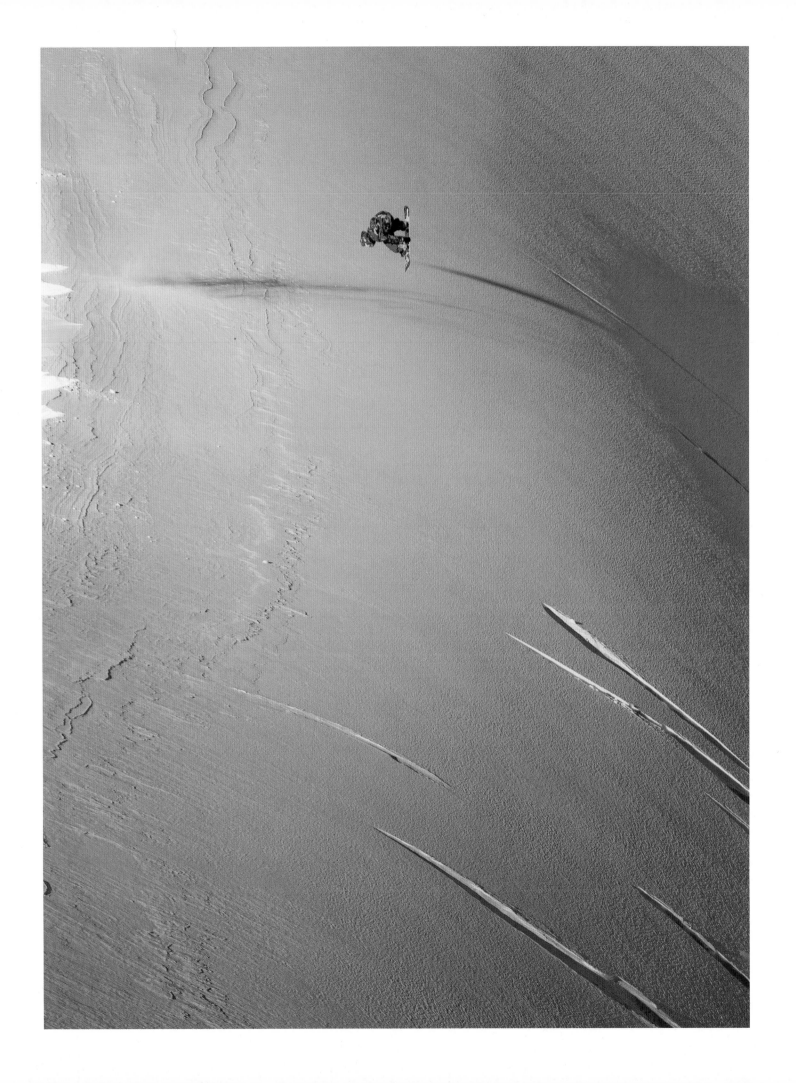

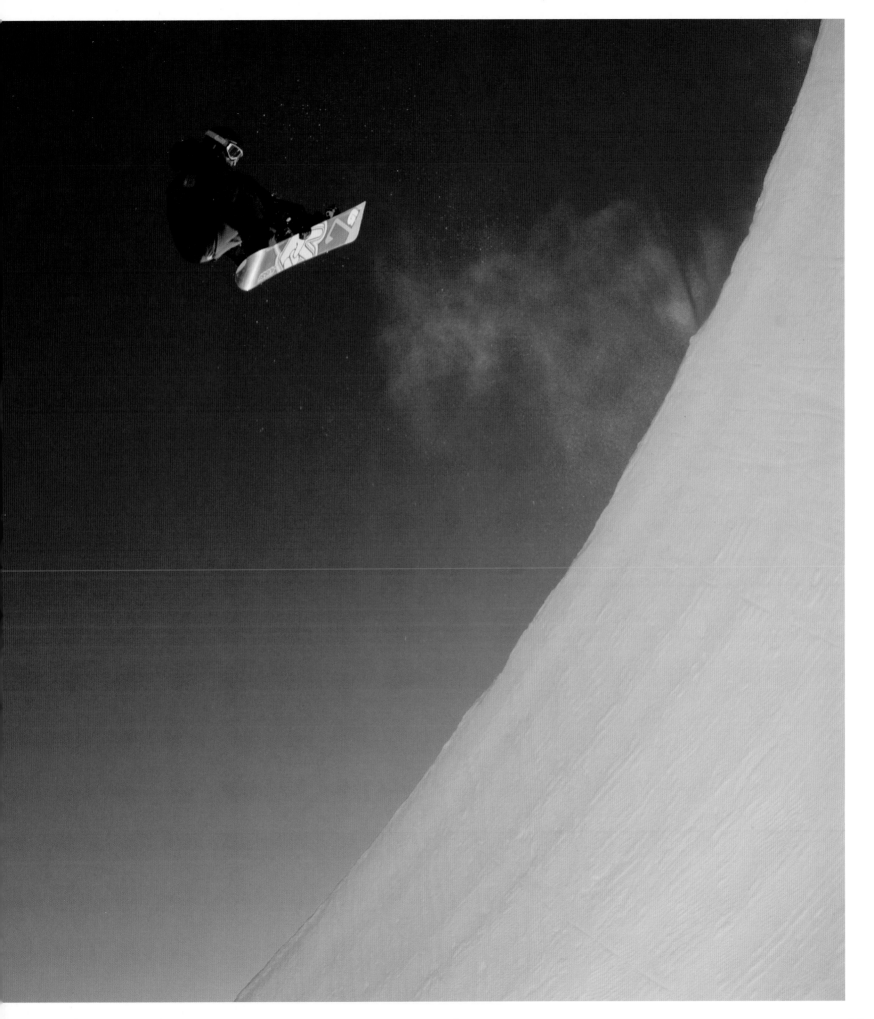

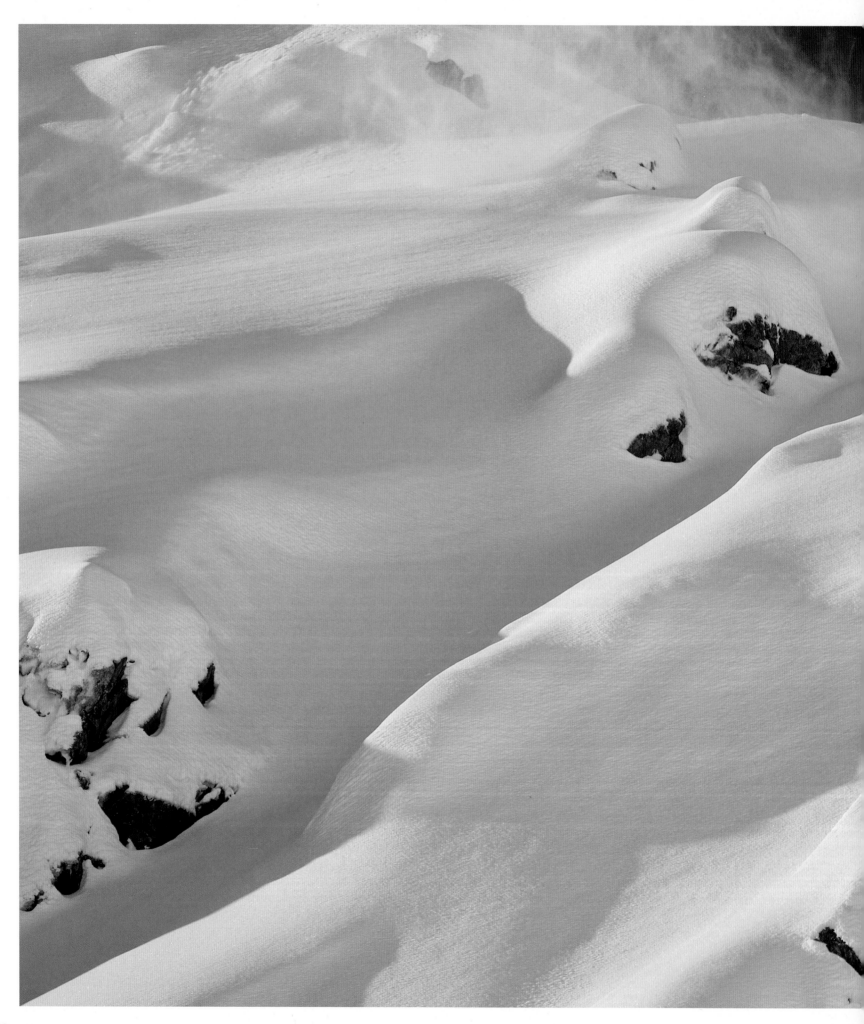

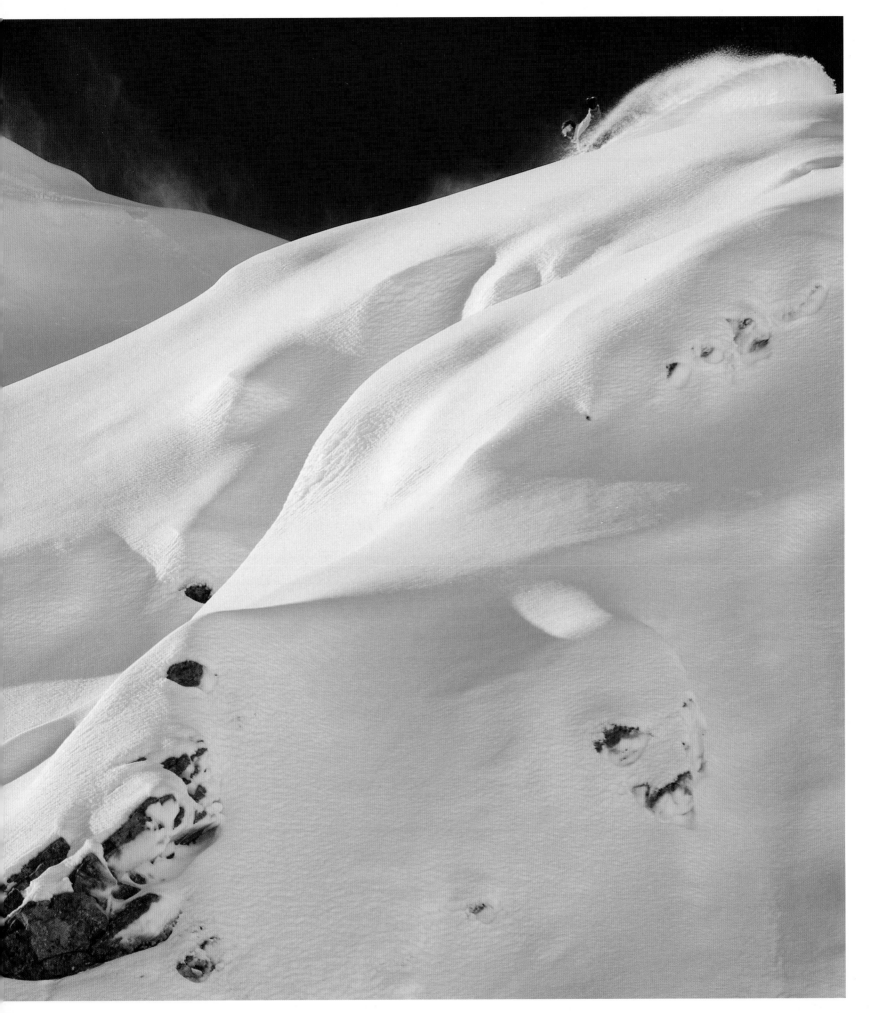

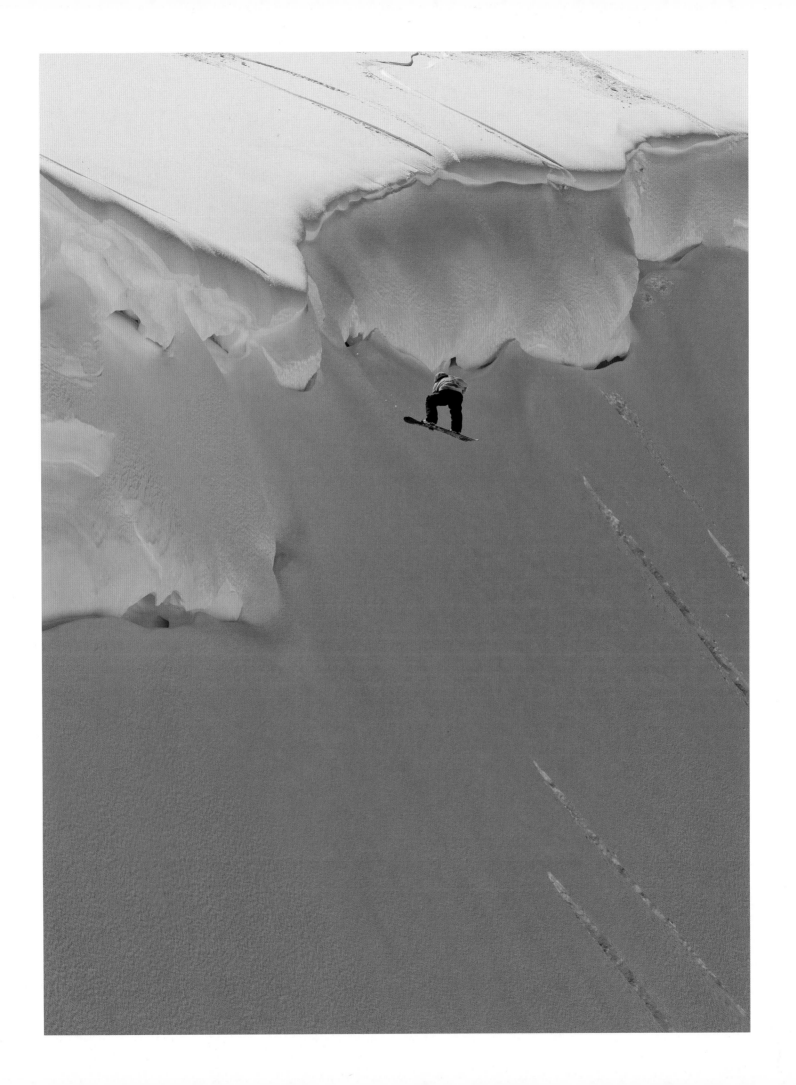

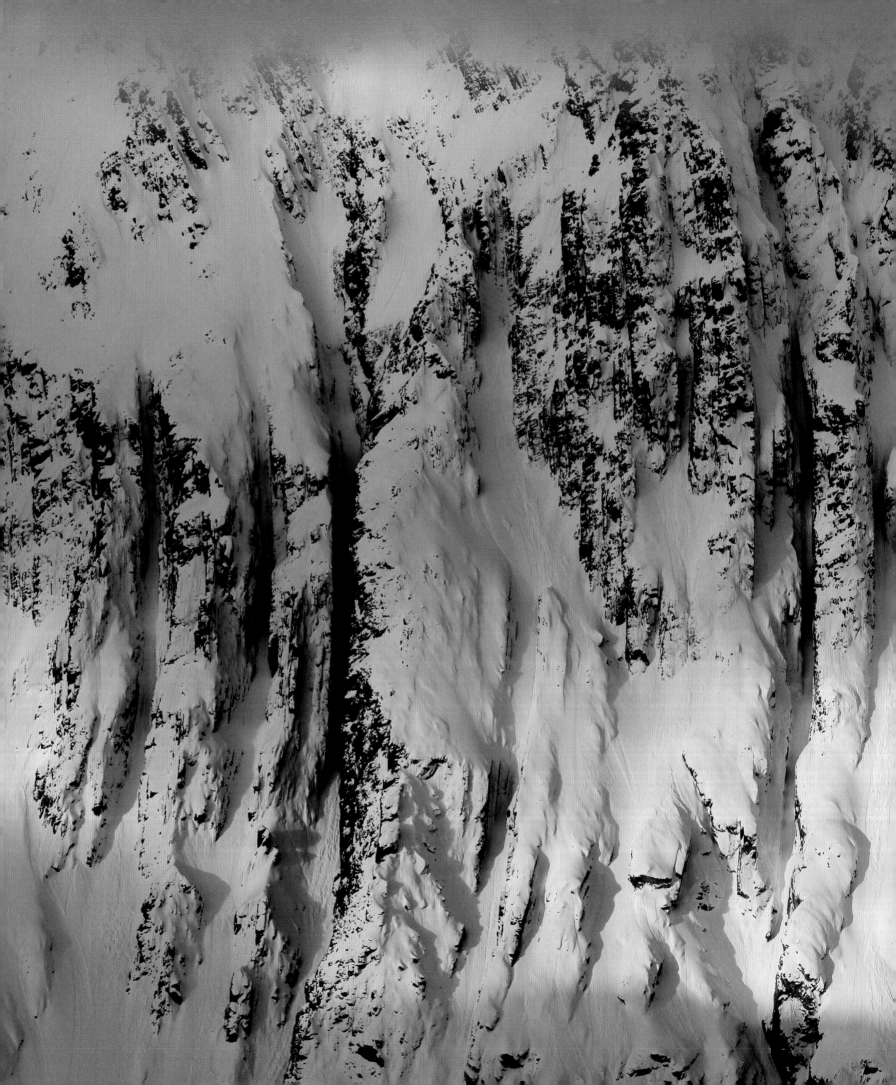

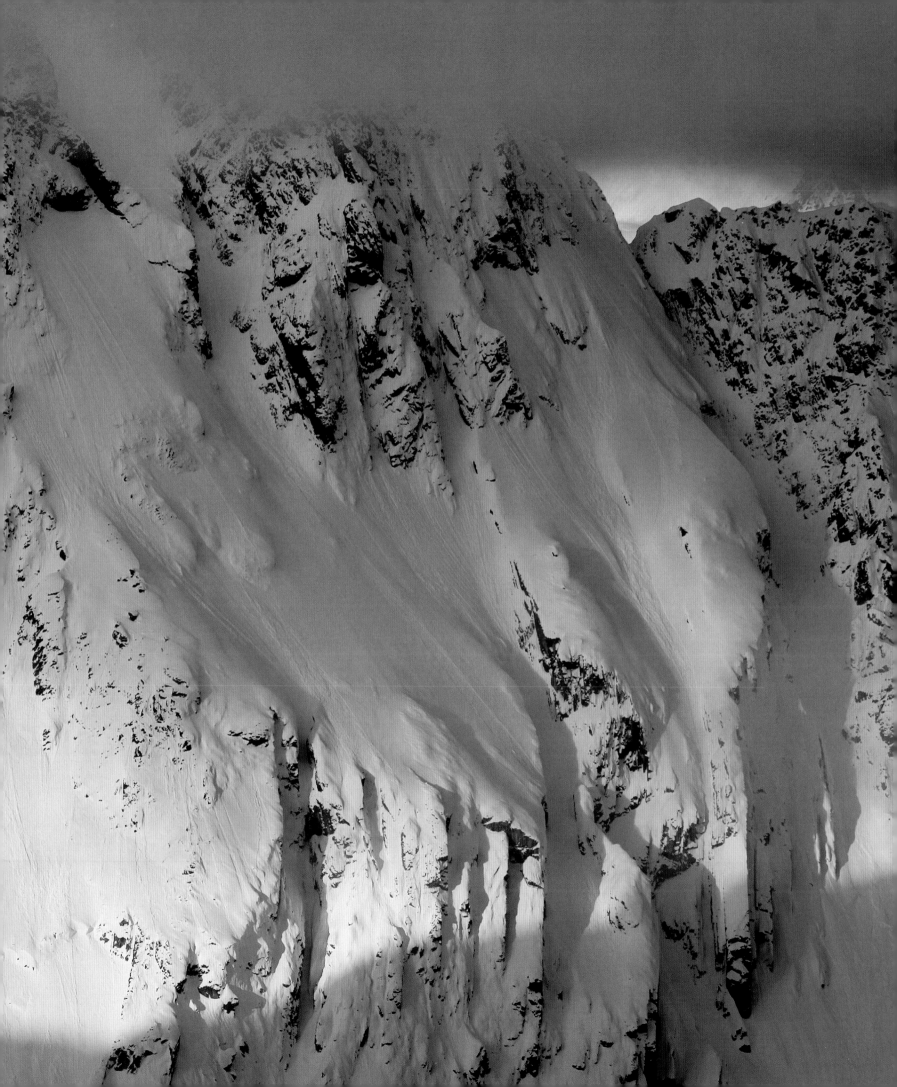

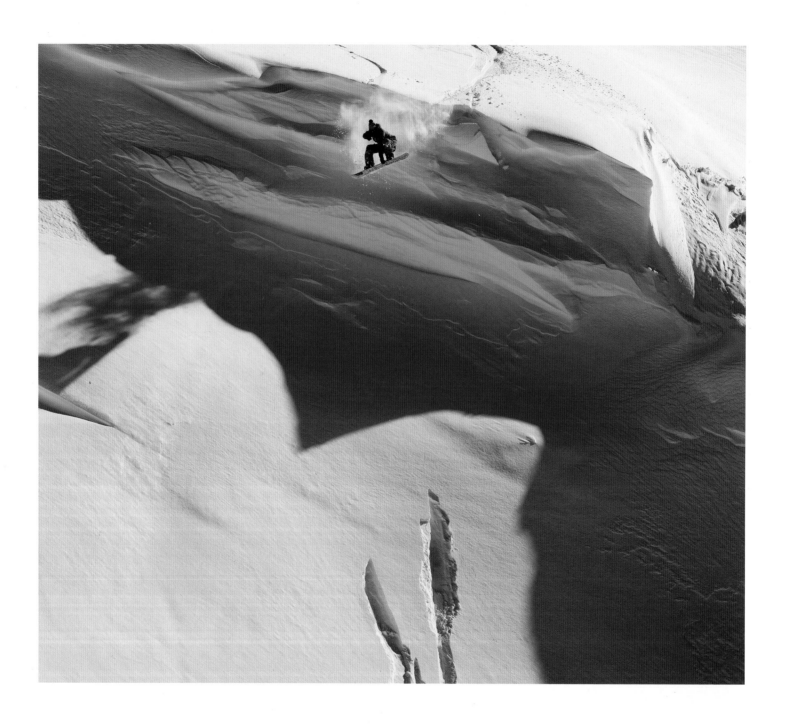

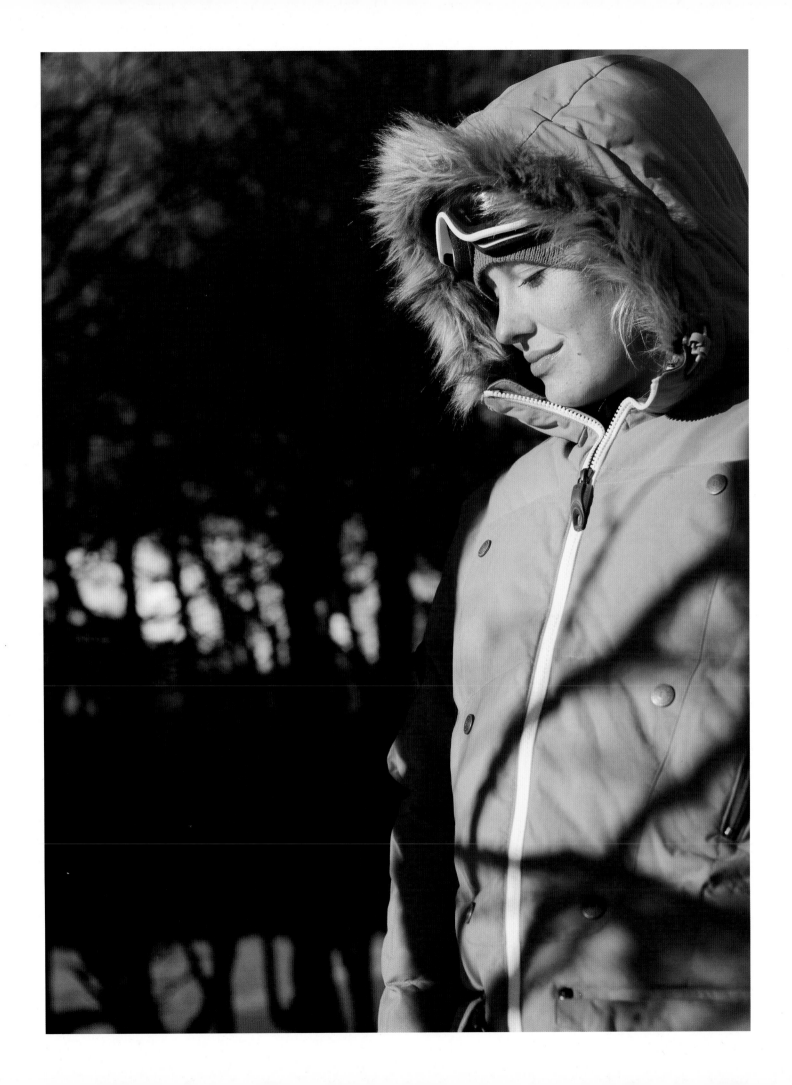

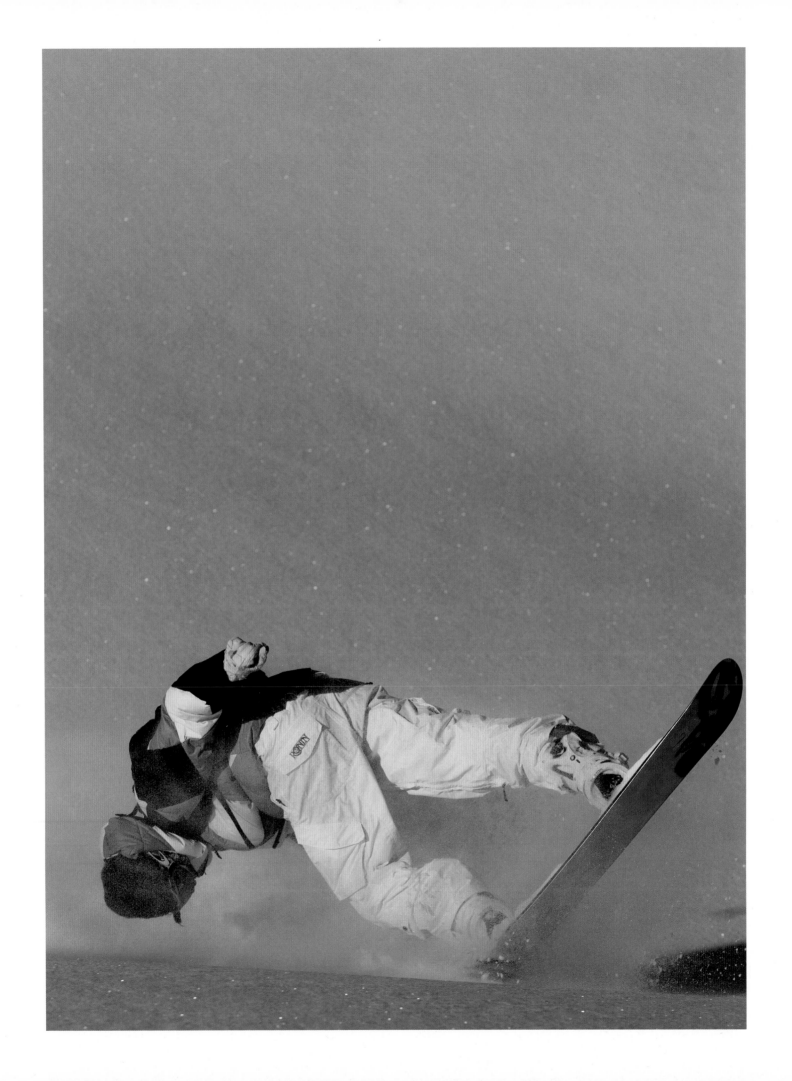

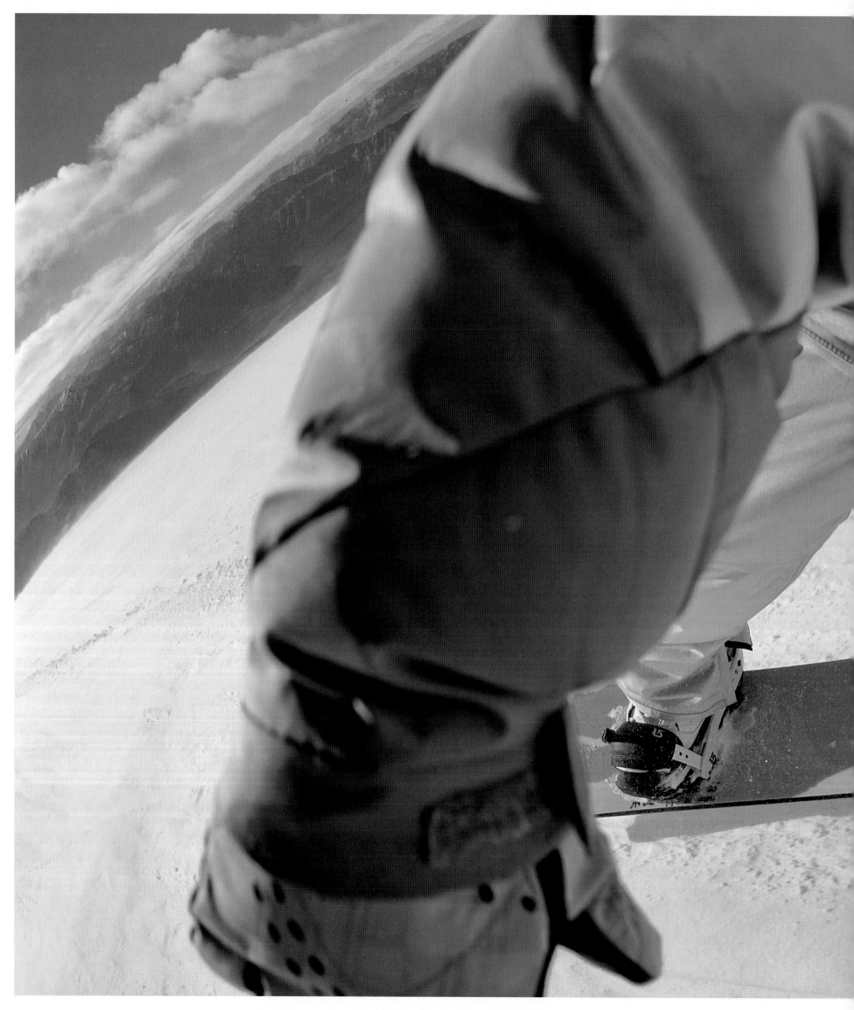

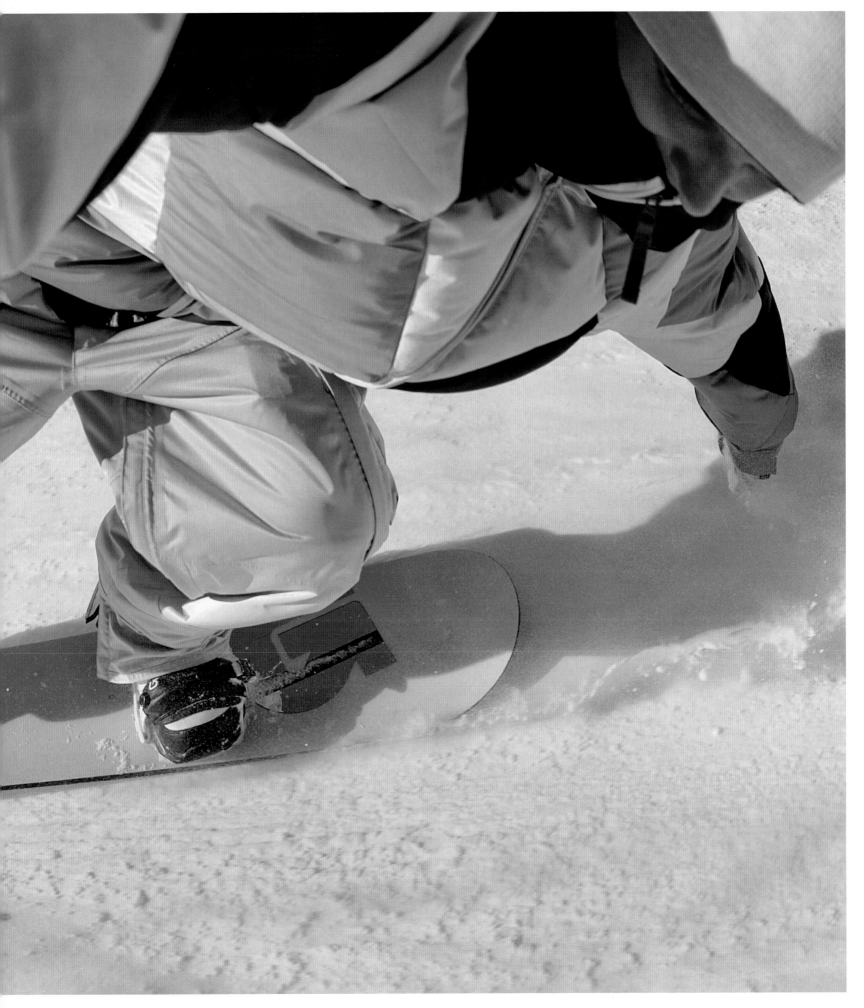

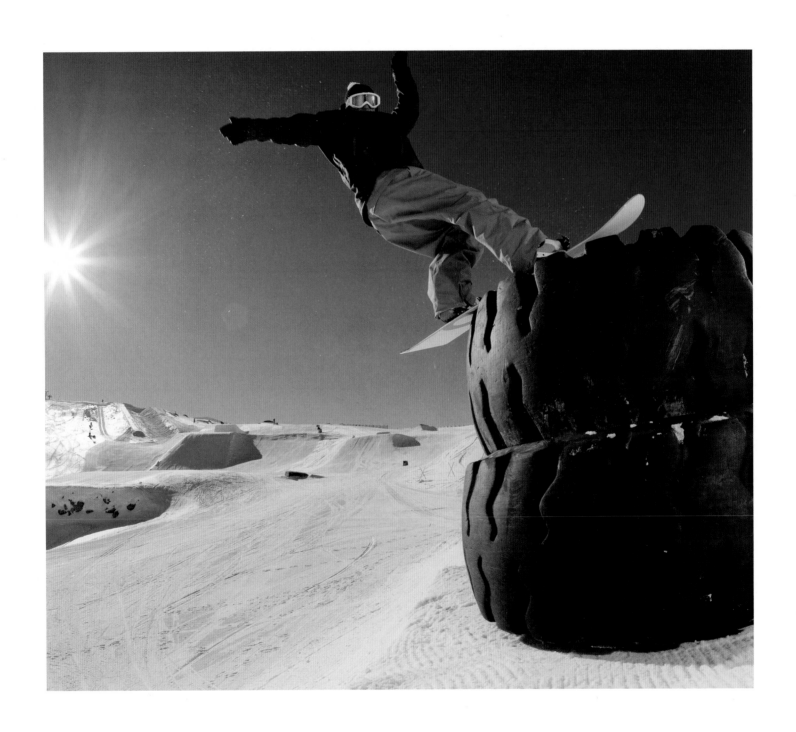

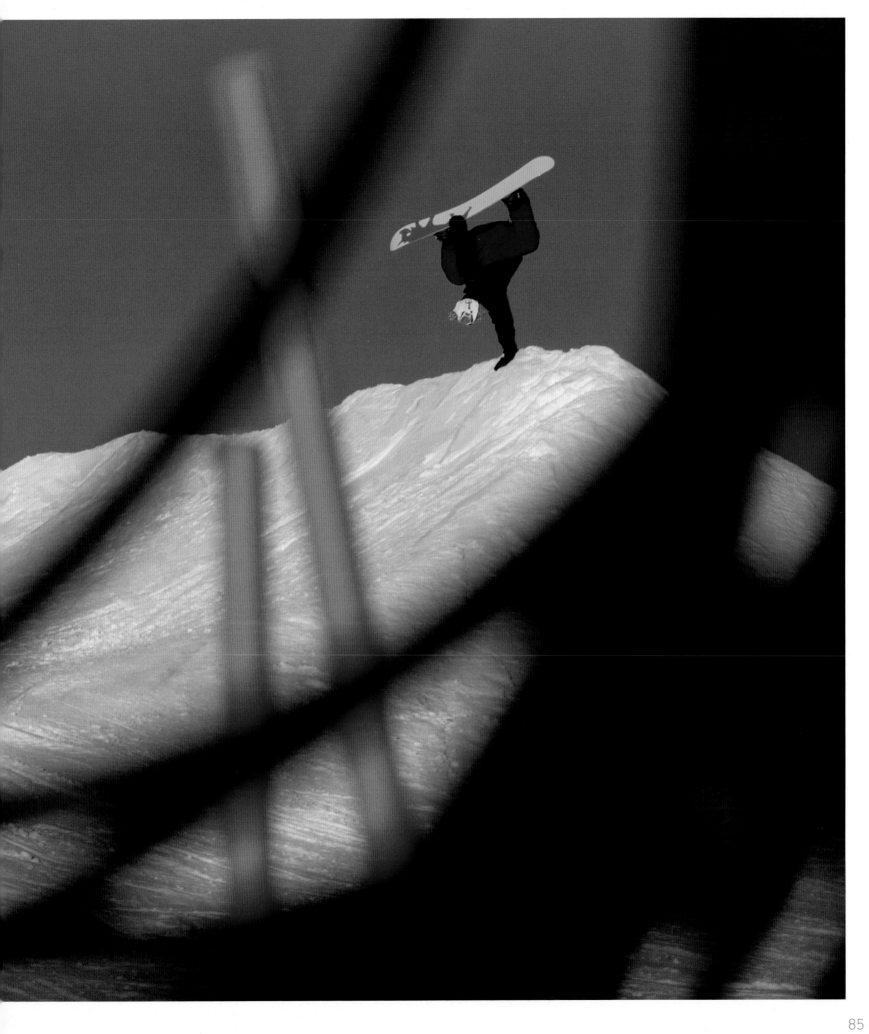

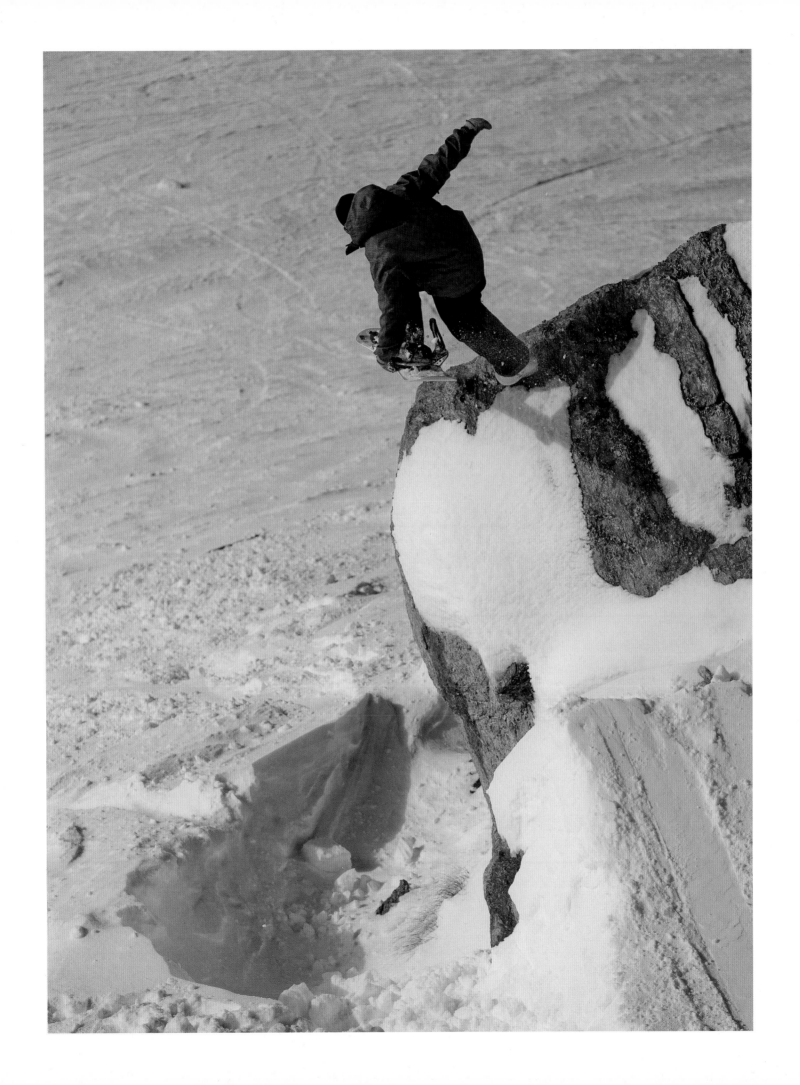

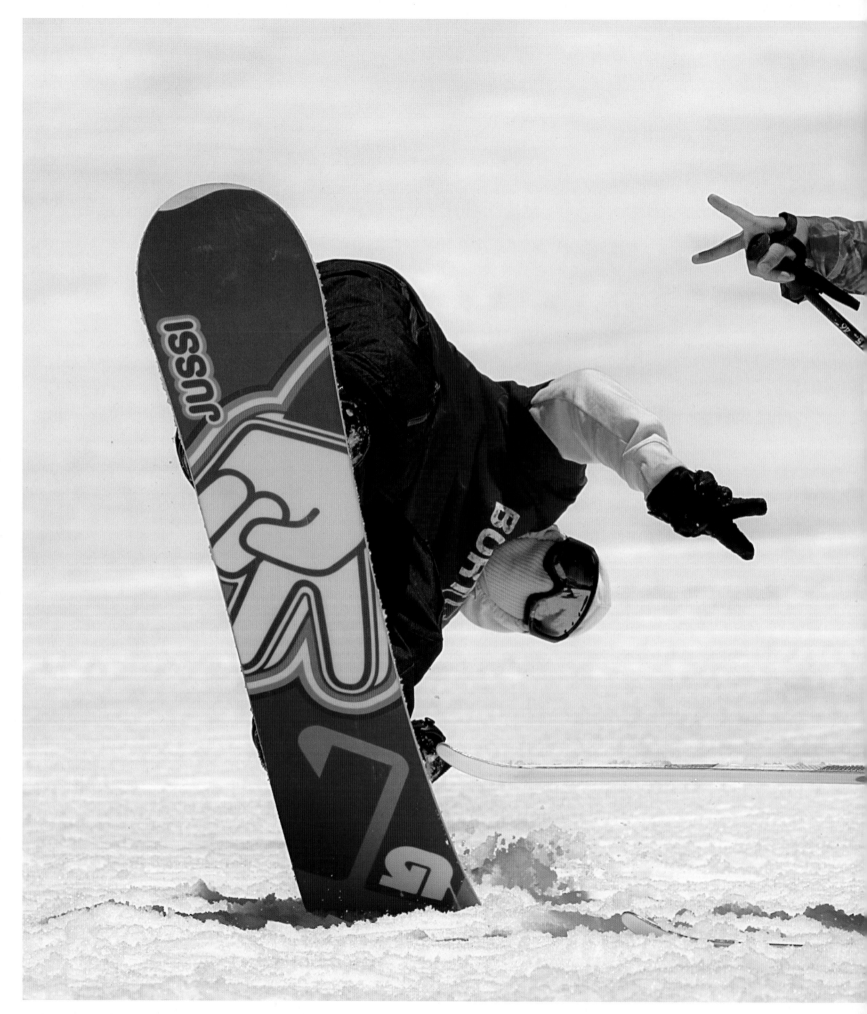

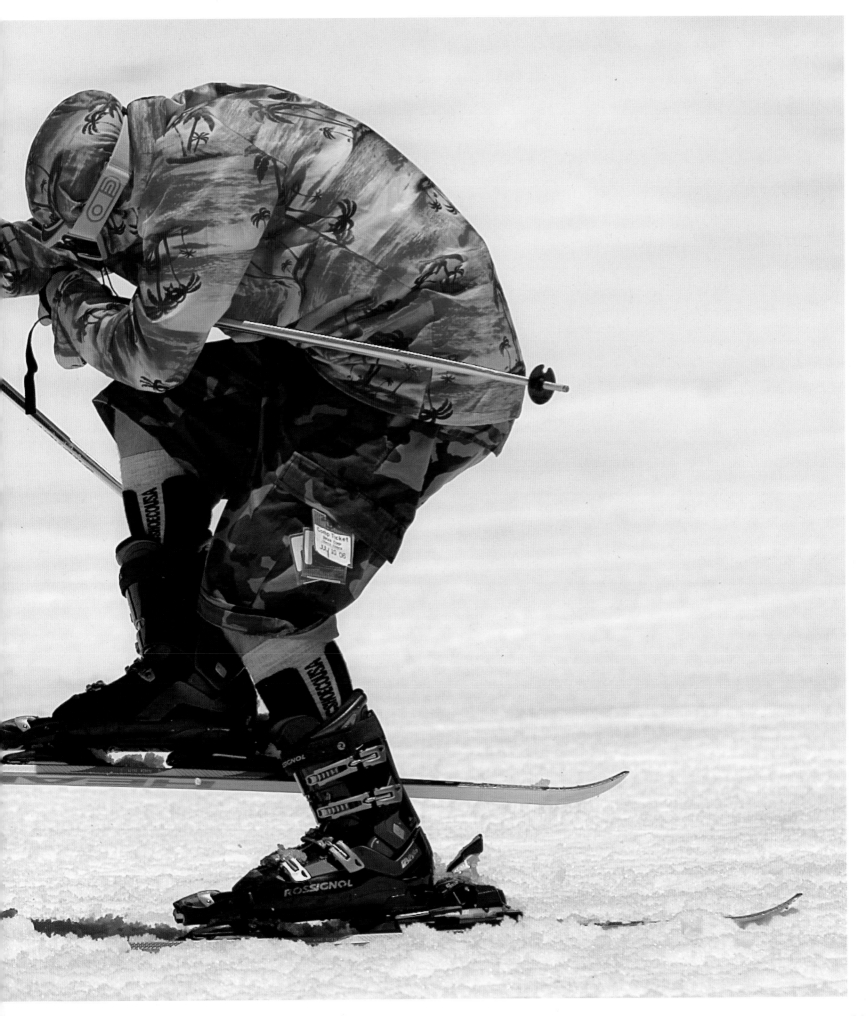

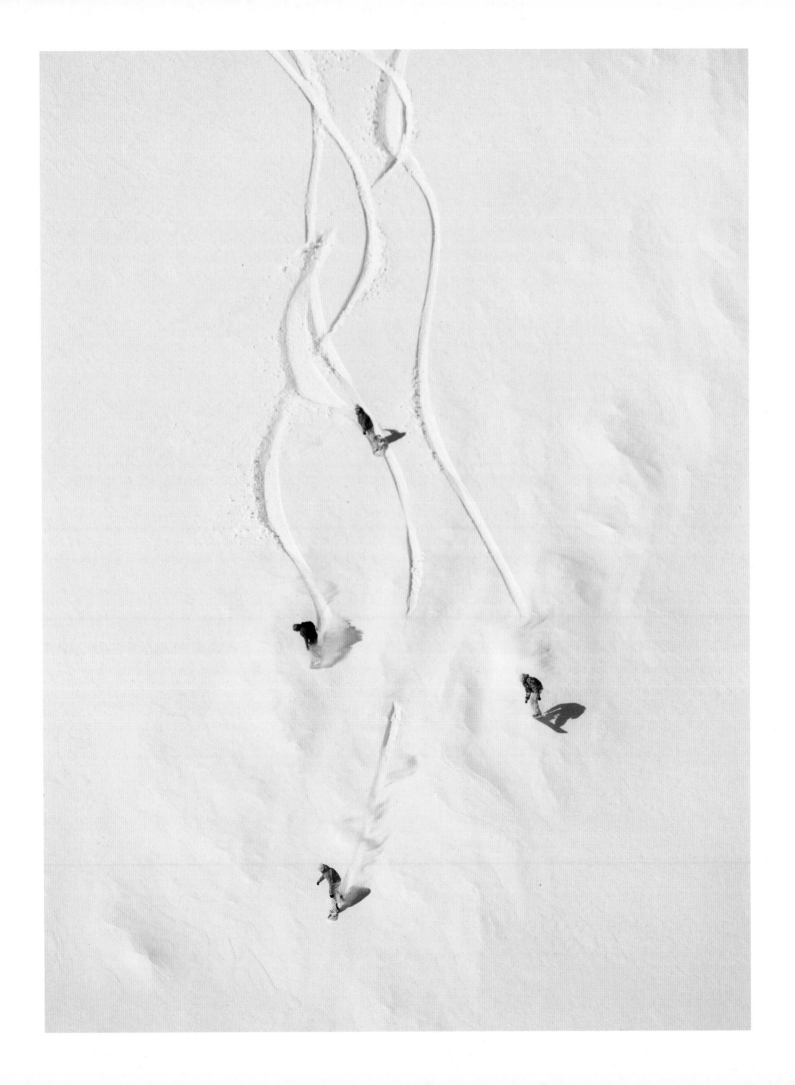

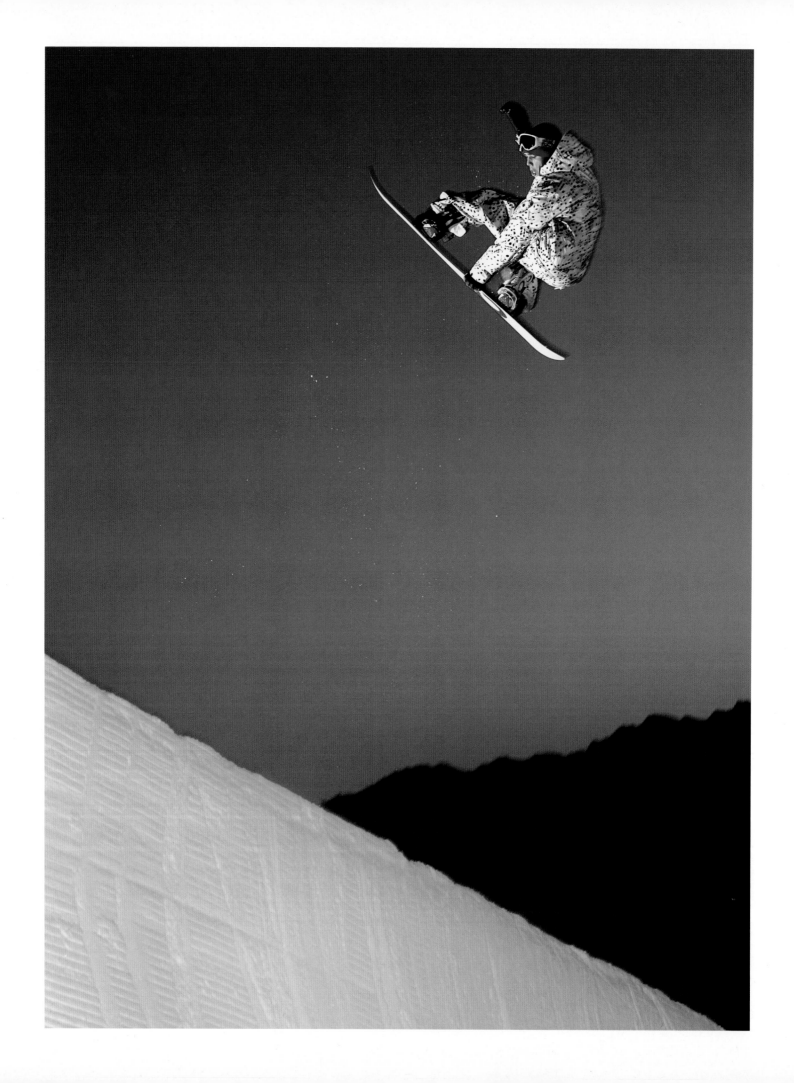

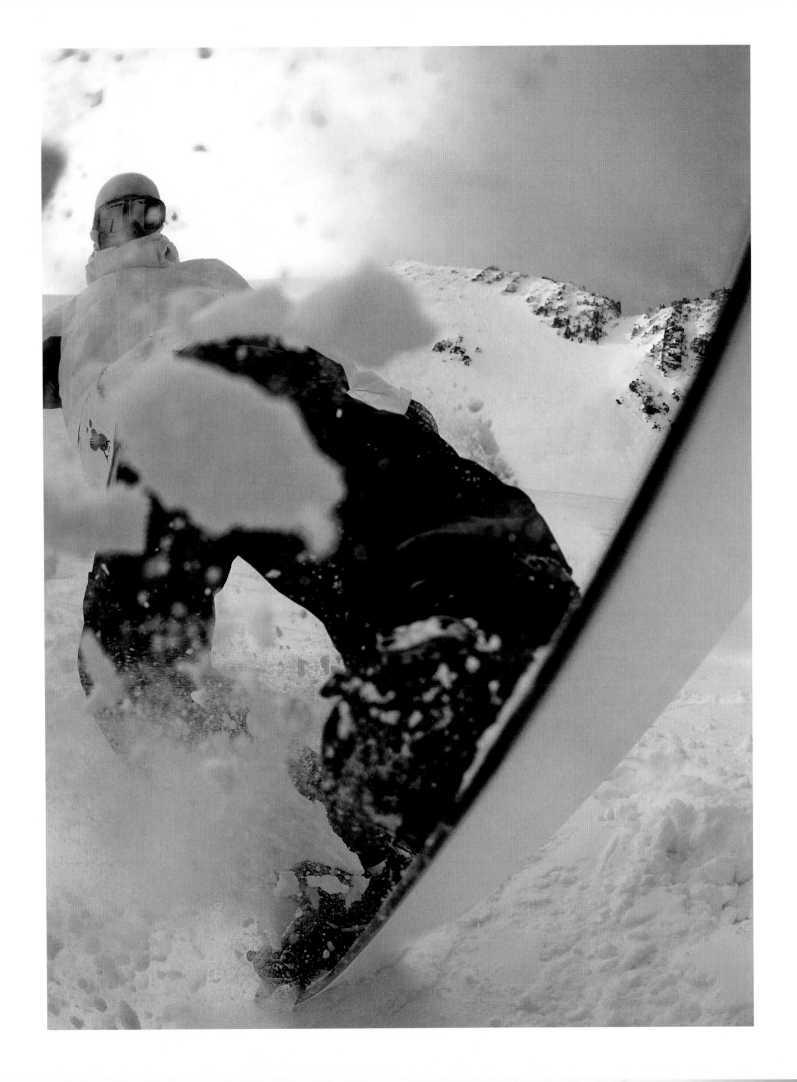

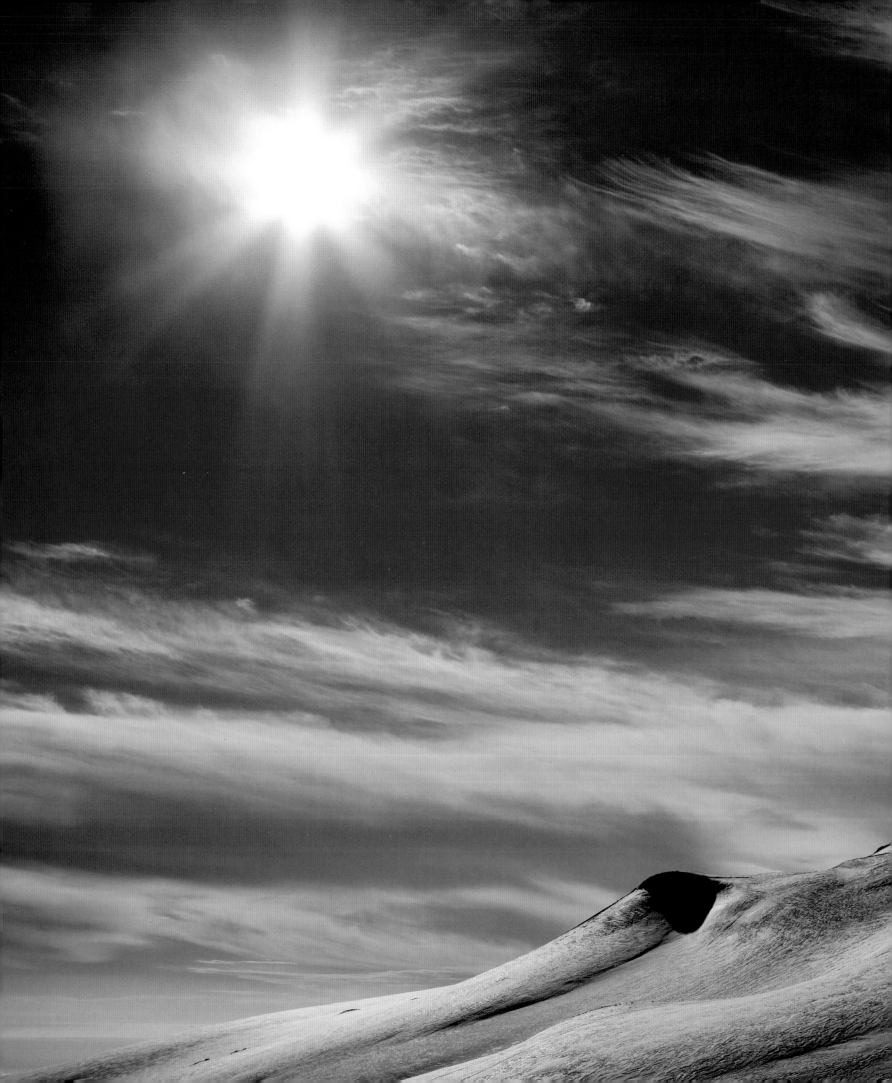

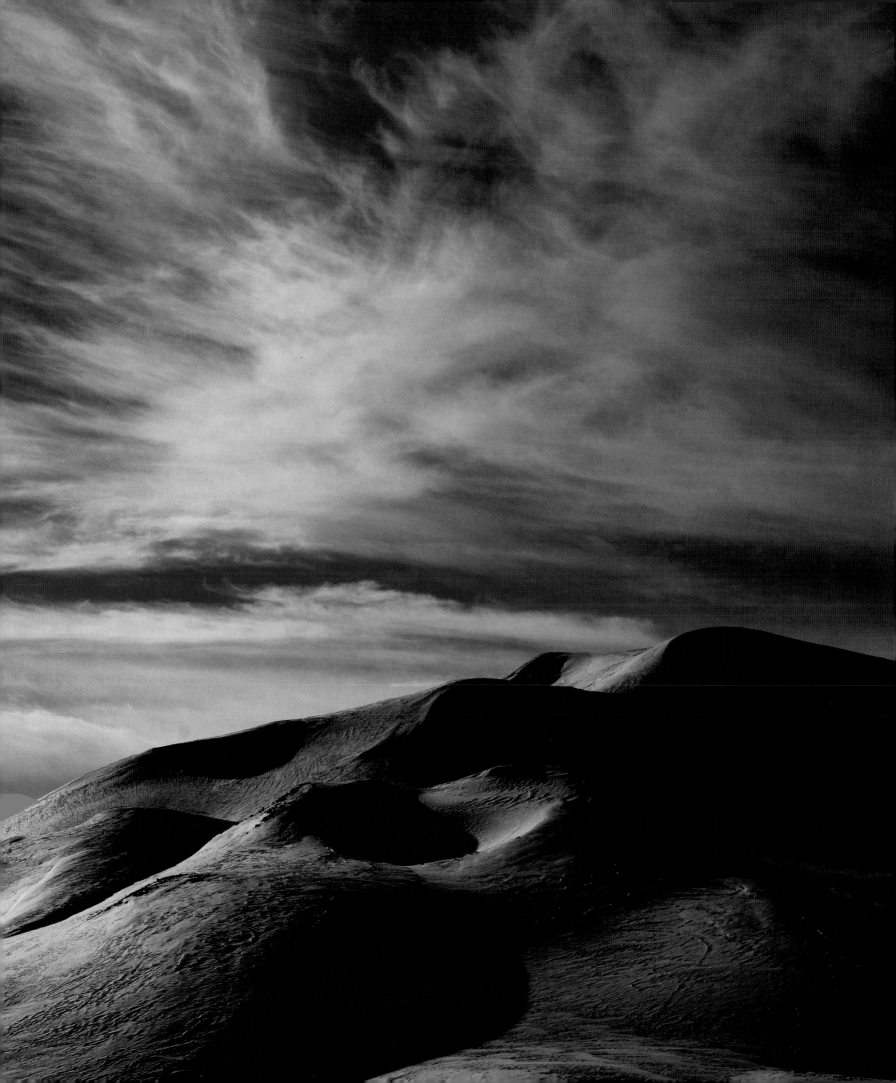

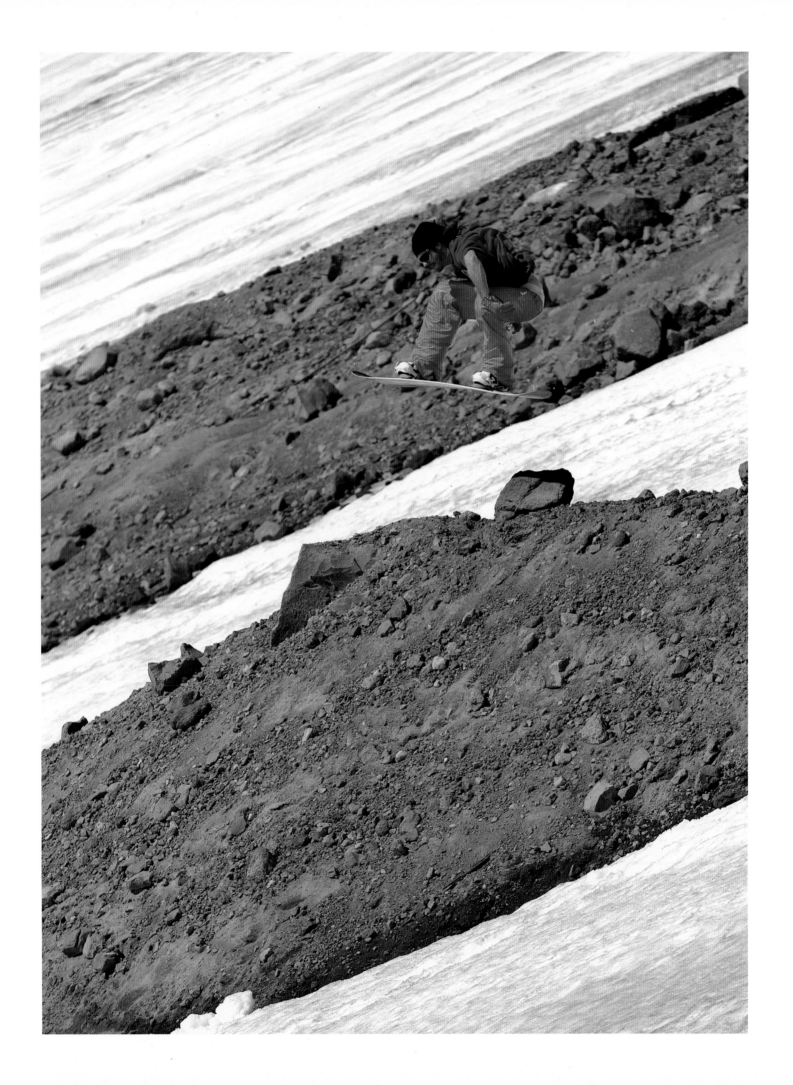

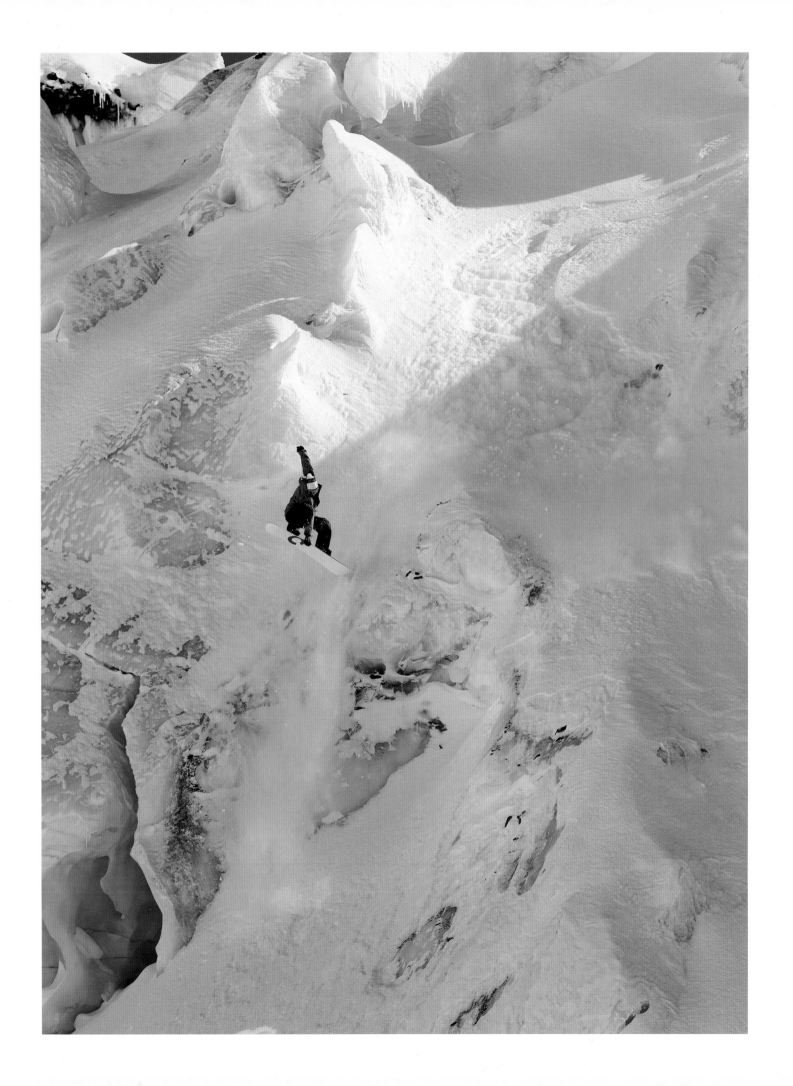

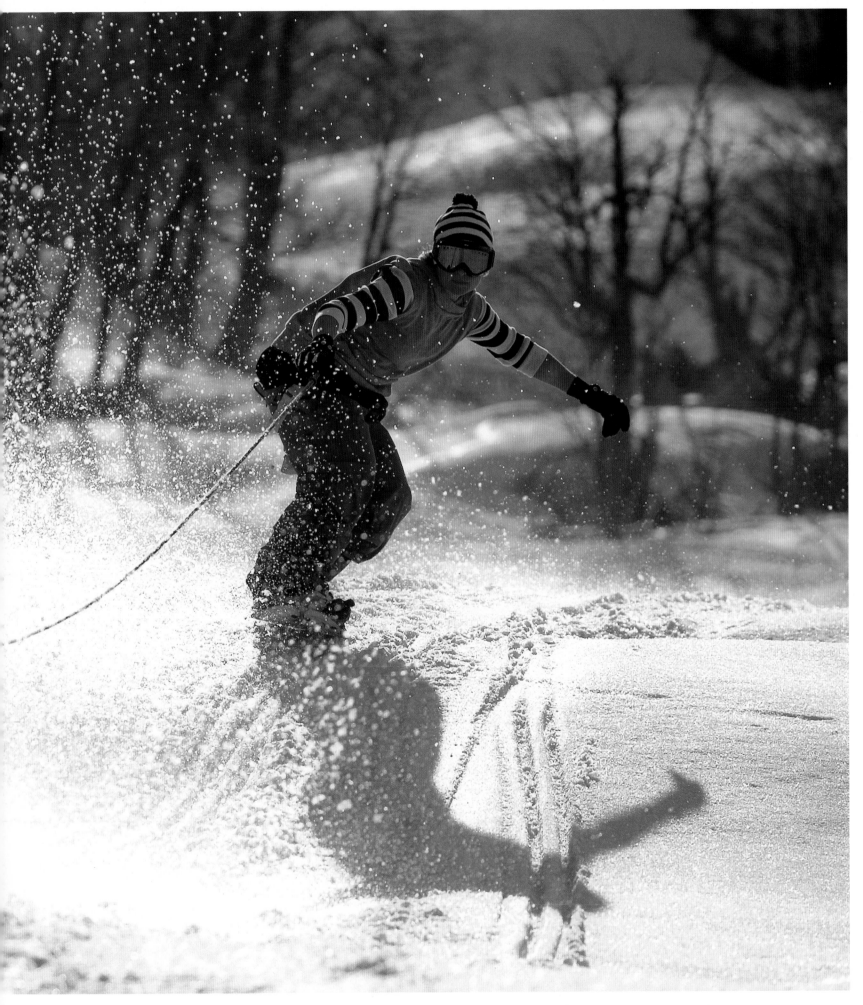

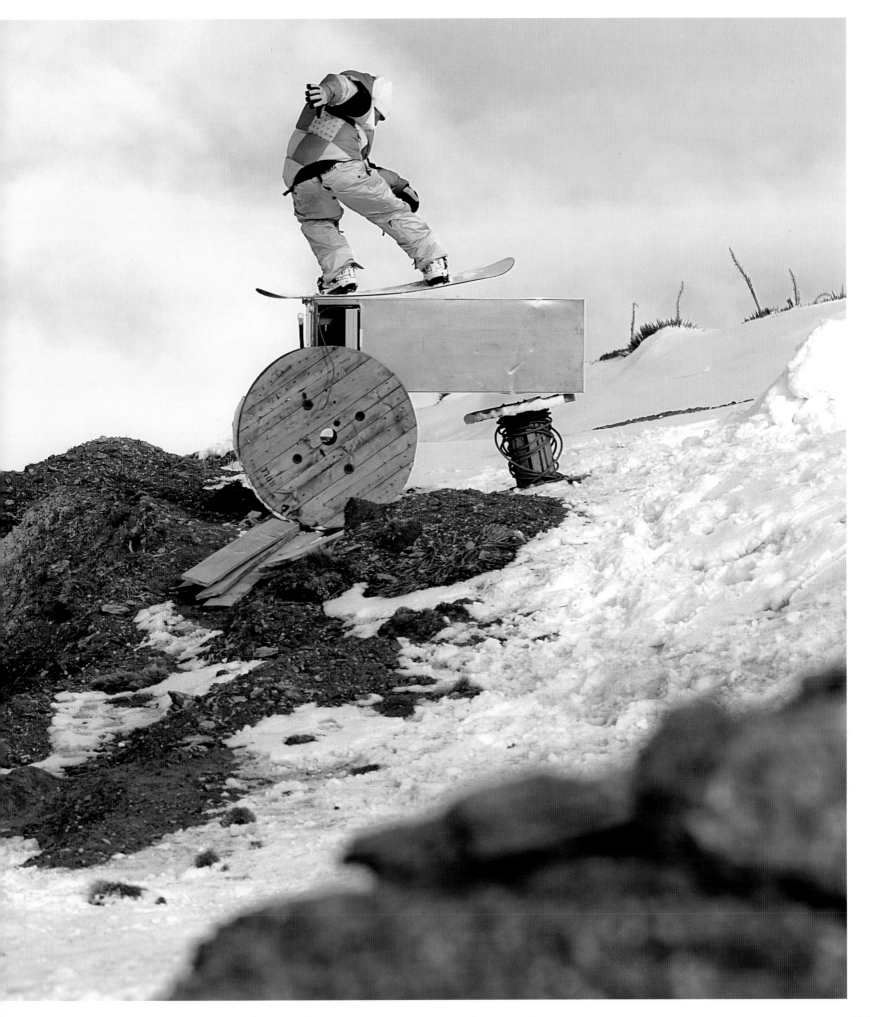

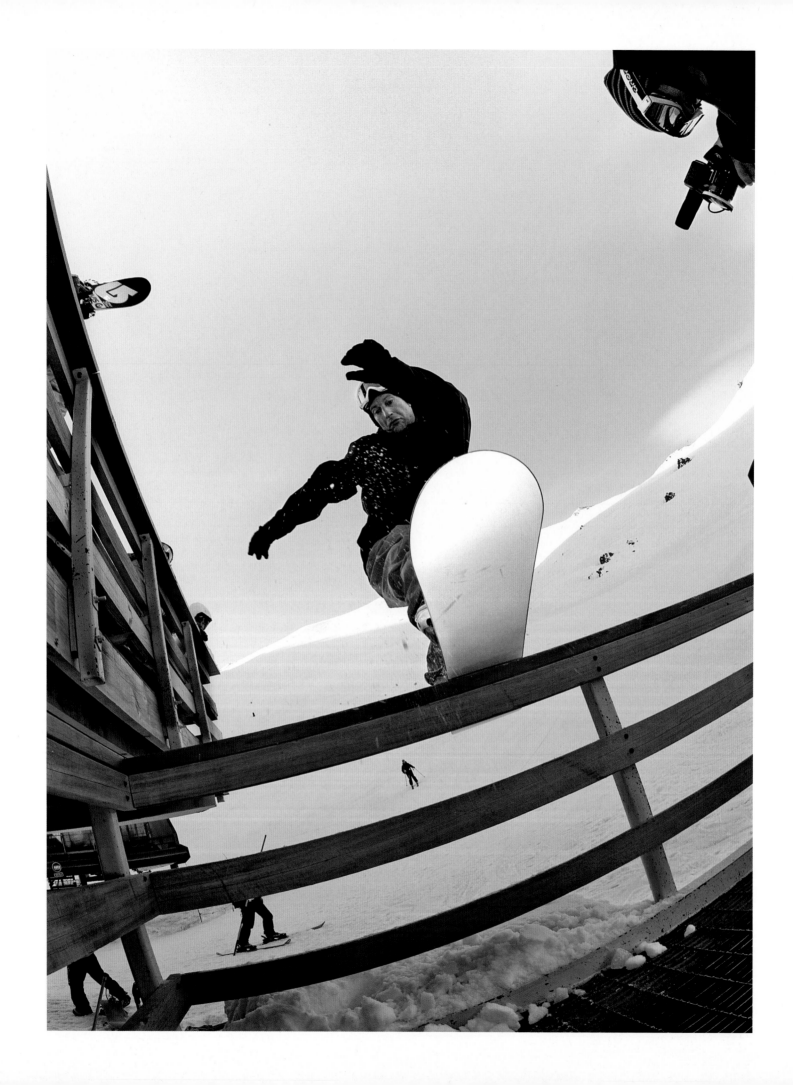

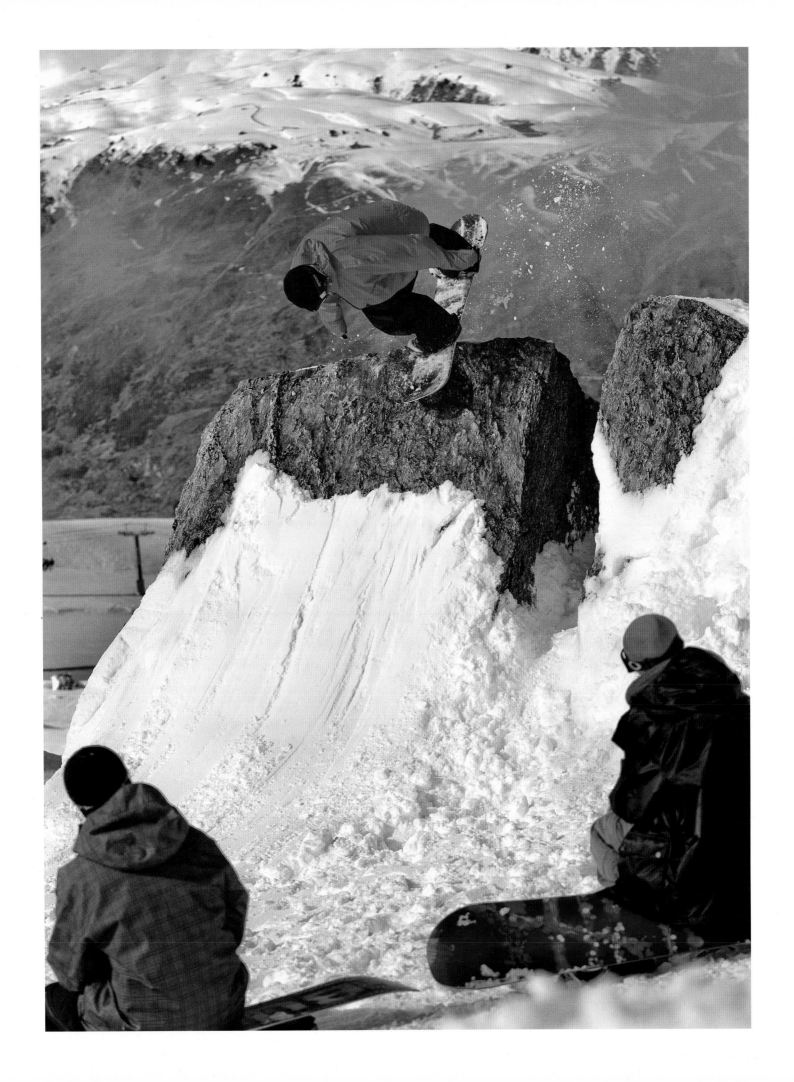

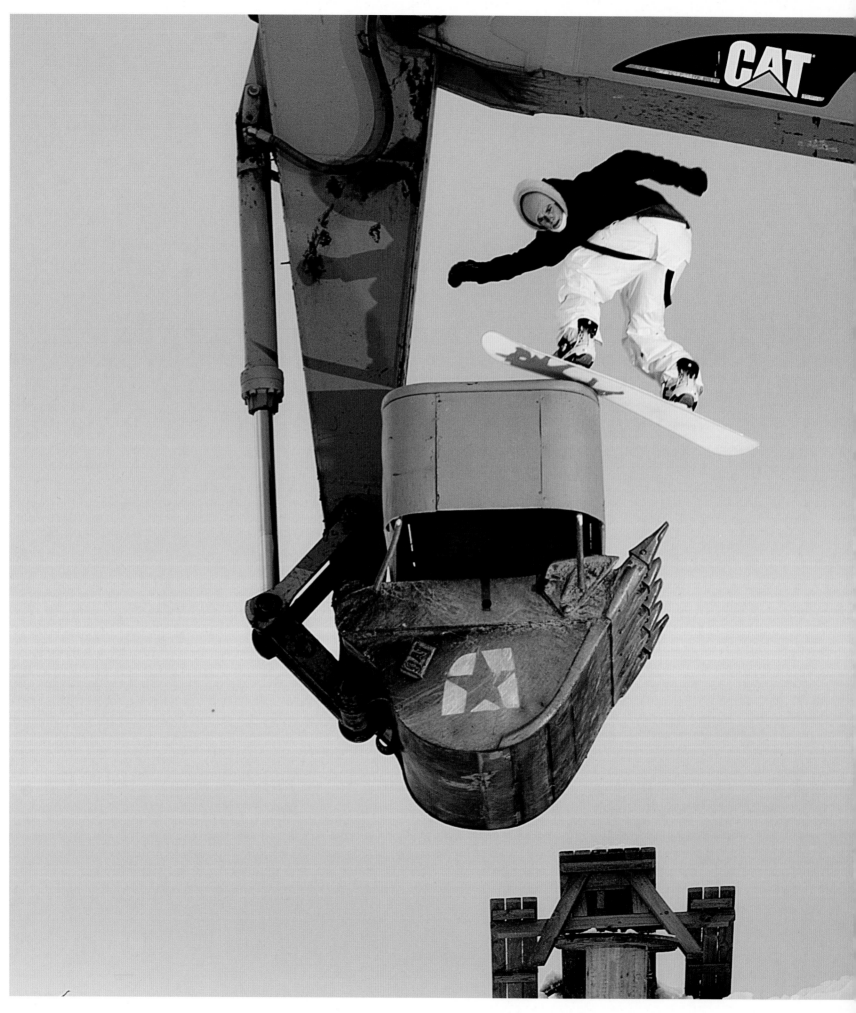

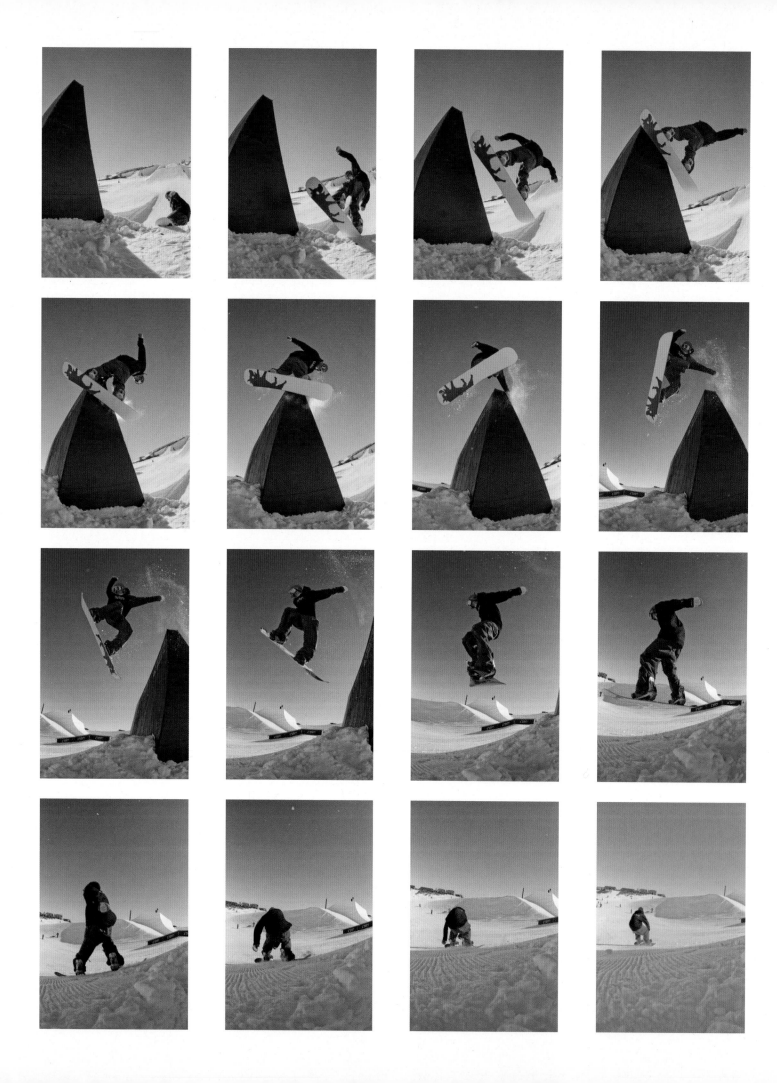

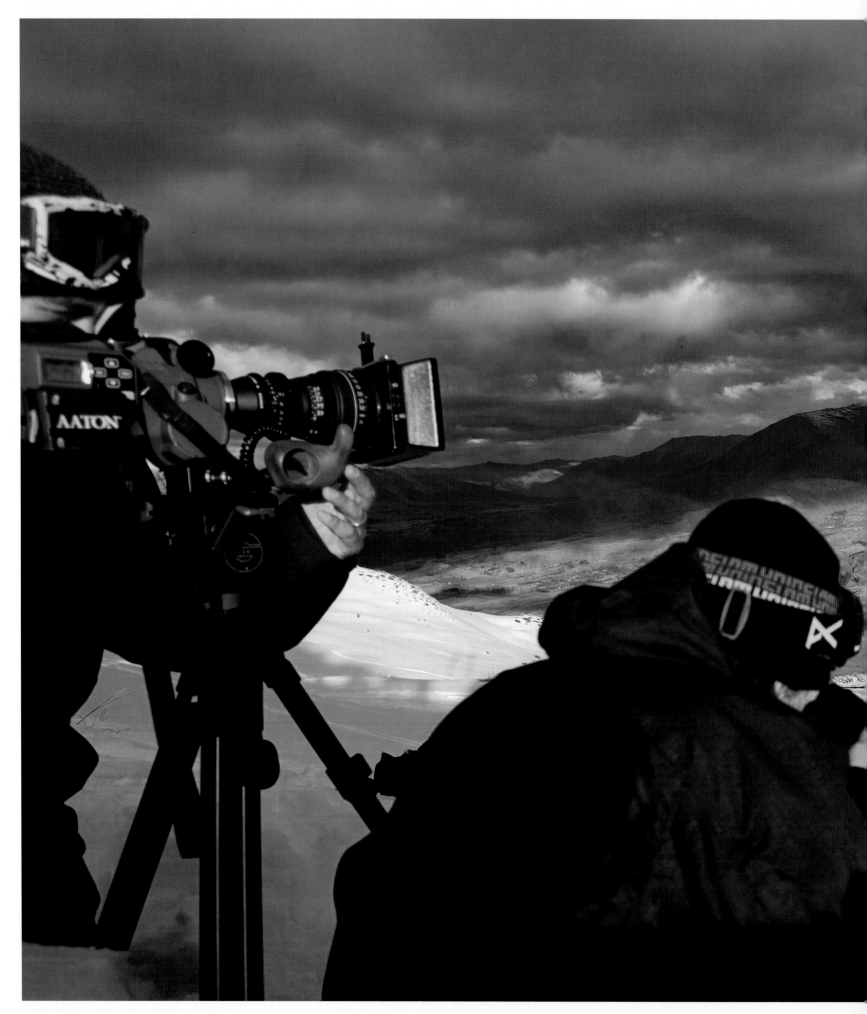

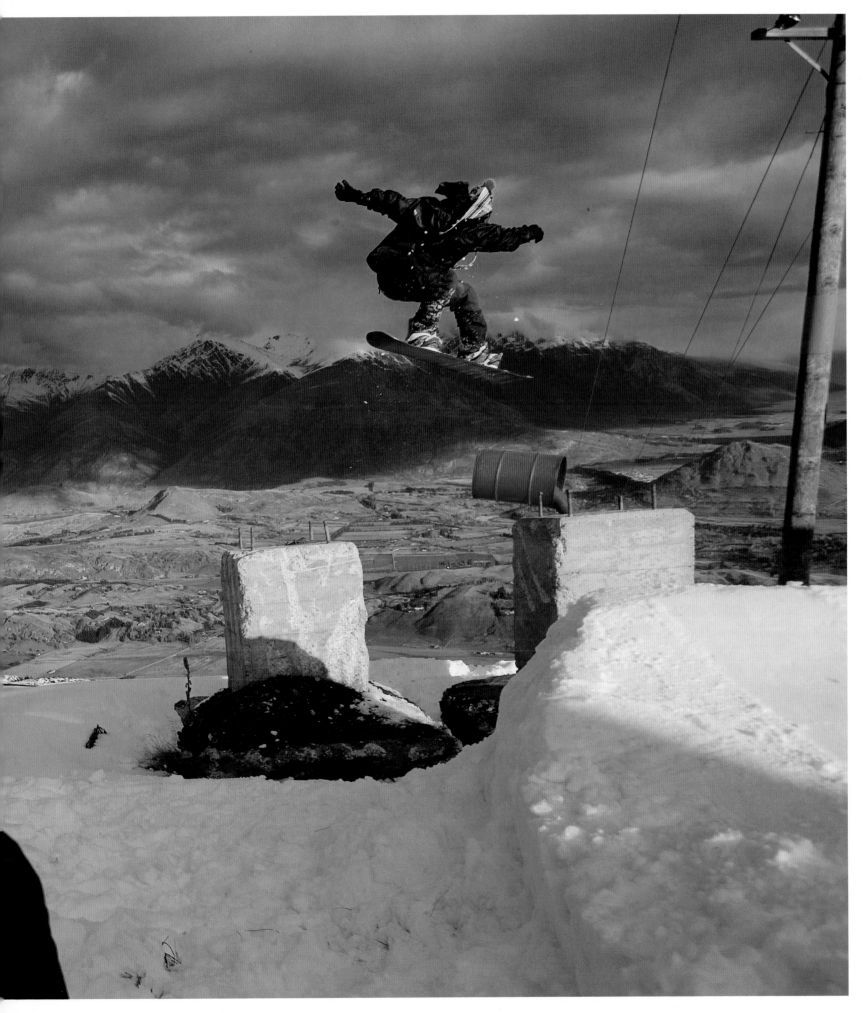

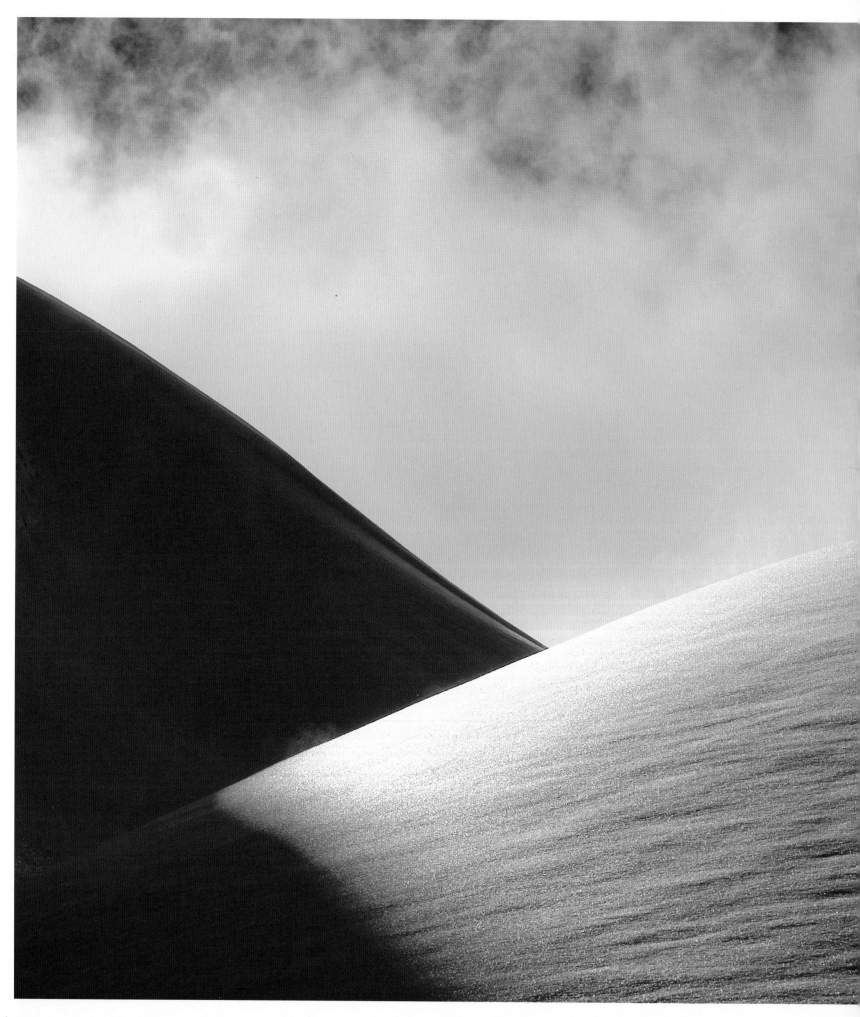

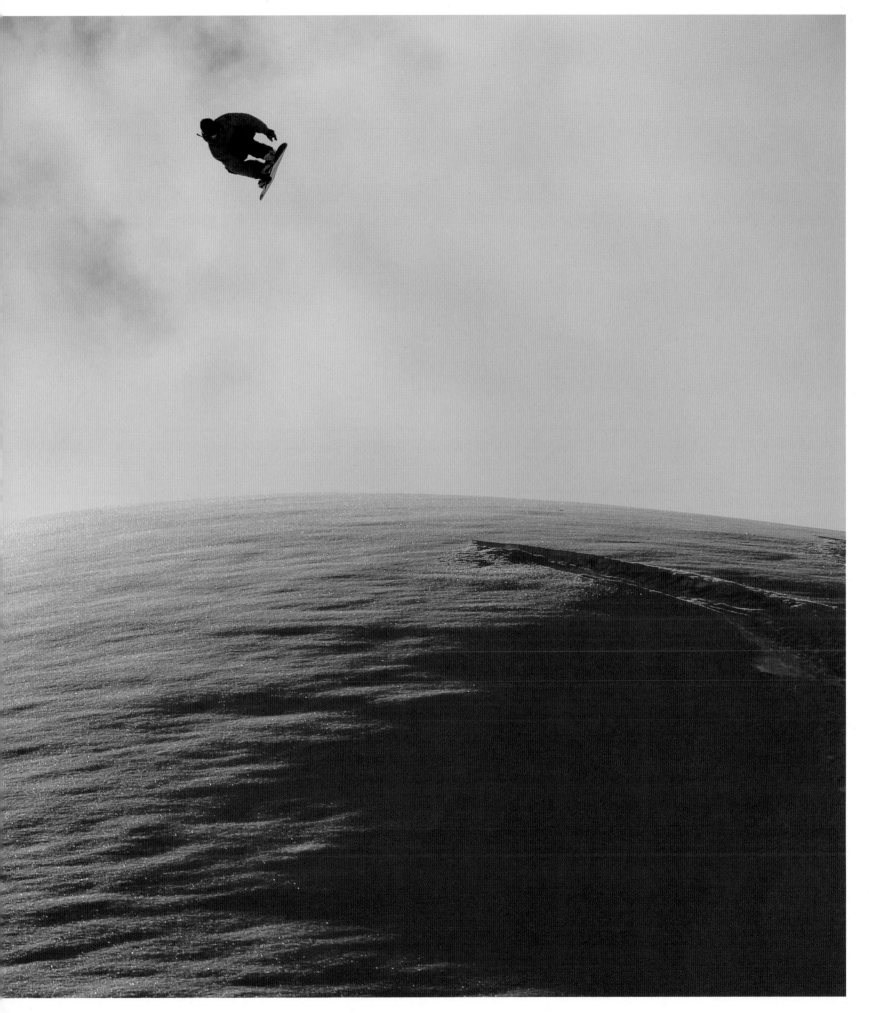

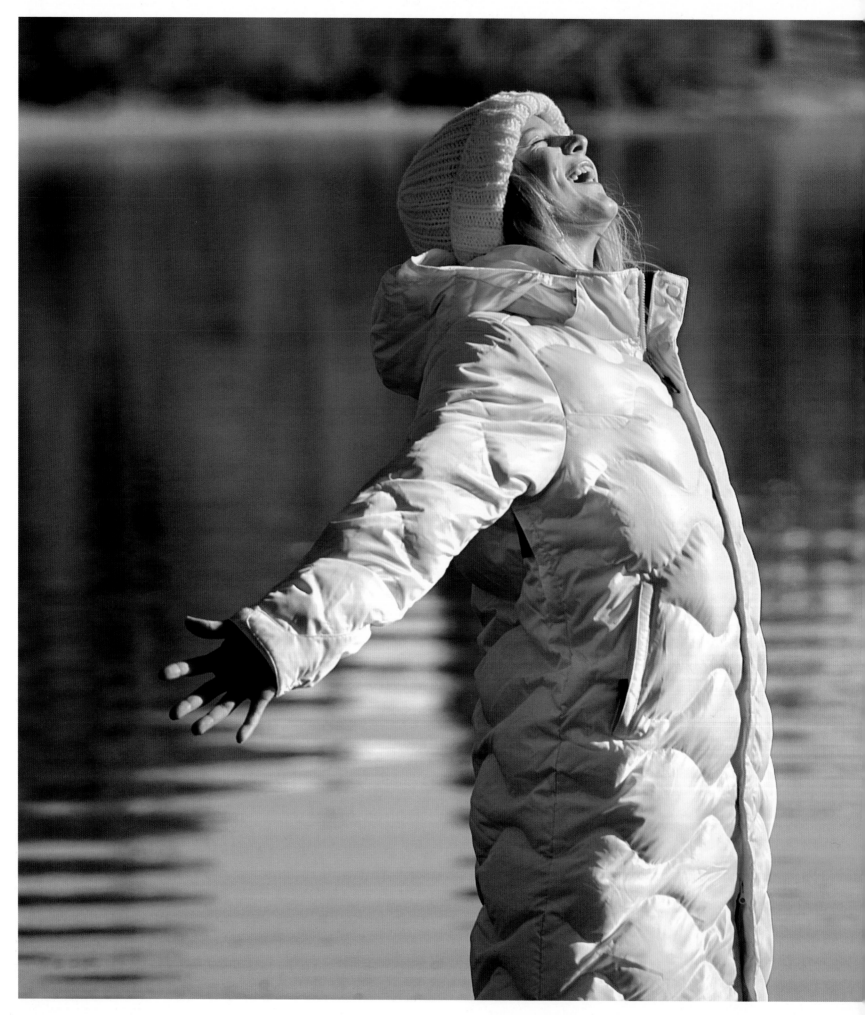

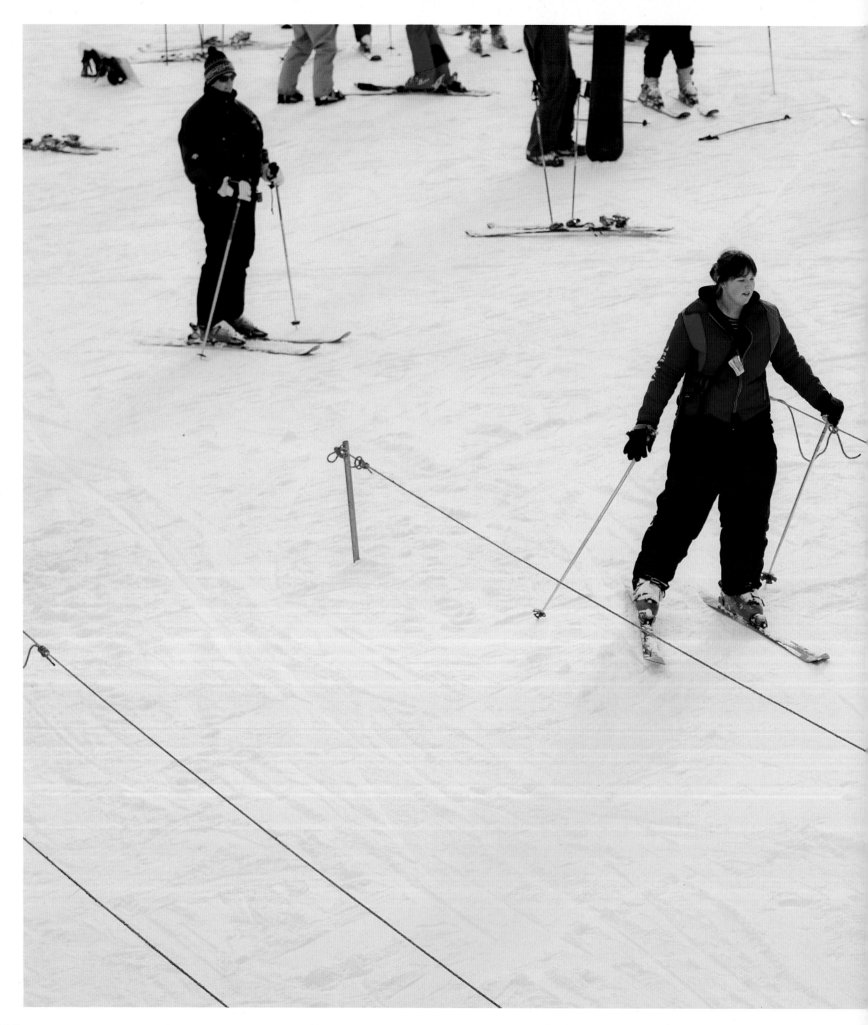

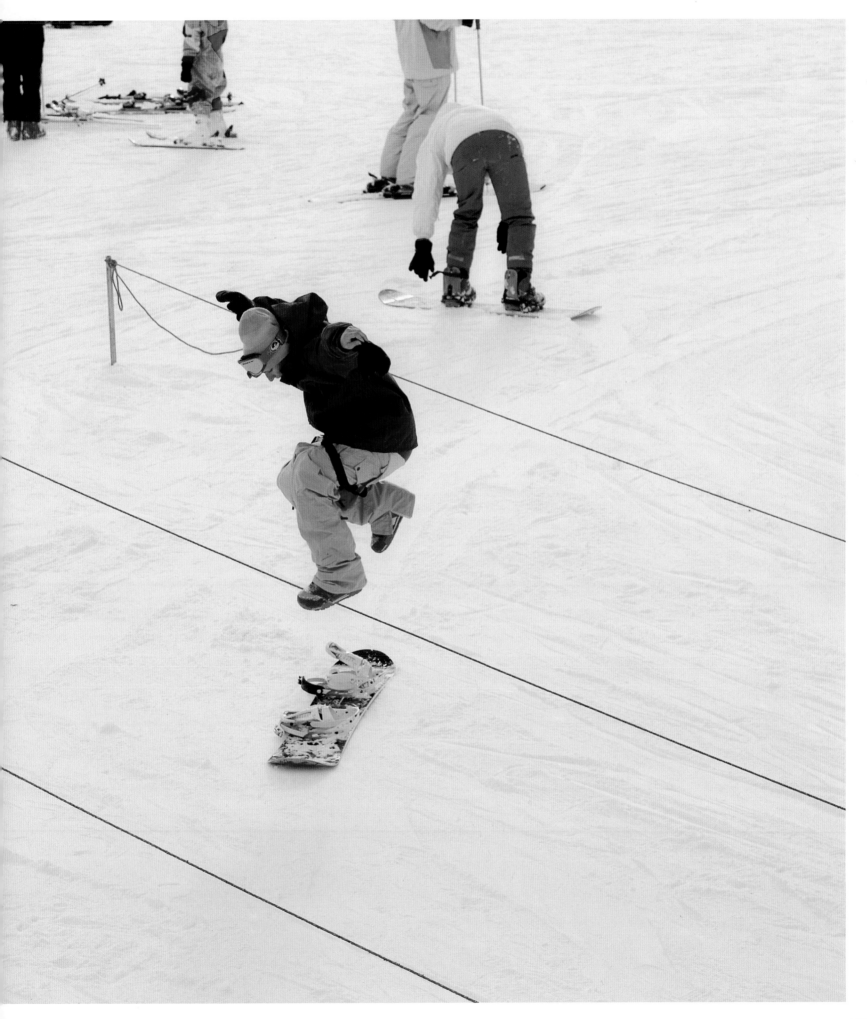

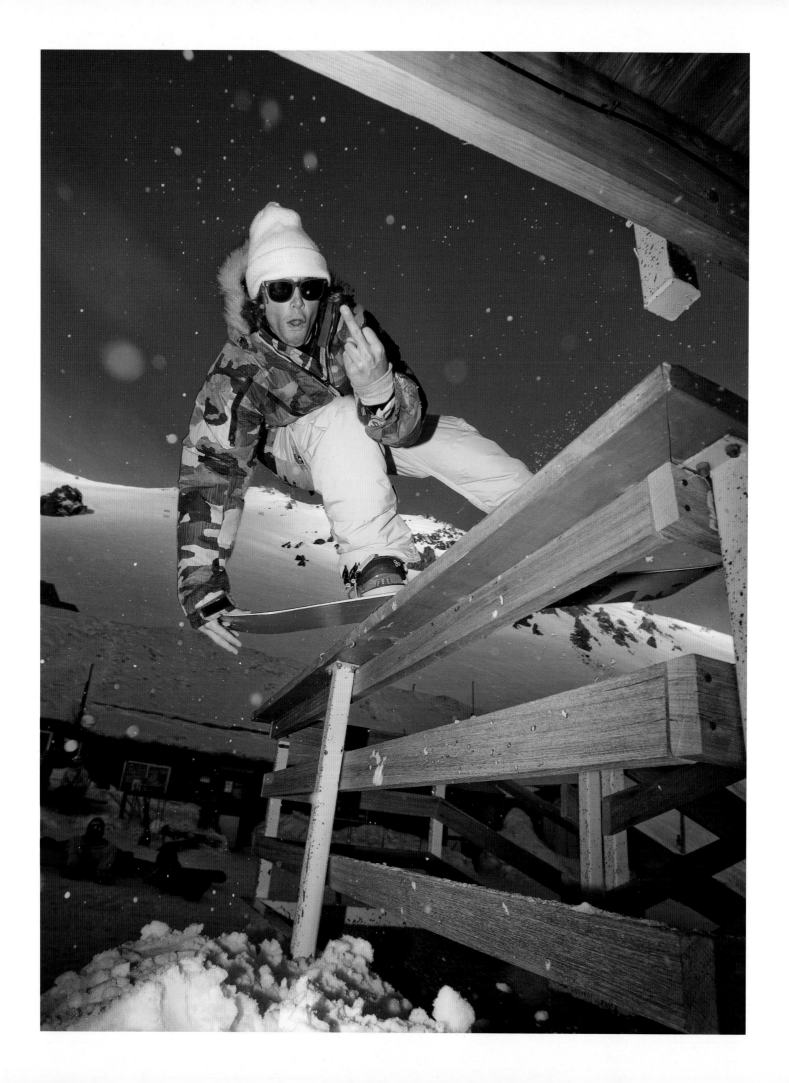

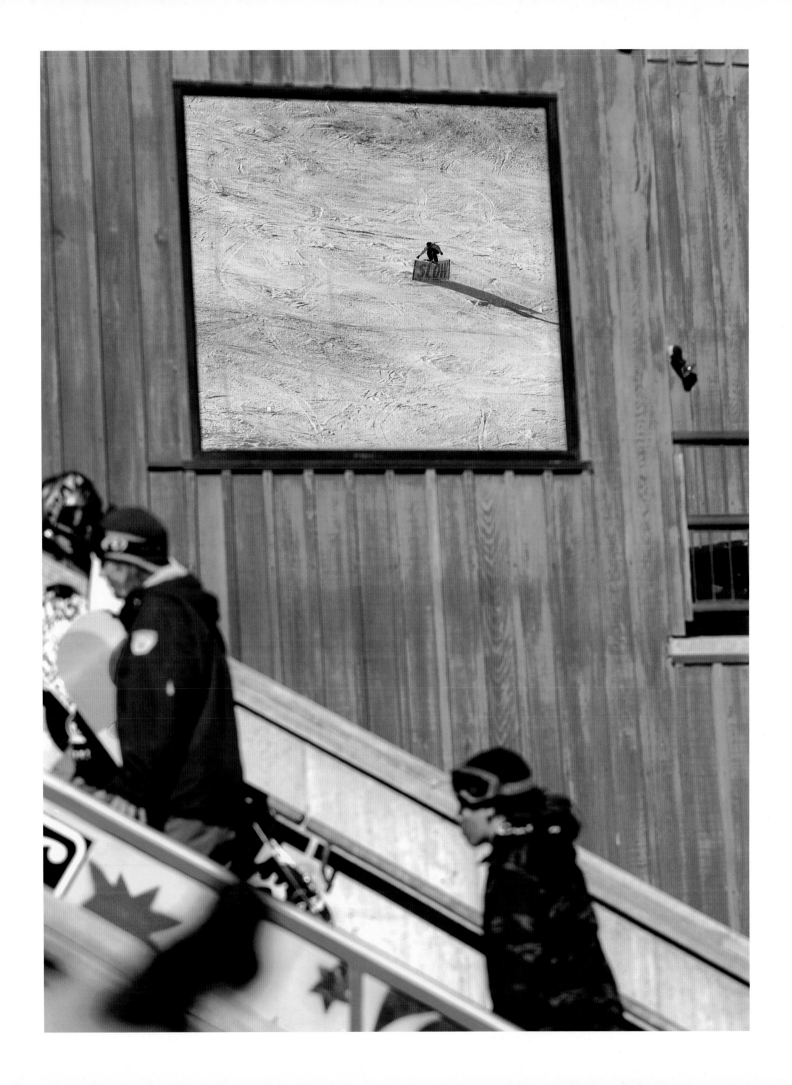

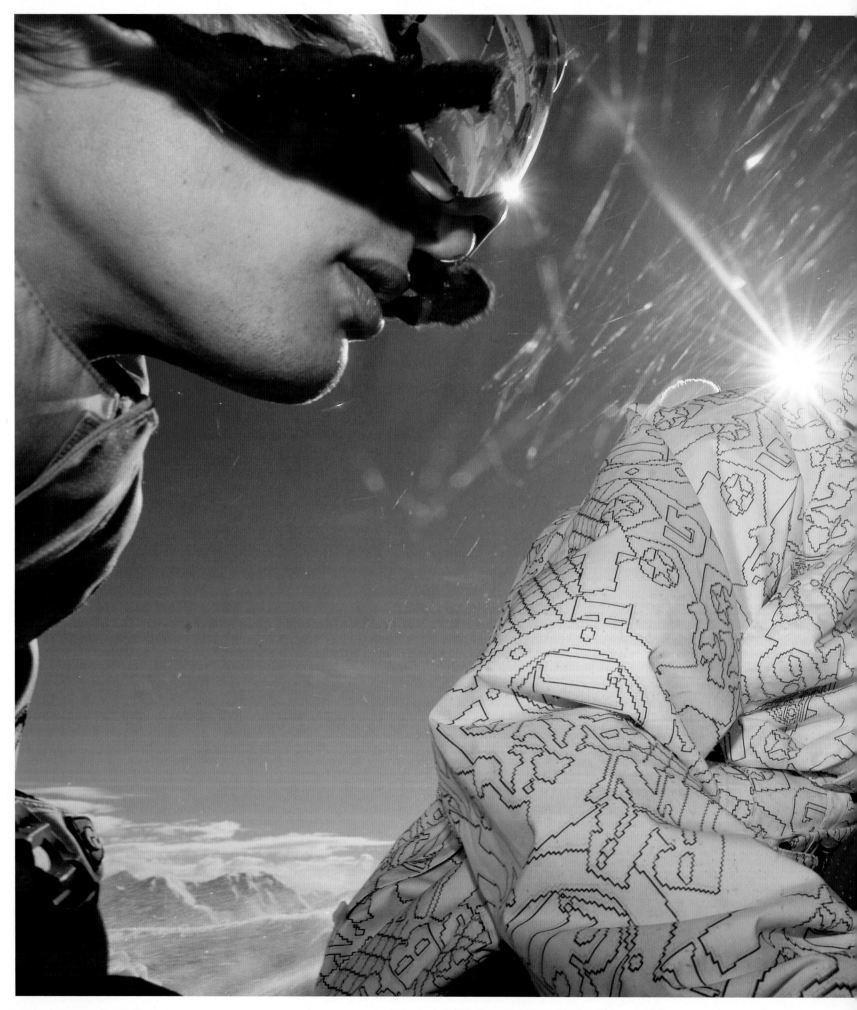

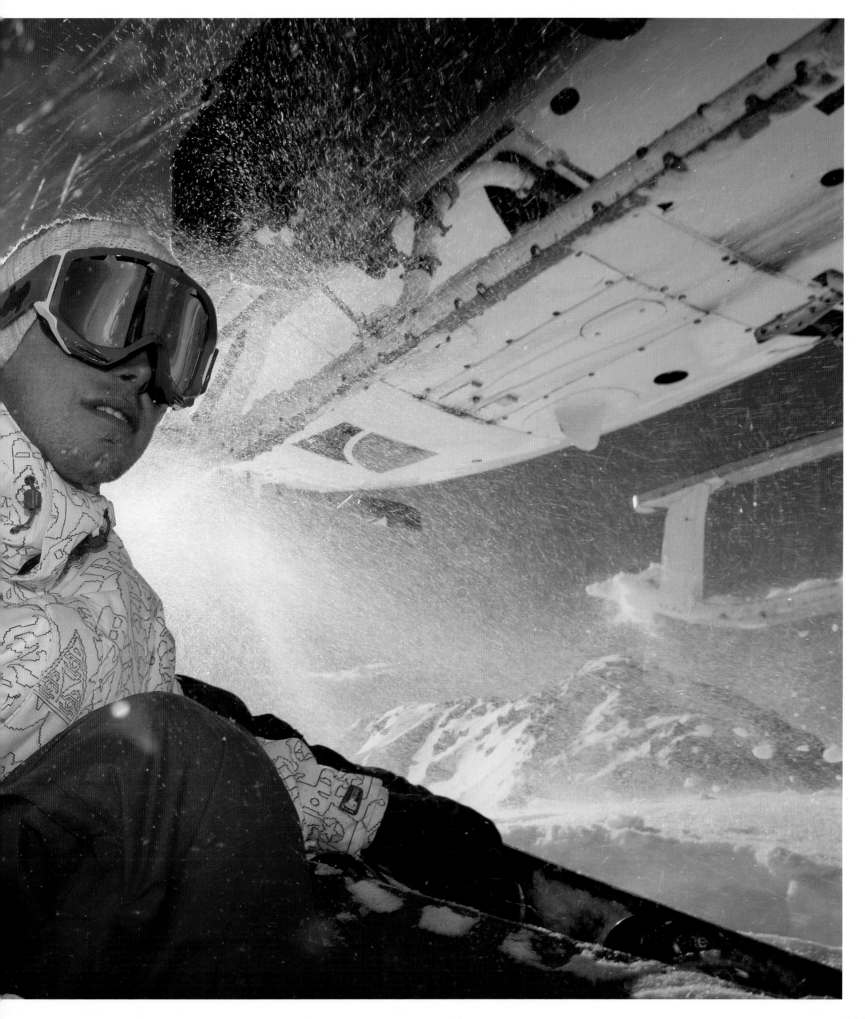

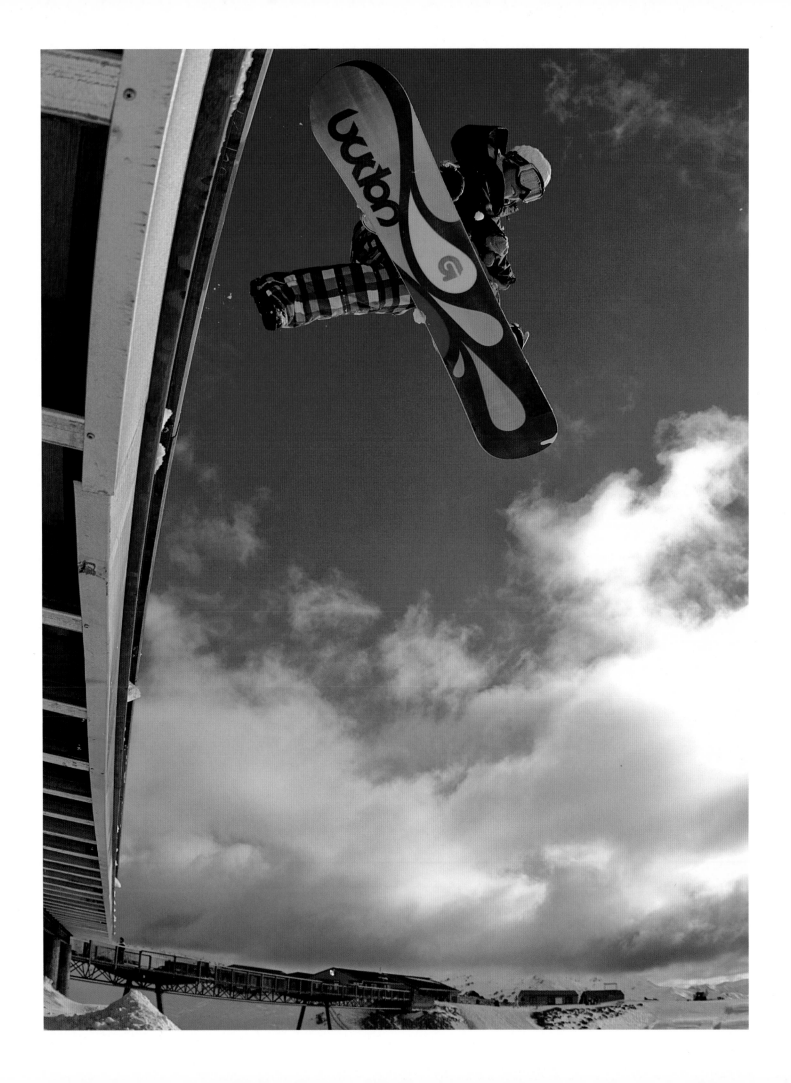

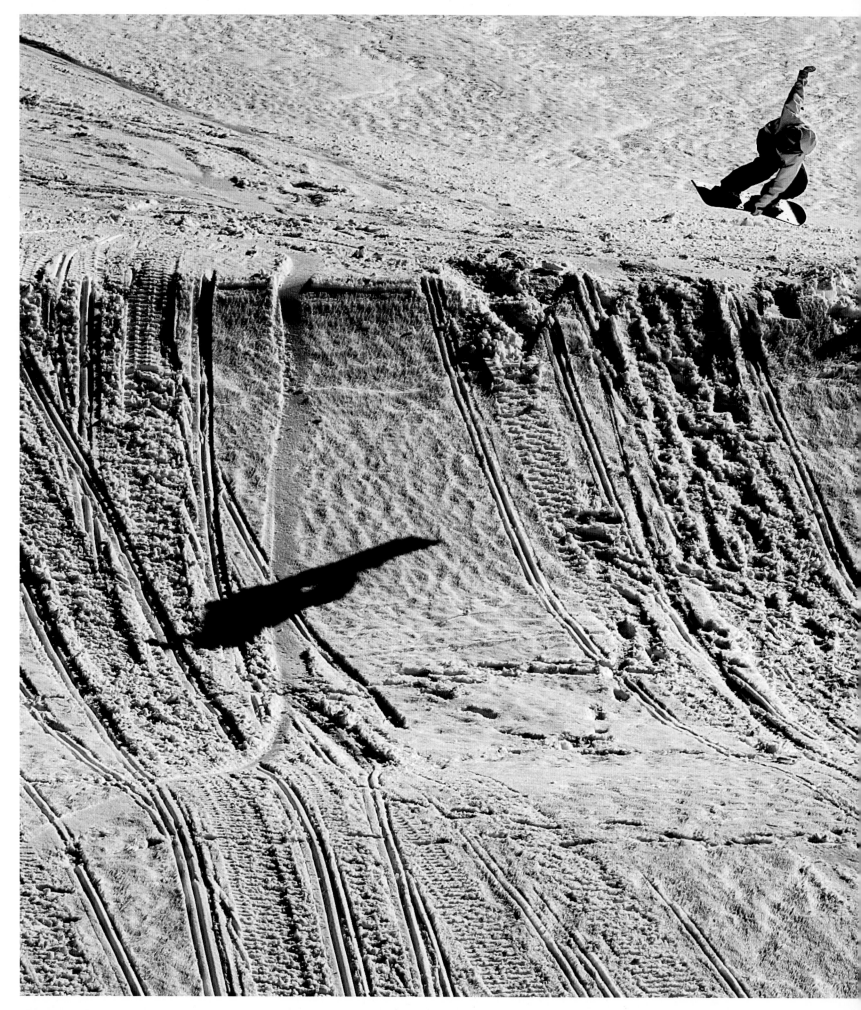

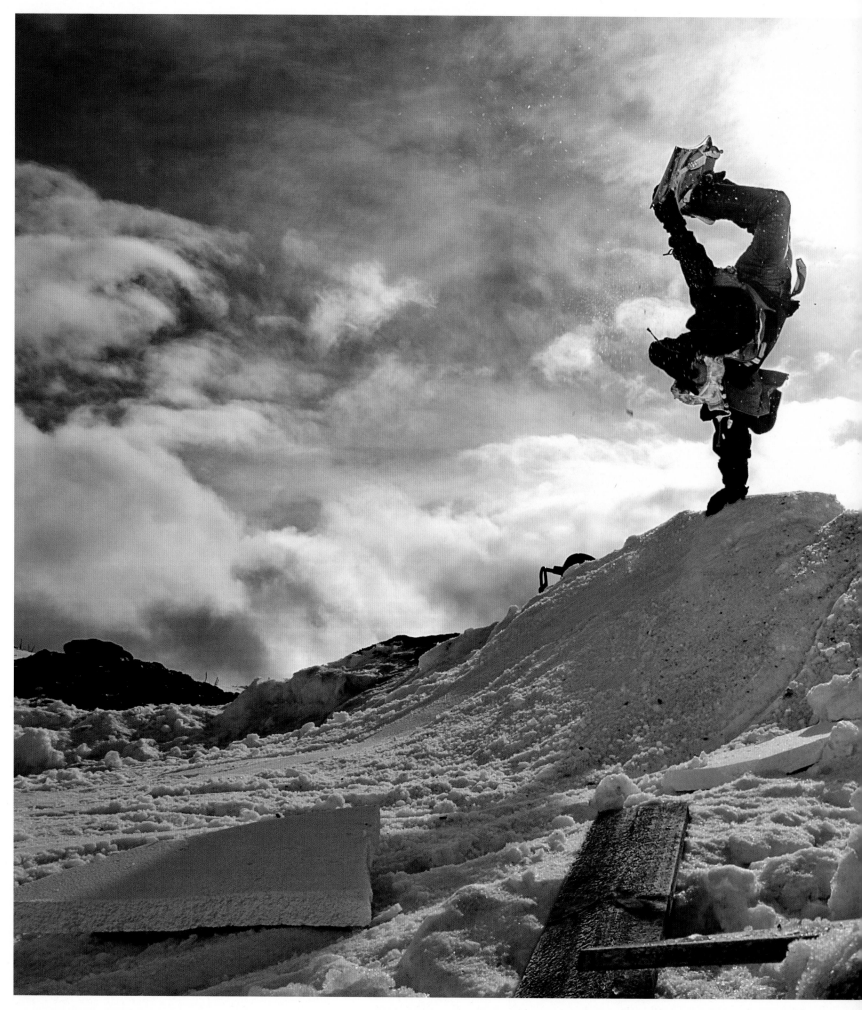

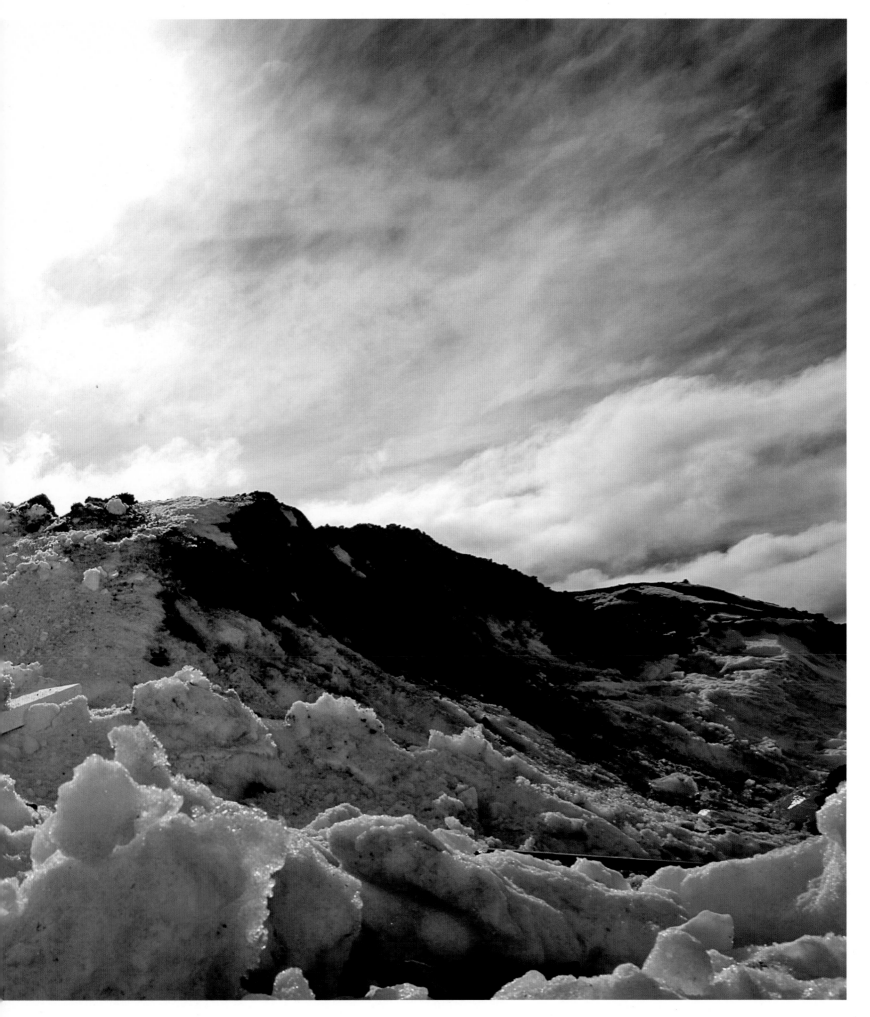

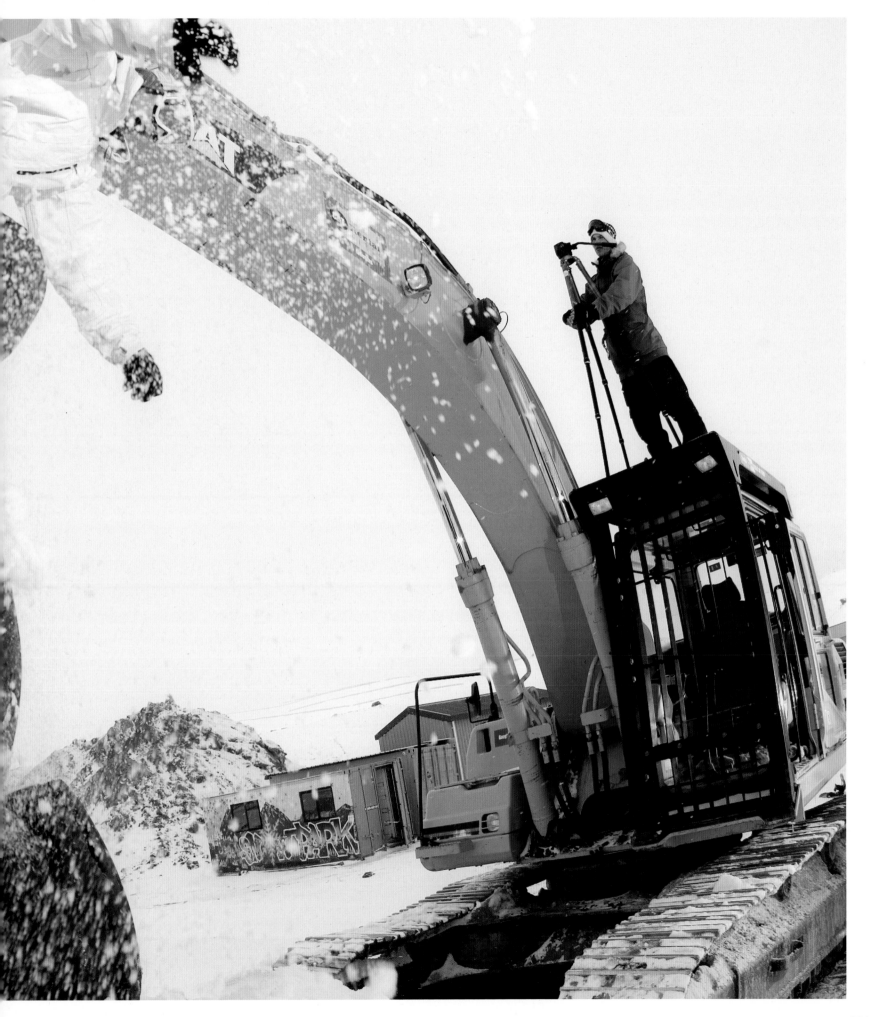

131

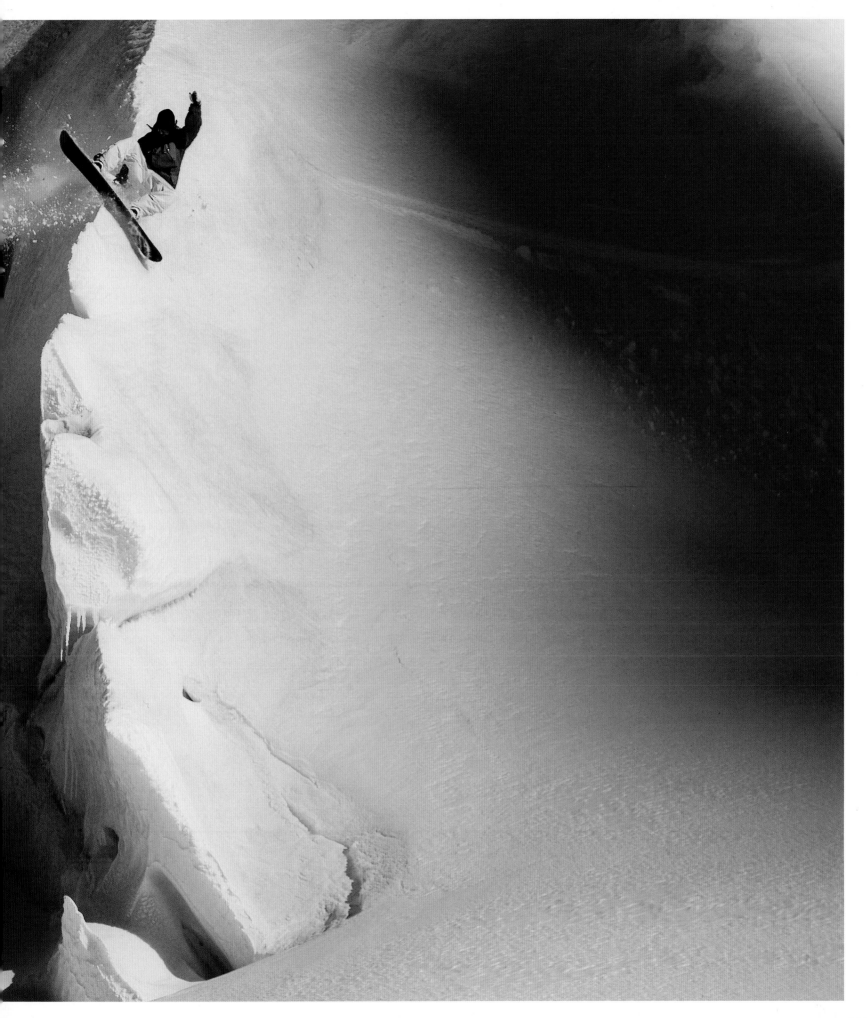

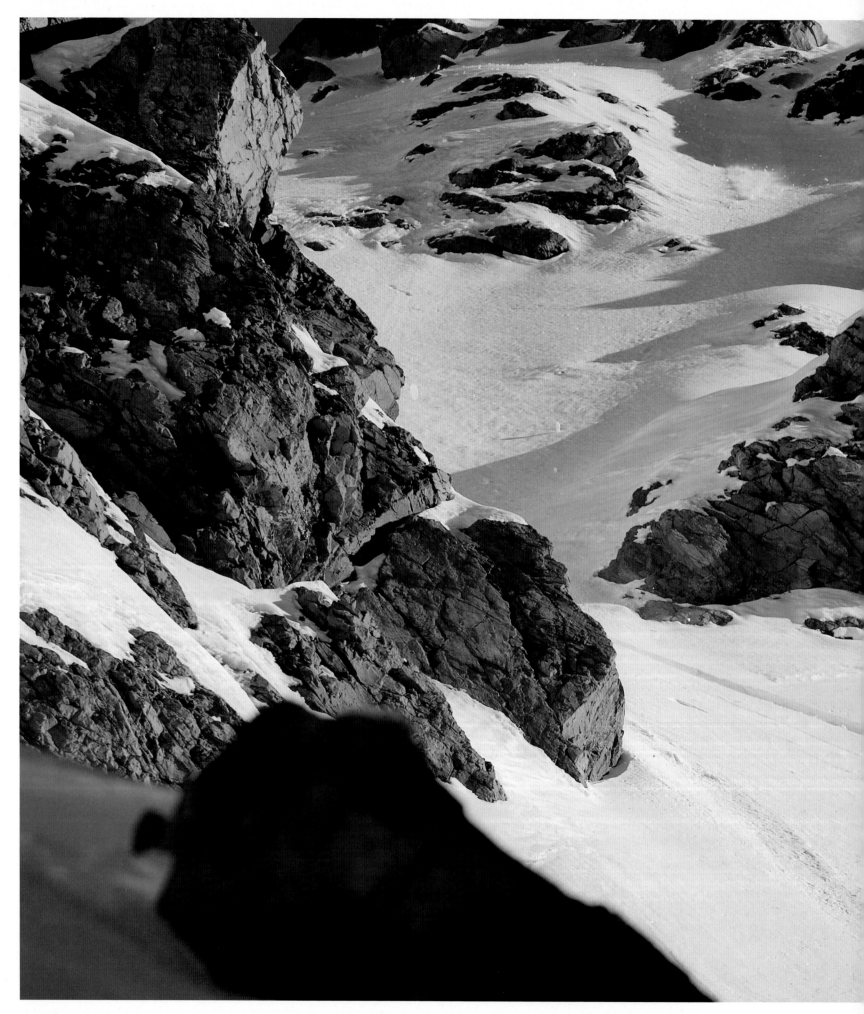

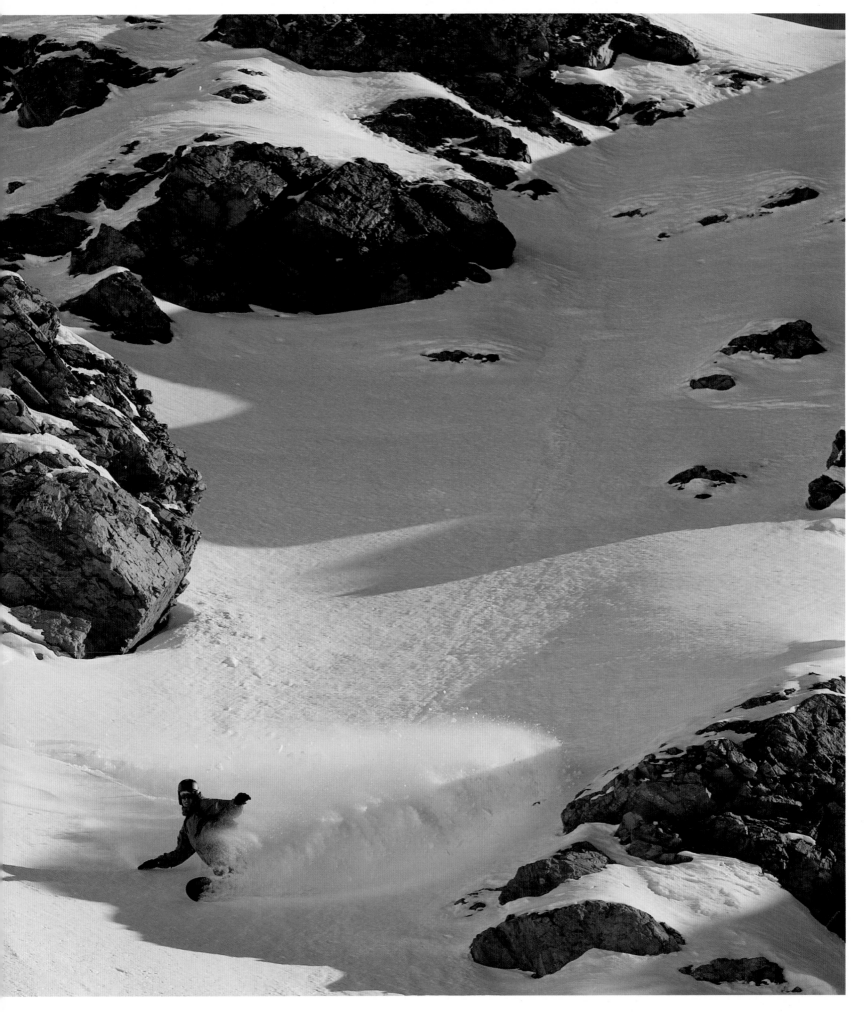

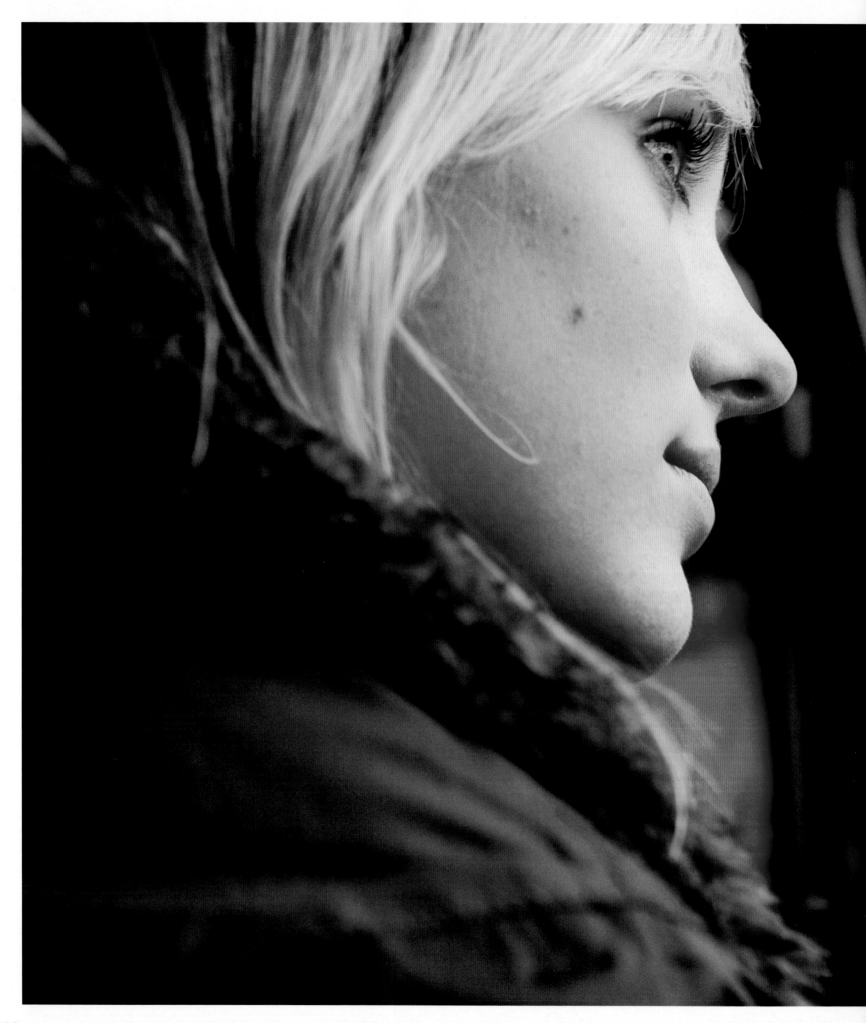

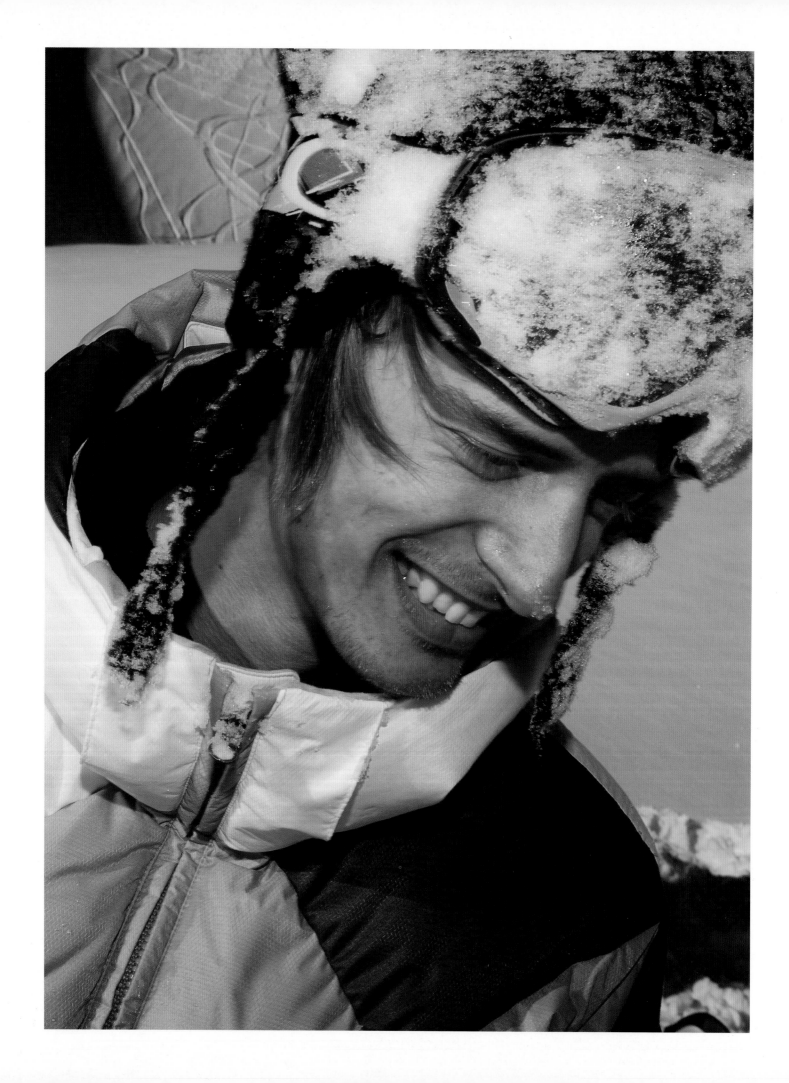

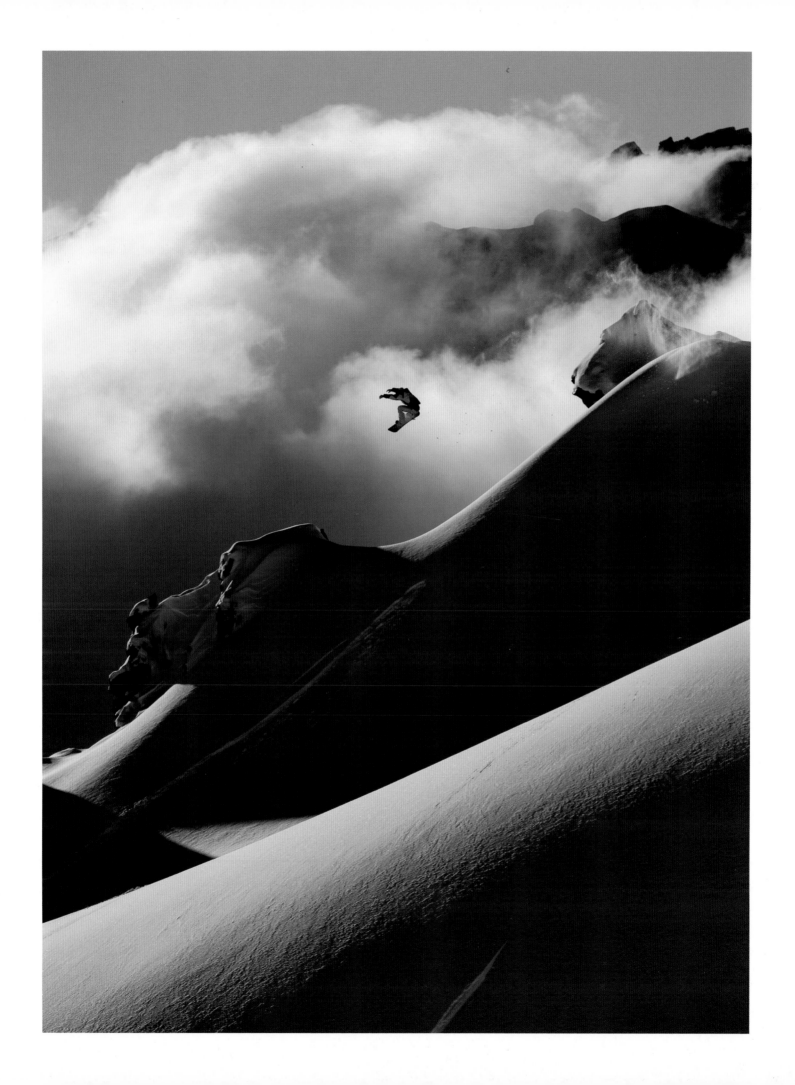

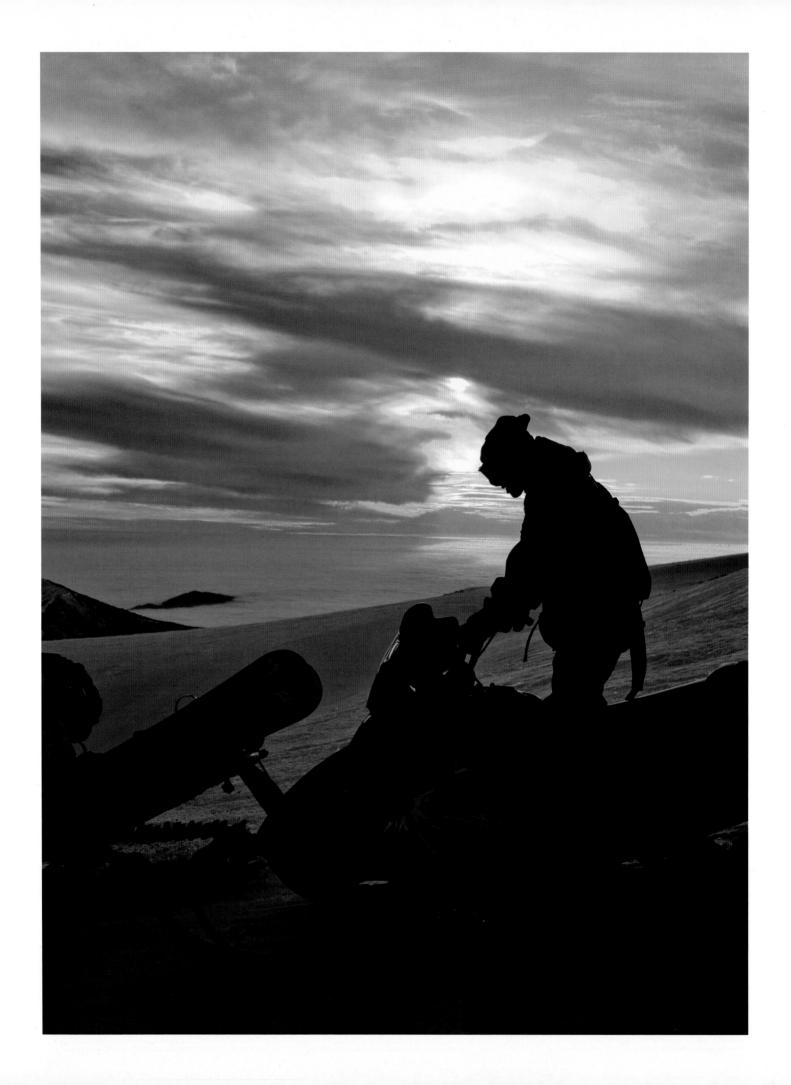

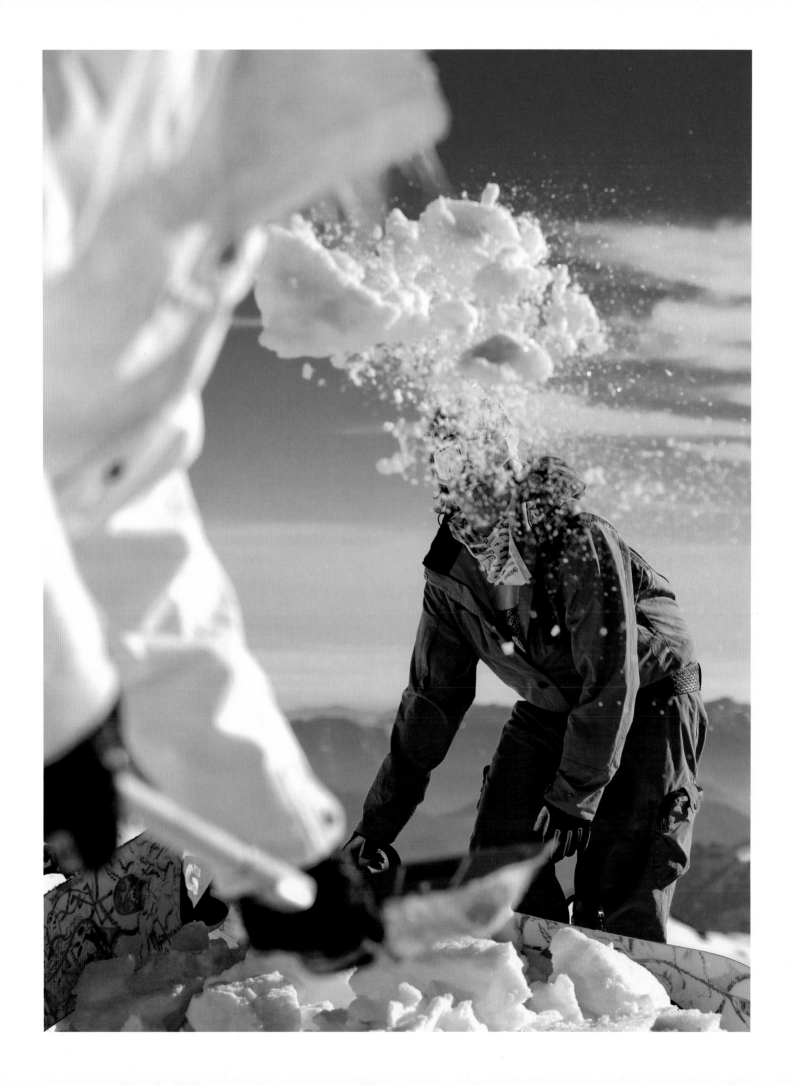

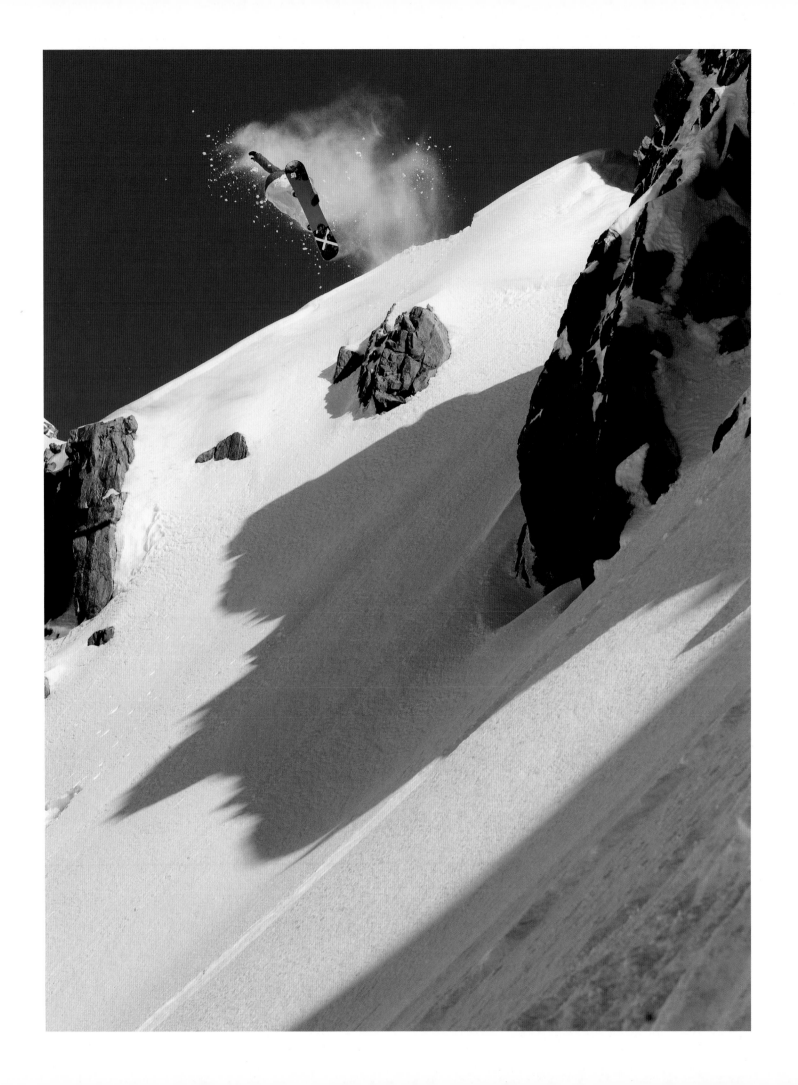

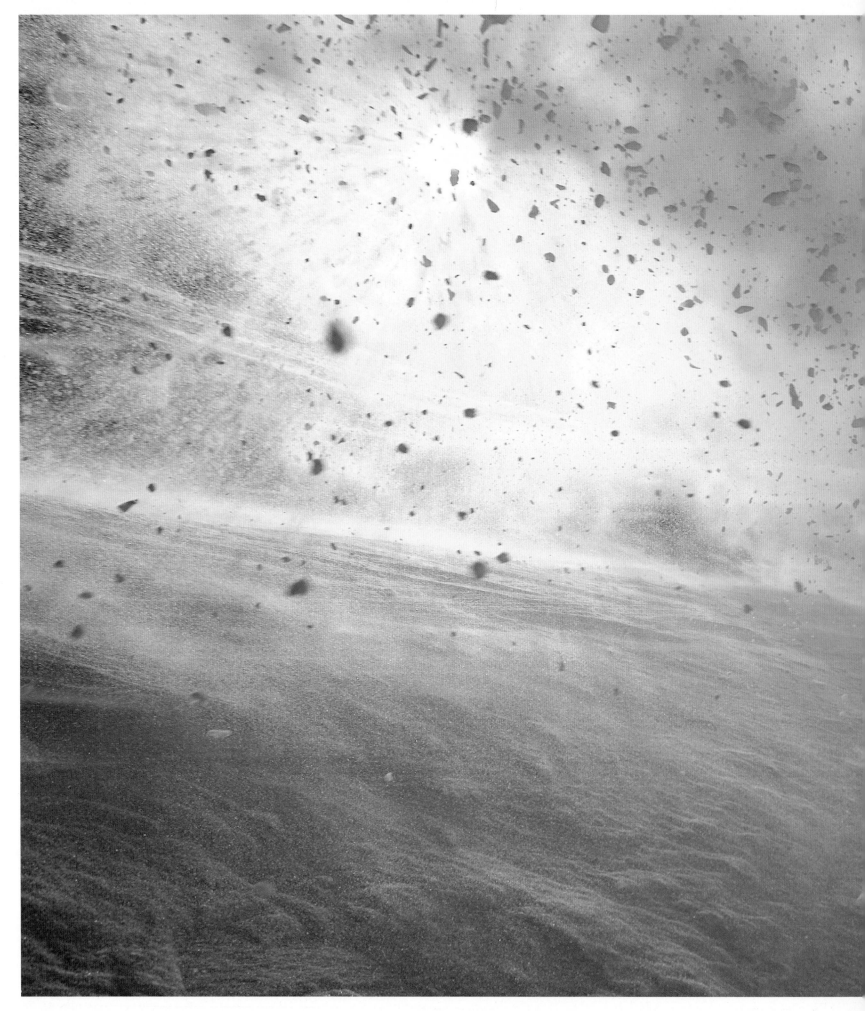

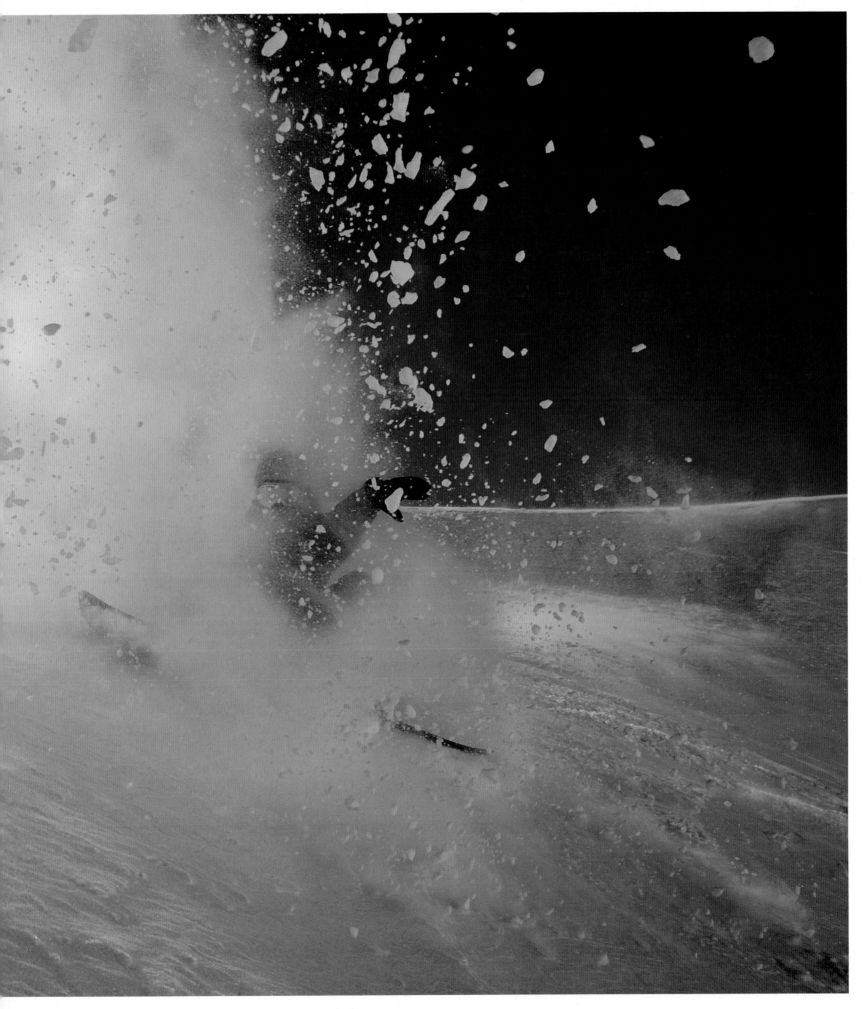

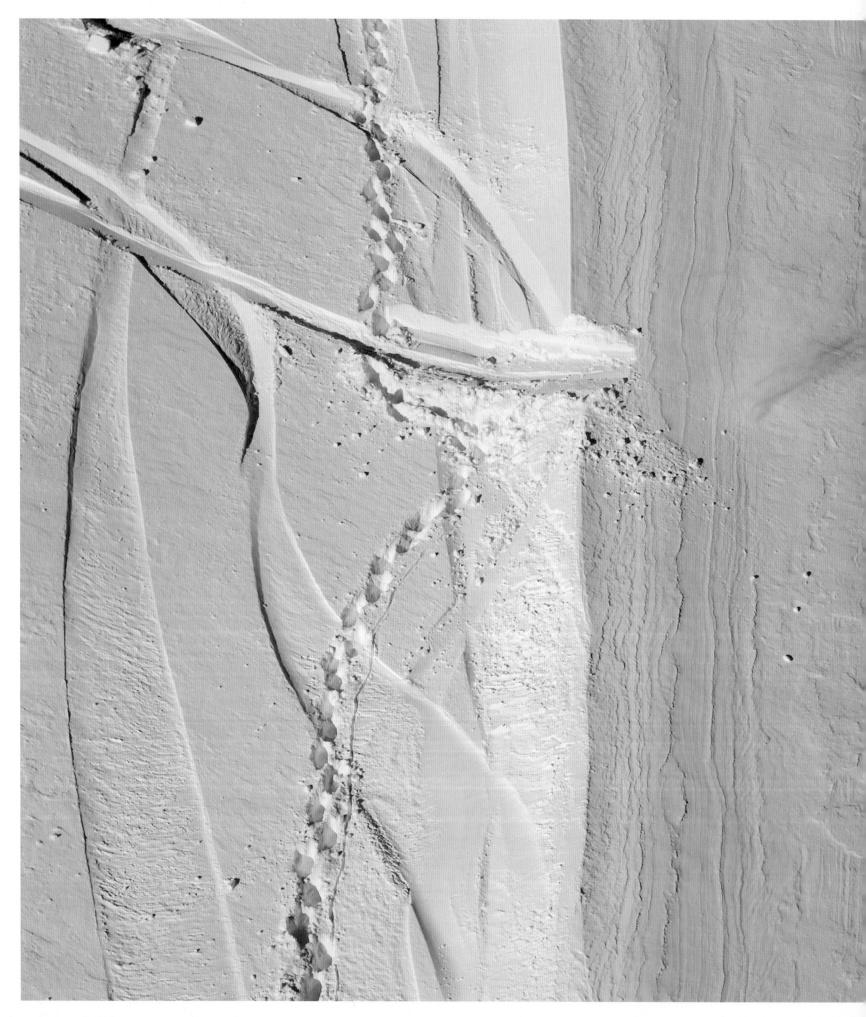

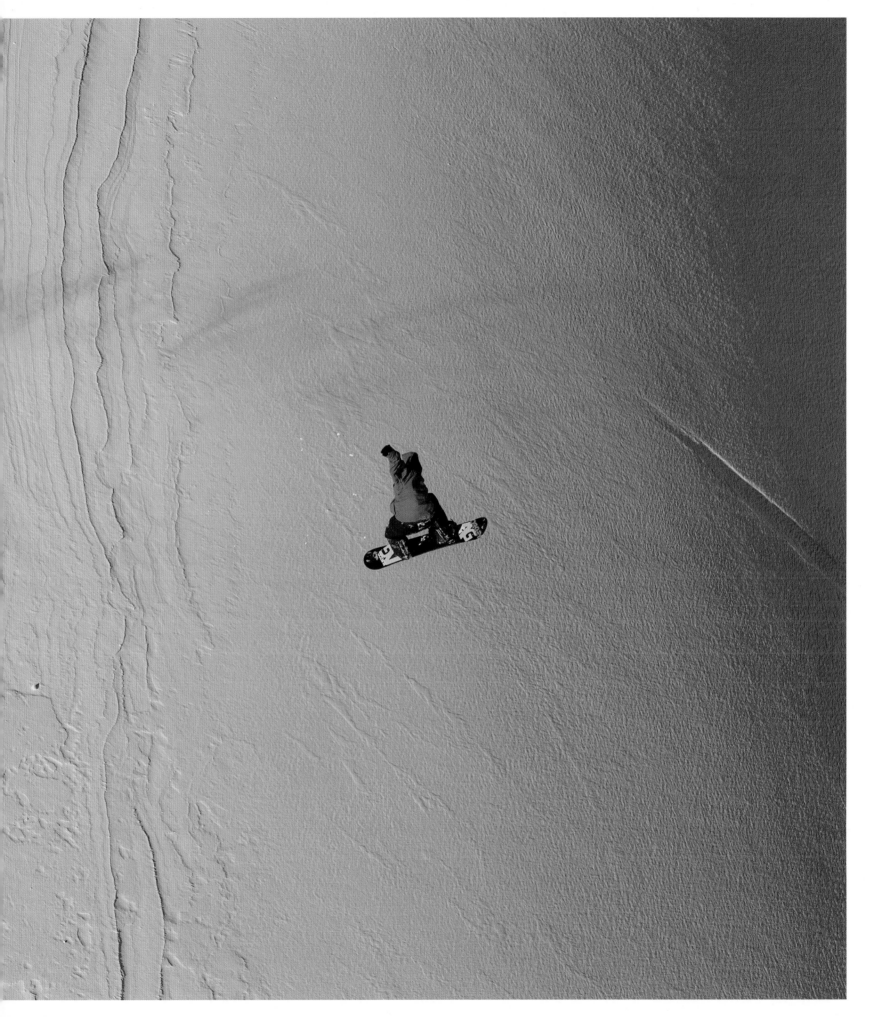

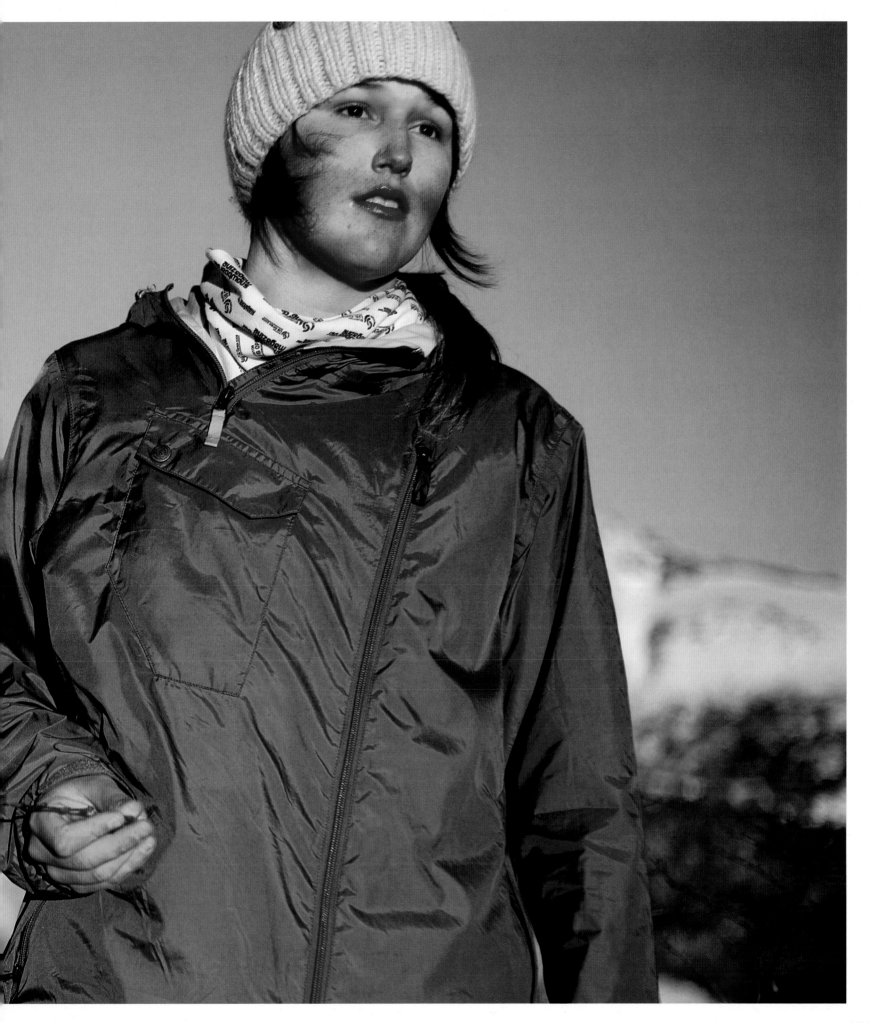

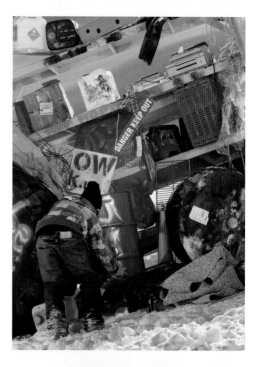
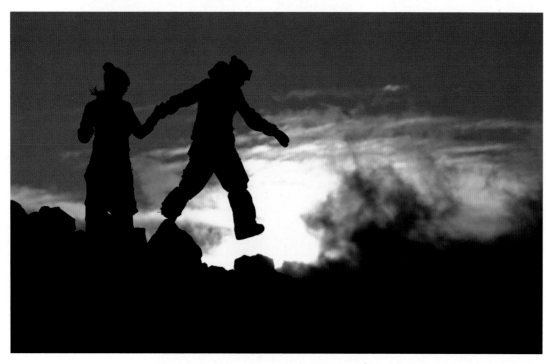

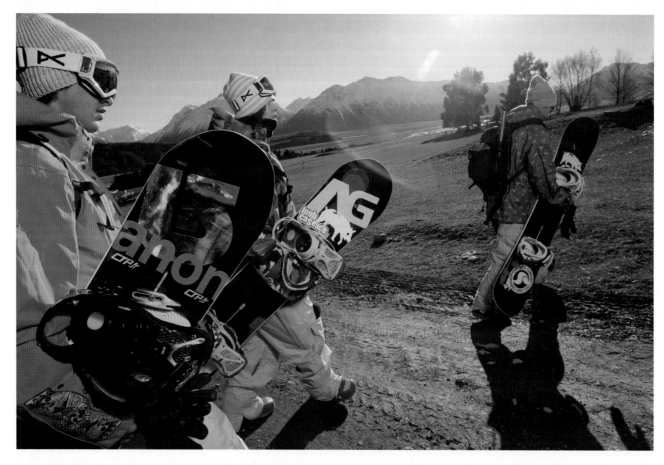

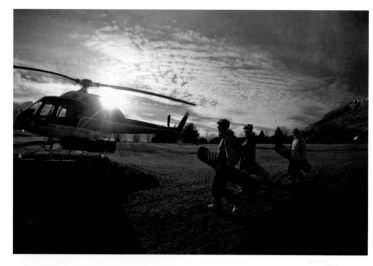

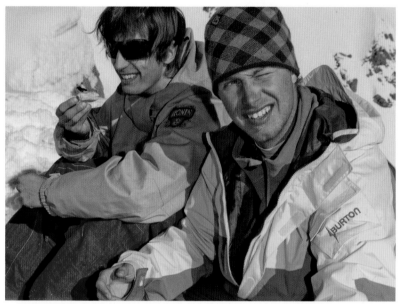

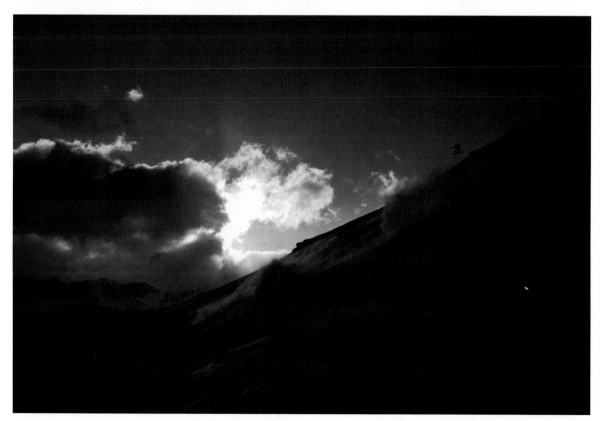

153

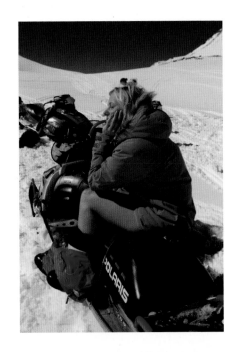

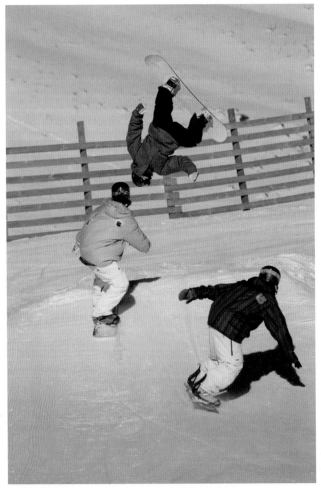

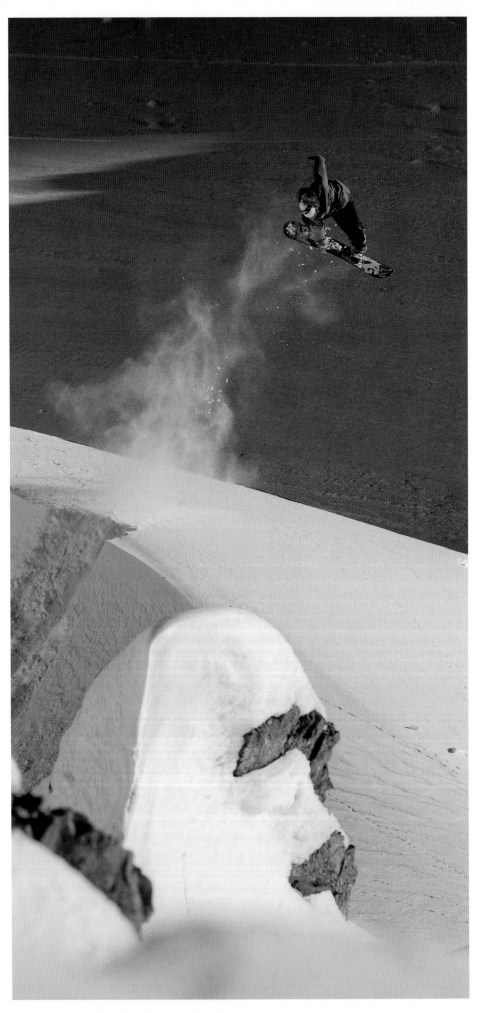

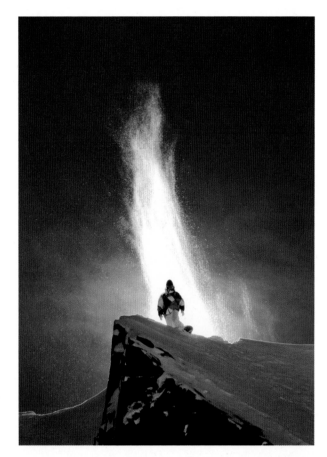

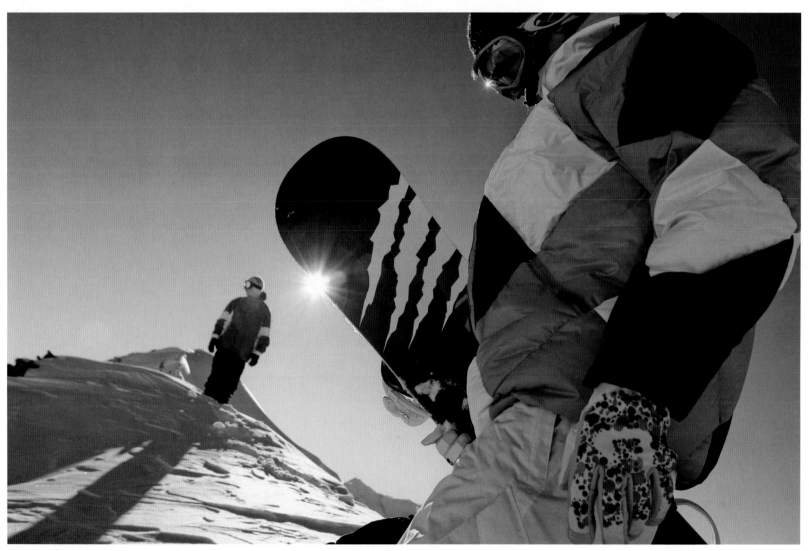

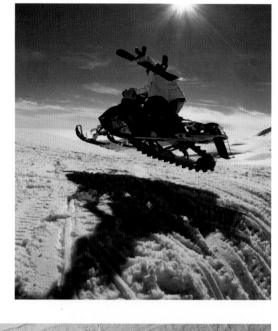
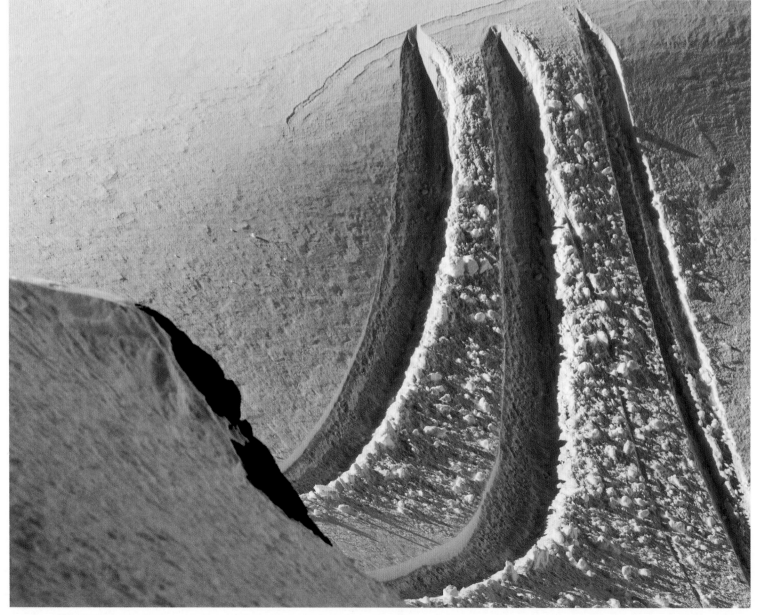

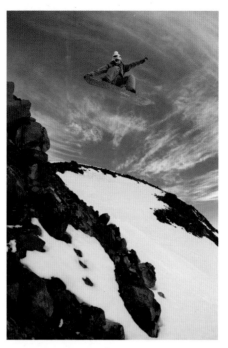

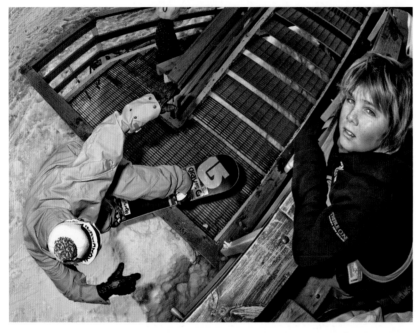

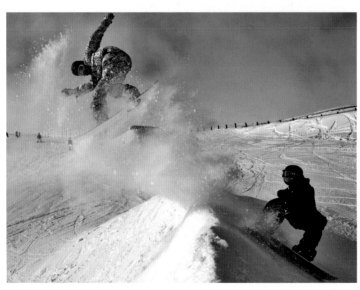

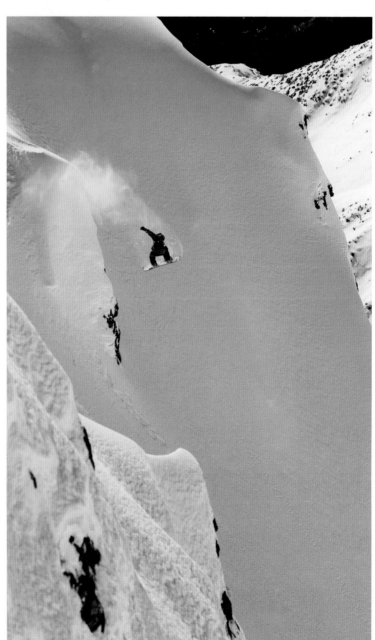

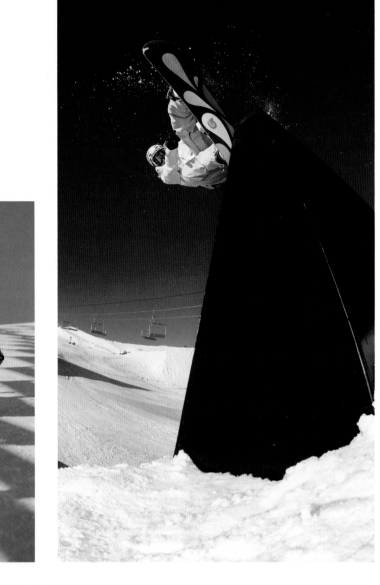

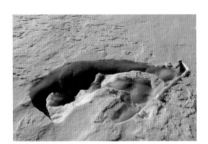

# 28 DAY WINTER

*Photographer bios:*

### Jeff Curtes:

*Jeff's addiction for snowboarding is unprecedented. No other snowboard photographer has traveled the globe as many times or seen as many good and bad days. He is the ultimate documentarian of snowboarding progression. His point of view has amplified and defined the soul and spirit of the lifestyle. His journalistic images depict the effort, courage, and camaraderie that go on behind the scenes. He is a facilitator that encourages riders to push the limits of what they can achieve; a professional that flawlessly captures these moments for eternity. Jeff is the principal photographer for Burton and has shot photos for them nonstop since 1994. In 1985 he learned to snowboard with his brother Joe in Menomonee Falls, Wisconsin but he currently resides between Boulder, Colorado and Portland, Oregon with his wife, Jess Mooney, who is, conveniently, a snowboard photographer as well.*

### Dean Blotto Gray:

*Dean Blotto Gray has been documenting the best riders in snowboarding and the heart of the sport's culture for years. In his current capacity as a Burton Team Photographer, Blotto is afforded the opportunity to travel over 300 days per year with one of the top contemporary crews in the game. From Nicolas and DCP slicing through the Japanese trees to anything and everything with Trevor Andrew and Danny Davis in the far reaches of the globe, Blotto gets more than just the hype and the hop. With his work featured in every major snowboard magazine on the planet, along with representation by one of photography's top sports photo houses, Blotto's images are finding their way into a lot more than just catalogs and shred magazines these days. After the magazines have been recycled, the catalogs tossed away, and the websites redesigned, Blotto's images will remain and stand the test of time. These original works represent both the man's work ethic and a farsighted aesthetic.*

### Adam Moran:

*Snowboarding has been a part of Adam Moran for almost his entire life. Starting back in 1987 with his older brother Jeff, he spent every free moment he could snowboarding and skateboarding. As a team manager for Burton Snowboards he now enjoys the luxury of traveling to the best places in the world with the best riders. He puts his passion together with his job and has managed to be published in every major snowboard magazine in the world as well as in Burton ads and catalogs. Adam now works full time team managing Shaun White and documenting the life of action sports' first major celebrity. With every rider at every shoot he has the stoke and passion that he had the first time he dropped in 20 years ago.*

*a big shout of thanks to:*

Rene Hansen, Clark Gundlach, Bryan Johnston, Greg Dacyshyn, Craig Wetherby, Jake Burton, Toby Grubb, Annemarie Buckley, Chris Doyle, Nick Simmons, George Carpenter, Craig Cohen, Sara Rosen, Aaron Hooper, Nathan Avila, Hasi, Dave Driscoll, Guy Alty, JG, Jaako Itaho, Michael Gardzina, Susie Floros, Lenny Glick, Rob Farrington.

Dos Tiempos, Cristian Wehrhahn, Frank Wells, Wesley Fabb, Sonny Fischer, Cristin Denight, Andrew Burke, Sam Lee, Snow Park, Cardrona, Coronet Peak, Treble Cone, Mt. Hutt, All Stars Travel NZ, Shane Tallman, Deb Friedman, Brinkley Village-Methven, Chris Cunningham, Eric Gaisser, Nate Bossard, Karen Yankowski, Tomas Ruprecht , Jonny, Kevin, Jamie and Kent at Methven Heli.

*a little credit goes to:*

The fine gents at PeetKegler for the art direction and design. peetkegler.com

This book is printed on recycled paper using soy inks.

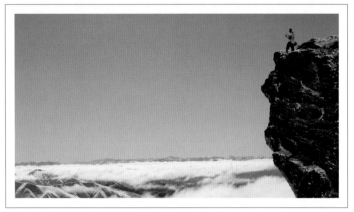

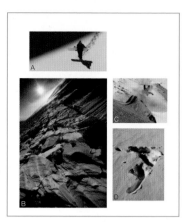

*p.*02
*rider:* TADASHI FUSE
*location:* Cardrona, New Zealand
*photographer:* Dean Blotto Gray

*"Curiosity found this spot for us… it was a mere two minutes off the beaten path."* Blotto

*p.*05
A: *rider:* MADS JONSSON *location:* Mt. Cook, New Zealand *photographer:* Jeff Curtes
B: *location:* Termas De Chillan, Chile *photographer:* Jeff Curtes
C: *rider:* MADS JONSSON *location:* Methven, New Zealand *photographer:* Jeff Curtes
D: *rider:* NICOLAS MÜLLER *location:* Methven, New Zealand *photographer:* Jeff Curtes

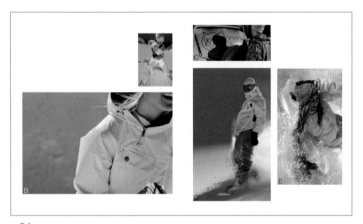

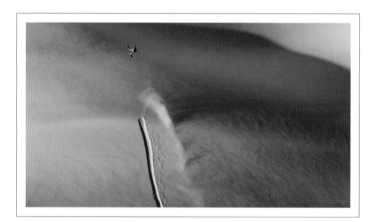

*p.*06
A: *rider:* NICOLAS MÜLLER *location:* Methven, New Zealand *photographer:* Jeff Curtes
B: *rider:* ANNE-FLORE MARXER *location:* Termas De Chillan, Chile *photographer:* Jeff Curtes
C: *rider:* GIGI RUF *location:* The Farm, New Zealand *photographer:* Dean Blotto Gray
D: *rider:* MADS JONSSON *location:* Mt. Cook, New Zealand *photographer:* Jeff Curtes
E: *rider:* VICTORIA JEALOUSE *location:* Termas De Chillan, Chile *photographer:* Jeff Curtes

*p.*08
*rider:* NICOLAS MÜLLER
*location:* Methven, New Zealand
*photographer:* Jeff Curtes

*"Some things in life you just cannot plan. Quick and sober, you will do the right thing, no hesitation."* Nicolas

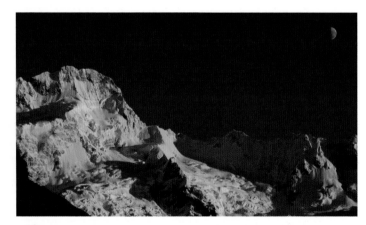

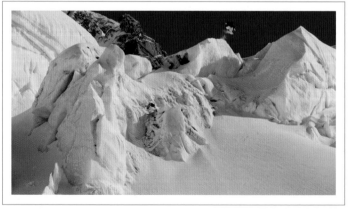

*p.*10
*location:* Mt. Cook, New Zealand
*photographer:* Jeff Curtes

*"Sunrise on Aoraki from our breakfast table."* Curtes

*p.*12
*rider:* NICOLAS MÜLLER
*location:* Methven, New Zealand
*photographer:* Jeff Curtes

*"Cold as ice… willing to sacrifice."* Tadashi

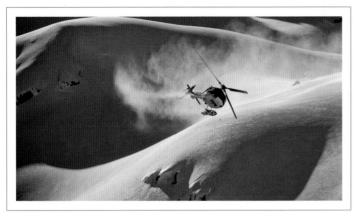

p. **14**
*location:* Mt. Cook, New Zealand
*photographer:* Jeff Curtes

*"Our guide on this particular morning was short and sweet… I know what you guys are looking for… and you ain't gonna find it here. Expectations from 100 to 0 in about five seconds. Unfortunately for the guide, who was on a bit of a self-proclaimed holiday, Mads and I found this little cirque filled with features… Mads solo sessioned lapping in the high speed quad… killing it." Mads and Curtes*

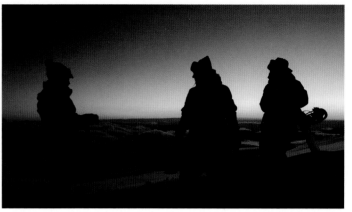

p. **16**
*rider:* ANNE-FLORE MARXER, NATASZA ZUREK, SPENCER O'BRIEN
*location:* Chile
*photographer:* Jeff Curtes

*"Chile was my first 'out of North America' experience. I felt like I was coming home rather than entering a completely new world. We drank fantastic wine every night, rode everyday, shopped in authentic Chilean markets, and watched the most incredibly beautiful sunsets I have ever seen." Spencer*

p. **18**
*rider:* JEREMY JONES
*location:* Mt. Hood, Oregon
*photographer:* Dean Blotto Gray

*"Closing day at Mt. Hood 2006." Blotto*

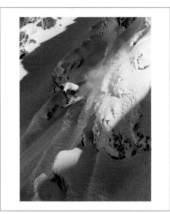
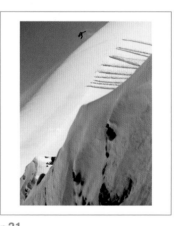

p. **20** FREDERIK KALBERMATTEN
*rider:*
*location:* Methven, New Zealand
*photographer:* Jeff Curtes

p. **21** DCP
*rider:*
*location:* Methven Heli, New Zealand
*photographer:* Dean Blotto Gray

p. **21** *"There's nothing better than finding a back country kicker spot that requires no construction, has natural speed, with a perfect landing. You can take it one step further and not have to hike because the heli picks you up at the bottom." Blotto*

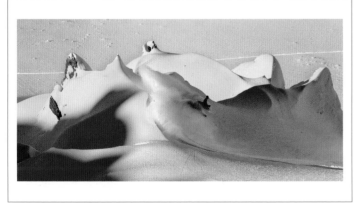

p. **22**
*rider:* ROMAIN DE MARCHI
*location:* Methven, New Zealand
*photographer:* Jeff Curtes

*"First track is always the best, but second ain't too bad either." Curtes*

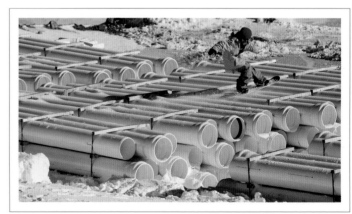

p. **24**
*rider:* KEEGAN VALAIKA
*location:* Snow Park, New Zealand
*photographer:* Dean Blotto Gray

*"Undergoing numerous upgrades to their resort to meet the growing demands of increased shredder visits, piles of these oversized PVC pipes were in shouting distance from the chairlift. This particular stack had natural speed, so Keegan and Mikkel took a break from the park to jack up a small wedge to hear the popping noise of P-Tex on plastic." Blotto*

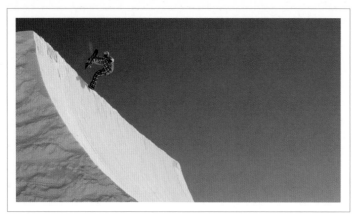

**p.26**
*rider:* MOLLY AGUIRRE
*location:* Snow Park, New Zealand
*photographer:* Dean Blotto Gray

*"Snow Park is one of the few resorts worldwide that maintains a quarter pipe all season long. This terrain park feature is definitely few and far between, so Molly took full advantage of the man-made obstacle with a session everyday. This Texas Plant took place after The New Zealand Open, while the QP was a monster standing 30 feet tall."* Blotto

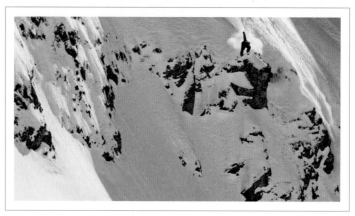

**p.28**
*rider:* MADS JONSSON
*location:* Mt. Hood, Oregon
*photographer:* Jeff Curtes

*"Options were getting kind of slim and we were almost turning our watches to free run o'clock. I spotted a line down the ridge from where we just had been riding. Found ourselves in the sickest little cirque. It turned out to be one of the funniest heli days I've ever had. I sessioned that place for a couple of hours. We topped it off with a 'stunner' of a free run!"* Curtes

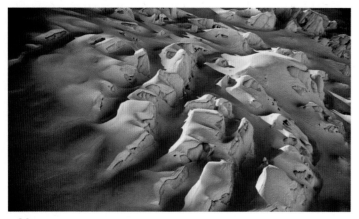

**p.30**
*location:* Methven, New Zealand
*photographer:* Jeff Curtes

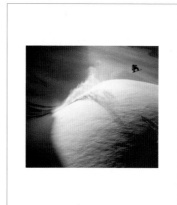

**p.32**
*rider:* DCP
*location:* Methven, New Zealand
*photographer:* Jeff Curtes

**p.33**
*rider:* DCP
*location:* Methven, New Zealand
*photographer:* Dean Blotto Gray

*"Every year we keep discovering and dialing in the NZ terrain and this last season we really found some awesome features, sweet wind lips, lines, and ice step downs... I feel very fortunate to be able to ride pow in the summer."* DCP

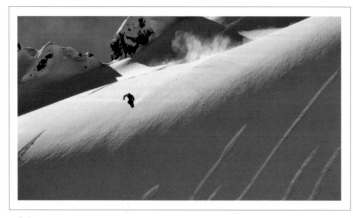

**p.34**
*rider:* DCP
*location:* Methven, New Zealand
*photographer:* Jeff Curtes

*"Sunset session number one on the epic roller. DCP spinning front side into oblivion."* Curtes

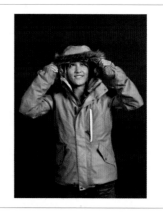

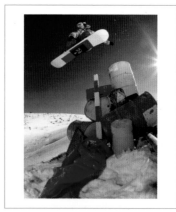

**p.36**
*rider:* ELENA HIGHT
*location:* Wanaka, New Zealand
*photographer:* Dean Blotto Gray

**p.37**
*rider:* ELENA HIGHT
*location:* Snow Park, New Zealand
*photographer:* Adam Moran

*"At this point we had gotten a little bored of being on the same hill every day and knew that if we just put a little extra time into setting up a simple ollie shot, it would turn out good."* Adam

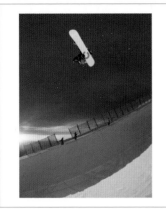

p.**38**
*rider:* LUKE MITRANI
*location:* Snow Park, New Zealand
*photographer:* Adam Moran

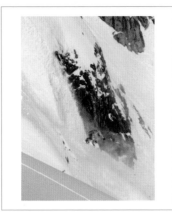

p.**39**
*rider:* DCP
*location:* Methven, New Zealand
*photographer:* Jeff Curtes

*"So, we were looking to do lines and as we flew over to pick our way down, we realized Blotto had slid almost all the way down above exposure and stopped right above rocks... ouff! It was so sketchy, so right there it told us it was gonna be icy... but we had picked our lines and we had to go down." DCP*

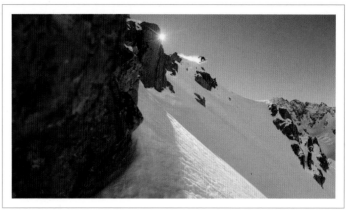

p.**40**
*rider:* ROMAIN DE MARCHI
*location:* Methven, New Zealand
*photographer:* Jeff Curtes

*"Last run before hooking up with Blotto's crew for a heli picnic, I traversed around, as there was no other way, to try to get a look at the run Romain was explaining to me over the radio that he wanted to ride. I was clueless actually, had no idea where he was gonna drop... I threw on the fisheye way out of range and made something happen." Curtes*

p.**42**
*rider:* TREVOR ANDREW
*location:* Snow Park, New Zealand
*photographer:* Dean Blotto Gray

*"Snowboarding gave me everything."*
Trevor

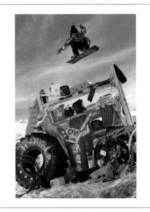

p.**43**
*rider:* TREVOR ANDREW
*location:* Snow Park, New Zealand
*photographer:* Dean Blotto Gray

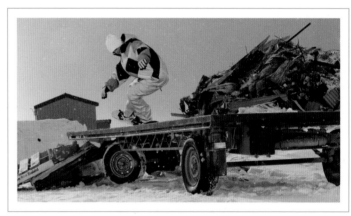

p.**44**
*rider:* MARKO GRILC
*location:* Snow Park, New Zealand
*photographer:* Dean Blotto Gray

*"The junkyard session at Snow Park was super cool. We had a sick park right next to it, but we saw way more fun in gathering a bunch of junk together and hitting that." Marko*

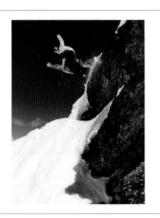

p.**46**
*rider:* SHAUN WHITE
*location:* Cardrona, New Zealand
*photographer:* Adam Moran

p.**47**
*rider:* SHAUN WHITE
*location:* Cardrona, New Zealand
*photographer:* Adam Moran

*"Due to changing plans and Shaun's skate schedule we ended up with only one hour to shoot while he was in NZ. Four runs, then he was off to the airport. We knew he didn't need to shoot something to prove himself, we just wanted to do something fun, and this is what we came up with." Adam*

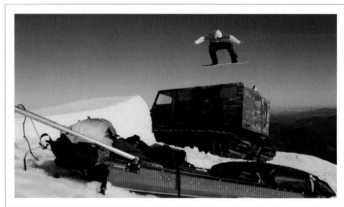

p.**48**
*rider:* JUSSI OKSANEN
*location:* Mt. Hood, Oregon
*photographer:* Adam Moran

*"This is the cat from the movie* The Shining. *Back in the days when I watched the movie, I didn't expect that I would be jumping over it one day on my snowboard." Jussi*

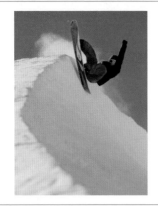

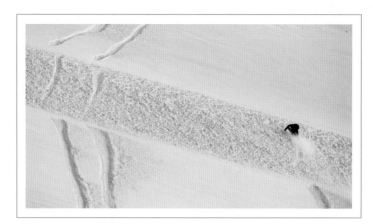

p.**50**
*rider:* KELLY CLARK
*location:* Snow Park, New Zealand
*photographer:* Dean Blotto Gray
*"My brother is a skier and he still calls 360s helicopters. It's awesome..."* Kelly

p.**51**
*rider:* KELLY CLARK
*location:* Snow Park, New Zealand
*photographer:* Dean Blotto Gray

p.**52**
*rider:* HEIKKI SORSA
*location:* Methven, New Zealand
*photographer:* Dean Blotto Gray
*"Nicolas Müller (not pictured), DCP (not pictured), and Heikki Sorsa (pictured). All three buttered up this avy debris 'text book' perfect."* Blotto

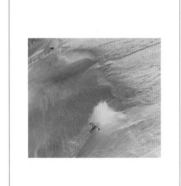

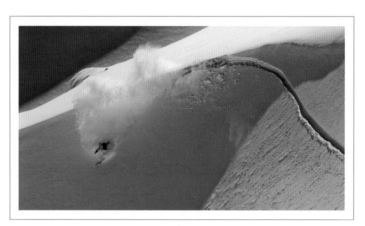

p.**54**
*rider:* VICTORIA JEALOUSE
*location:* Termas De Chillan, Chile
*photographer:* Jeff Curtes

p.**55**
*rider:* VICTORIA JEALOUSE
*location:* Termas De Chillan, Chile
*photographer:* Jeff Curtes

p.**56**
*rider:* NICOLAS MÜLLER
*location:* Methven, New Zealand
*photographer:* Jeff Curtes
*"Blower bottom turn, no one makes it look more fun."* Curtes

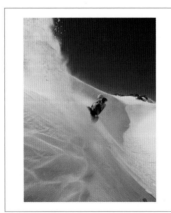

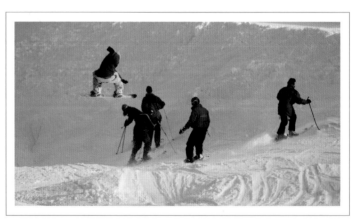

p.**58**
*rider:* SPENCER O'BRIEN
*location:* Termas De Chillan, Chile
*photographer:* Jeff Curtes
*"Studio session after one of Deb's Q&A interrogation dinners. Hooper had to leave the room."* Curtes

p.**59**
*rider:* SPENCER O'BRIEN
*location:* Termas De Chillan, Chile
*photographer:* Jeff Curtes

p.**60**
*rider:* GIGI RÜF
*location:* Mt. Hutt, New Zealand
*photographer:* Dean Blotto Gray
*"For me, this photo captures exactly why snowboarding is so damn fun. You can snowboard on anything, anywhere, anytime, and it's all good. Heli down-day turned resort shred."* Tadashi

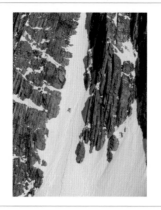
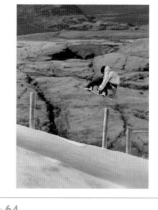
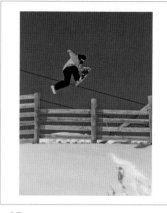

**p.62**
*rider:* ROMAIN DE MARCHI
*location:* Methven, New Zealand
*photographer:* Dean Blotto Gray

**p.63**
*rider:* ROMAIN DE MARCHI
*location:* Methven, New Zealand
*photographer:* Dean Blotto Gray

"There were three key elements to Romain's straight shot, with the last being the gnarliest in my opinion. First is getting in. Second is going through, and number three is holding on for dear life as you exit the chute doing a hundred." *Blotto*

**p.64**
*rider:* MARKO GRILC
*location:* Treble Cone, New Zealand
*photographer:* Dean Blotto Gray

**p.65**
*rider:* TADASHI FUSE
*location:* Coronet Peak, New Zealand
*photographer:* Dean Blotto Gray

"The vibe with the crew was super sick. I guess it had a lot to do with there being no pressure of doing the craziest things. We were just enjoying riding the resorts, and that doesn't happen often as a professional snowboarder filming video parts." *Marko*

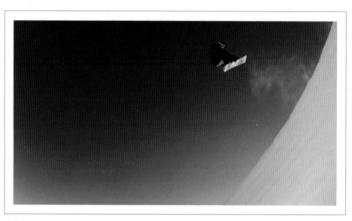

**p.66**
*rider:* DANNY DAVIS
*location:* Methven, New Zealand
*photographer:* Jeff Curtes

**p.67**
*rider:* DANNY DAVIS
*location:* Methven, New Zealand
*photographer:* Dean Blotto Gray

**p.68**
*rider:* KEVIN PEARCE
*location:* Snow Park, New Zealand
*photographer:* Adam Moran

"This was the last shot of the epic heli session that went down on the wind lip. Davis outlasting everyone else squeezing in one more." *Curtes*

"Double-angle Davis. Two shots for the price of one jump..." *Blotto*

"Air to fakie—a night pipe session with the homies always turns out well. This time it was Mase, Danny, Jack, and myself. Small crew, good pipe, and a chill night." *Kevin*

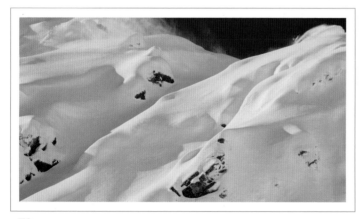

**p.70**
*rider:* DCP
*location:* Methven, New Zealand
*photographer:* Dean Blotto Gray

**p.72**
*rider:* NATASZA ZUREK
*location:* Termas De Chillan, Chile
*photographer:* Jeff Curtes

**p.73**
*rider:* NATASZA ZUREK
*location:* Termas De Chillan, Chile
*photographer:* Jeff Curtes

"Heli-boarding involves a lot of luck, from snow stability and quality to those rare bluebird days. During the week-long session with DCP, Nico, and Heikki, the moons aligned and blessed the boys with blower pow, zero avalanches, and perfect weather." *Blotto*

"Nat belting it out like none other... and those pipes! Both on and off of the snow, Nat is the real deal." *Curtes*

"The back country terrain in Termas is easily accessed by snowmobile right off the back of the resort. The wind formed landscape changes every year making the terrain look totally different." *Natasza*

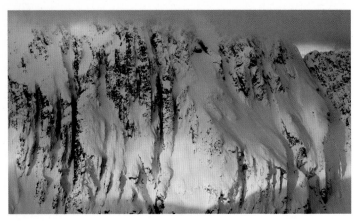

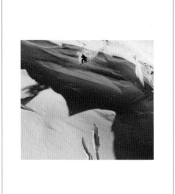

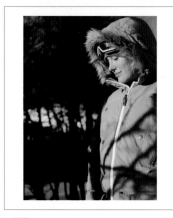

*p.***74**
*location:* Methven, New Zealand
*photographer:* Jeff Curtes

*"I got dizzy and I almost peed myself, then I came to. It was like heaven. The sun was definitely shining down upon me!" Tadashi*

*p.***76**
*rider:* ANNE-FLORE MARXER
*location:* Termas De Chillan, Chile
*photographer:* Jeff Curtes

*p.***77**
*rider:* ANNE-FLORE MARXER
*location:* Termas De Chillan, Chile
*photographer:* Jeff Curtes

*"Hard pack covered in a foot of fresh snow. Anne-Flore getting it done." Curtes*

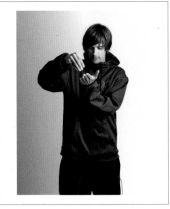

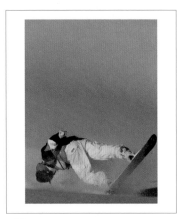

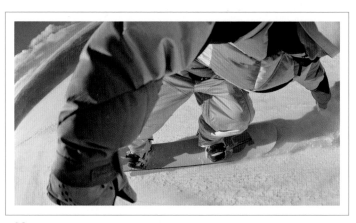

*p.***78**
*rider:* NICOLAS MÜLLER
*location:* Methven, New Zealand
*photographer:* Dean Blotto Gray

*"Nico breaking it down." Blotto*

*p.***79**
*rider:* NICOLAS MÜLLER
*location:* Methven, New Zealand
*photographer:* Jeff Curtes

*"The muffin is now buttered." Curtes*

*p.***80**
*rider:* MARKO GRILC
*location:* Treble Cone, New Zealand
*photographer:* Dean Blotto Gray

*"Our first day riding chairs at Treble Cone was... Let's say, 'tough.' The wind was blowing so hard at the top, I couldn't believe the lift was still operating. Fisheye follow cam of Marko's butter moves was the call." Blotto*

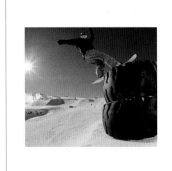

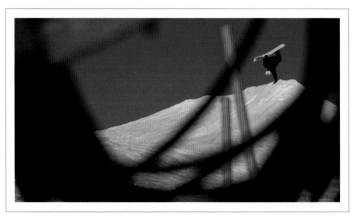

*p.***82**
*rider:* DAVE DOWNING
*location:* Methven, New Zealand
*photographer:* Jeff Curtes

*"Downing keeping it going with the boys." Curtes*

*p.***83**
*rider:* DAVE DOWNING
*location:* Snow Park, New Zealand
*photographer:* Dean Blotto Gray

*"Dave flew all the way to New Zealand hoping for heli time. That didn't work out so well due to wind, so we headed south for jibbing at Snow Park." Blotto*

*p.***84**
*rider:* ROMAIN DE MARCHI
*location:* Snow Park, New Zealand
*photographer:* Adam Moran

*"This was Romain's second day back riding after eight months out due to knee surgery. We were just messing around and he suddenly got the urge to shoot. So I went and got my camera and this is what we came up with. His first shot back, second day on snow. He was driven to get back into it as fast as he could." Adam*

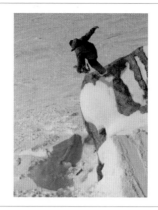

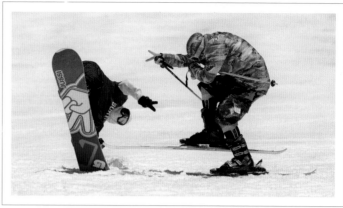

*p.***86**
*rider:* TADASHI FUSE
*location:* Wanaka, New Zealand
*photographer:* Dean Blotto Gray

*"I was super stoked for the opportunity to shred and hangout with the Burton crew and see how 'the big boys do it.' I've been riding the mountains around Wanaka since I was real young and know all the good spots. It was awesome to be able to take Tadashi, Trevor, and Marko there and witness what they threw down."* Tim

*p.***87**
*rider:* TADASHI FUSE
*location:* Cardrona, New Zealand
*photographer:* Dean Blotto Gray

*p.***88**
*rider:* JUSSI OKSANEN and TRAVIS PARKER
*location:* Mt. Hood, Oregon
*photographer:* Dean Blotto Gray

*"As we prepared to shoot an old-school fakie butter, we spotted this skier and decided to use him as a prop in the photo. Jussi flagged down our hopeful participant, and when he lifted his goggles it was Travis Parker! You couldn't have wished for a better candidate, we really lucked out."* Blotto

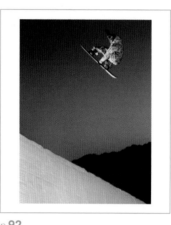

*p.***90**
*rider:* GIGI RÜF
*location:* Methven, New Zealand
*photographer:* Dean Blotto Gray

*"JP was unable to attend the summer shoot due to injury and JG happened to be in town talking design with the UnInc crew. With an open seat in the heli, JG managed some very real testing time with Romain, Gigi, and Danny."* Blotto

*p.***91**
*rider:* UNINC CREW
*location:* Methven, New Zealand
*photographer:* Dean Blotto Gray

*p.***92**
*rider:* MASON AGUIRRE
*location:* Snow Park, New Zealand
*photographer:* Adam Moran

*"Classic front side alley-oop. This trick will never get boring to shoot and Mason's style is insane here!"* Adam

*p.***93**
*rider:* MASON AGUIRRE
*location:* Wanaka, New Zealand
*photographer:* Dean Blotto Gray

*"Evoke the stoke. I'm backin' that philosophy."* Mason

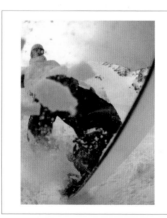

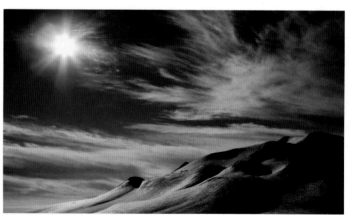

*p.***94**
*rider:* MADS JONSSON
*location:* Methven, New Zealand
*photographer:* Jeff Curtes

*"Supporting the troops, Mads pledging his allegiance to his friends in LAX."* Curtes

*p.***95**
*rider:* MADS JONSSON
*location:* Snow Park, New Zealand
*photographer:* Jeff Curtes

*p.***96**
*location:* Termas De Chillan, Chile
*photographer:* Jeff Curtes

*"Chilean summer sky."* Curtes

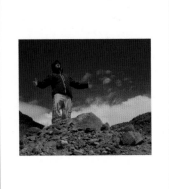

**p.98**
*rider:* JEREMY JONES
*location:* Mt. Hood, Oregon
*photographer:* Dean Blotto Gray

*"...I don't understand..."* Jeremy commenting on ski patrol telling us not to jump over a pile of rocks.

**p.99**
*rider:* JEREMY JONES
*location:* Mt. Hood, Oregon
*photographer:* Dean Blotto Gray

**p.100**
*rider:* HEIKKI SORSA
*location:* Methven, New Zealand
*photographer:* Dean Blotto Gray

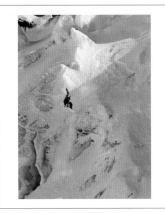

**p.101**
*rider:* HEIKKI SORSA
*location:* Methven, New Zealand
*photographer:* Jeff Curtes

*"New Zealand is a pretty awesome place for heli'n. One day me, DCP, and Nico went to this glacier spot. It was really cool cause it was all ice but you could still find some cool lines between the blue ice. I saw this little cool drop, so I started to hit that and it turned out to be pretty cool! Stoked!"* Heikki BMS "Big Mountain Sorsa"

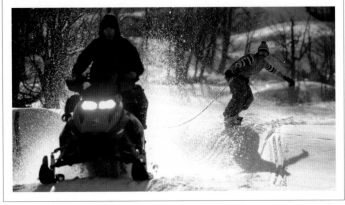

**p.102**
*rider:* NATASZA ZUREK
*location:* Chile
*photographer:* Jeff Curtes

*"Hooper found the spot, drove the sled, and got the shot. BMX-style banked slalom to river gap."* Curtes

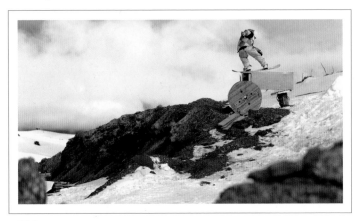

**p.104**
*rider:* MARKO GRILC
*location:* Snow Park, New Zealand
*photographer:* Dean Blotto Gray

*"Really good snowboarders make technical riding look easy... to the point where you start thinking to yourself: Maybe I could do that. The truth of it is: No way. Watching Marko stomp this 'nose press backside 180 out over the dirt to flat' made me think about this, but I quickly realized why the camera is in my hand and the board on his feet."* Blotto

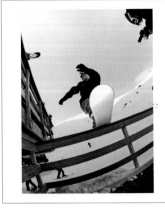

**p.106**
*rider:* DAVE DOWNING
*location:* Mt. Hutt, New Zealand
*photographer:* Dean Blotto Gray

*"While we waited out the wind in Methven, daily chairlift laps at Mt. Hutt were the call. After a couple hours worth of resort shred, it was down to the lodge for mini-shred."* Blotto

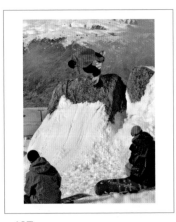

**p.107**
*rider:* TIM JACKWAYS
*location:* Cardrona, New Zealand
*photographer:* Dean Blotto Gray

*"Our local boy Tim brought us up to Cardrona to a slanted rock he and his crew had been sessioning since the day. This was one of the best obstacles of the trip."* Trevor

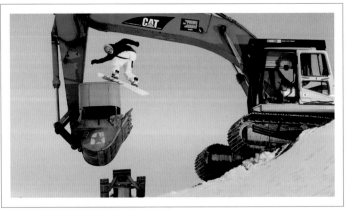

**p.108**
*rider:* MIKKEL BANG
*trick:* Loader Jib
*location:* Snow Park, New Zealand
*photographer:* Adam Moran

*"Sam Lee that owns Snow Park told us we could jib anything we wanted. I thought we might have been asking too much when I came back saying I wanted to use the bucket loader. But it was no problem at all. Two days to set up and Mikkel killed it."* Adam

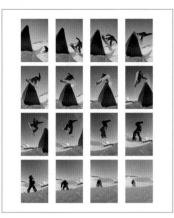

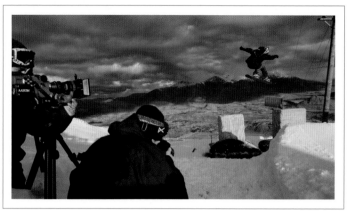

p. **110**
rider: KEEGAN VALAIKA
location: Snow Park, New Zealand
photographer: Adam Moran

"If it's a jib, Keegan can make it look really good and really fun. While everyone else was doing the standard wall ride tricks on this wall, he was just cruising through snapping off this fs bonk to backside 3 every time. I rarely shoot sequences anymore, but knew this one I had to get." *Adam*

p. **111**
rider: KEEGAN VALAIKA
location: Snow Park, New Zealand
photographer: Adam Moran

p. **112**
rider: TREVOR ANDREW
location: Coronet Peak, New Zealand
photographer: Dean Blotto Gray / Marko Grilc

"This block ollie was next to the lower parking lot at Coronet Peak. Feeling the need for a medium format photo, I set up and got ready for the shot. Marko quickly ran over and asked if he could shoot the digi. It was up to him to secure a good angle and fire away. Nice work Grilo, you nailed it!" *Blotto*

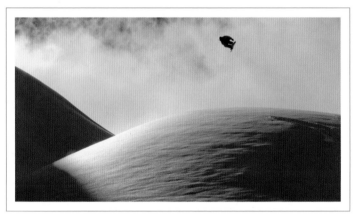
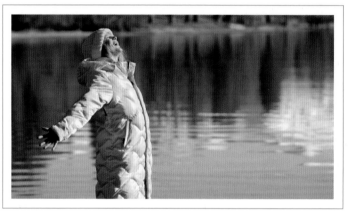

p. **114**
rider: NICOLAS MÜLLER
location: Methven, New Zealand
photographer: Dean Blotto Gray

"The terrain is just endless... it's terrain for days... there's so much stuff you can hit... it allows you to be creative." *Nicolas during his post photo shoot interview with Nathan Avila*

p. **116**
rider: HANNAH TETER
location: Snow Park, New Zealand
photographer: Adam Moran

"Hannah and I were at the lake shooting some catalog stuff and as I turned around I got this shot of her before she knew I was shooting. This is just Hannah being herself." *Adam*

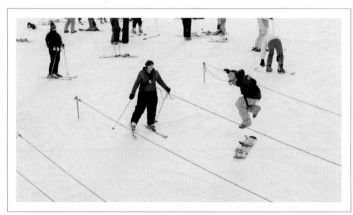
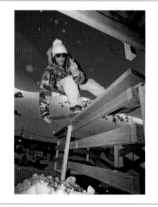

p. **118**
rider: GIGI RÜF
location: Mt. Hutt, New Zealand
photographer: Dean Blotto Gray

"Summer is a surreal time to pack your board bag when kids are playing jump rope out in the street. This was a great way to get my legs back." *Gigi commenting on summer shredding and hitting up the chairlifts at Mt. Hutt.*

p. **120**
rider: DANNY DAVIS
location: Mt. Hutt, New Zealand
photographer: Jeff Curtes

"Danny fitting in perfectly with the UnInc crew... mini-shred resort session at Mt. Hutt on a heli down day." *Curtes*

p. **121**
rider: TADASHI FUSE
location: Coronet Peak, New Zealand
photographer: Dean Blotto Gray

"No fancy Photoshop, no camera tricks, just Tadashi and the slow-sign ollie." *Blotto*

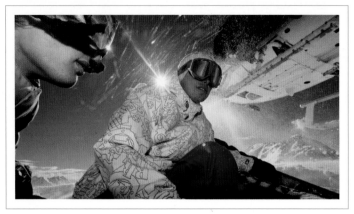

p. **122**
*rider:* NICOLAS MÜLLER AND DCP
*location:* Methven, New Zealand
*photographer:* Jeff Curtes

p. **124**
*rider:* MOLLY AGUIRRE
*location:* Snow Park, New Zealand
*photographer:* Dean Blotto Gray

p. **125**
*rider:* MOLLY AGUIRRE
*location:* Snow Park, New Zealand
*photographer:* Dean Blotto Gray

*"It's days like these that I love about snowboarding!! You don't have to be in a park or in powder to ride. All you need is snow and you have a ticket to ride, anywhere, anytime."* Molly

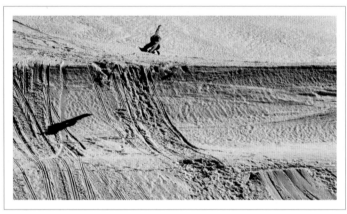

p. **126**
*rider:* NATASZA ZUREK
*location:* Termas De Chillan, Chile
*photographer:* Jeff Curtes

*"We sessioned a naturally formed step up that barely needed any prep work before we hit it. It was just there all perfect and waiting for us. We didn't need any shovels, just a few sideslips."* Natasza

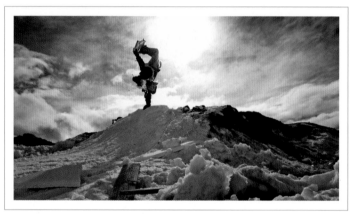

p. **128**
*rider:* TREVOR ANDREW
*location:* Snow Park, New Zealand
*photographer:* Dean Blotto Gray

*"The summer of 06 was a rad transition for me. I felt like I rediscovered snowboarding in a trash pile."* Trevor talking about the resort tour and shooting photos at the junk pile.

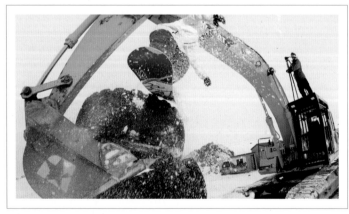

p. **130**
*rider:* KEVIN PEARCE
*location:* Snow Park, New Zealand
*photographer:* Adam Moran

*"Finding elements off the mountain is a whole different side to snowboarding. This bucket loader was sketchy!"* Kevin

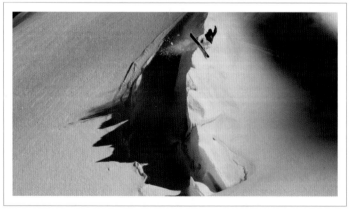

p. **132**
*rider:* NICOLAS MÜLLER
*location:* Methven, New Zealand
*photographer:* Jeff Curtes

*"Lay back glacial ice grind above the looming impaler."* Curtes

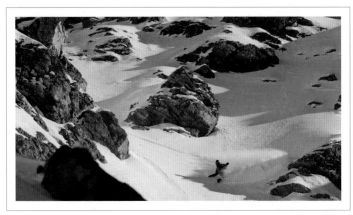

p. **134**
*rider:* TERJE HAAKONSEN
*location:* Methven, New Zealand
*photographer:* Jeff Curtes

*"Methven is a delicate spot. My first time there was with Michi Albin and Seaone in 96 shooting for a Volcom project. None of us had tried the NZ heli yet, but we had been to the 'pie and no worries country' before, so we knew kind of what to expect." Terje*

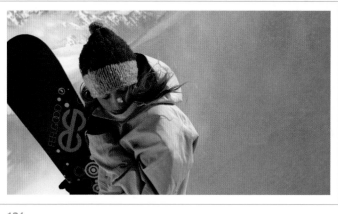

p. **136**
*rider:* VICTORIA JEALOUSE
*location:* Chile
*photographer:* Jeff Curtes

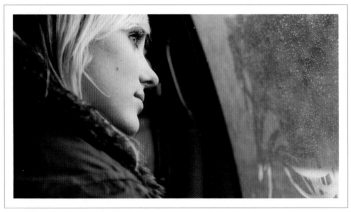

p. **138**
*rider:* ANNE-FLORE MARXER
*location:* Chile
*photographer:* Jeff Curtes

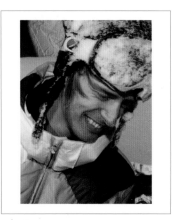

p. **140**
*rider:* NICOLAS MÜLLER
*location:* Methven, New Zealand
*photographer:* Jeff Curtes

*"Nicolas looking stoked after a post lunch snow angel session." Curtes*

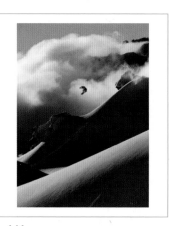

p. **141**
*rider:* NICOLAS MÜLLER
*location:* Methven, New Zealand
*photographer:* Jeff Curtes

*"Good things come to those who wait. Last run of the day, you gotta respect the sunset." Nicolas*

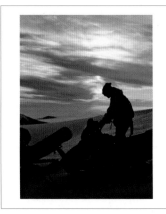

p. **142**
*rider:* NATASZA ZUREK
*location:* Termas De Chillan, Chile
*photographer:* Jeff Curtes

*"Amazing Chilean sunset on the road home." Curtes*

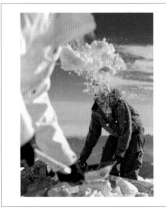

p. **143**
*rider:* ANNE-FLORE MARXER AND SPENCER O'BRIEN
*location:* Termas De Chillan, Chile
*photographer:* Jeff Curtes

*"Wedge party pillow fight." Curtes*

p. **144**
*rider:* FREDERIK KALBERMATTEN
*location:* Methven, New Zealand
*photographer:* Jeff Curtes

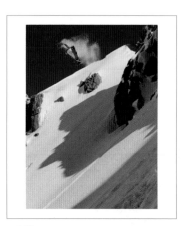

p. **145**
*rider:* FREDERIK KALBERMATTEN
*location:* Mt. Cook, New Zealand
*photographer:* Jeff Curtes

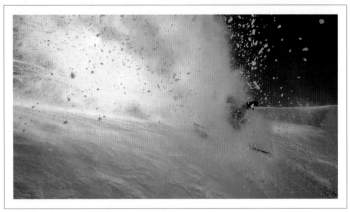

p.**146**
*rider:* SPENCER O'BRIEN
*location:* Termas De Chillan, Chile
*photographer:* Jeff Curtes

*"Spencer turning out the lights in Termas." Curtes*
*"Everything there is so uniquely beautiful and full of character. From Santiago to the shanty towns along the railroad tracks to Termas, everything has its own personality." Spencer*

p.**150**
*rider:* SPENCER O'BRIEN
*location:* Termas De Chillan, Chile
*photographer:* Jeff Curtes

*"Oh, and they have amazing chocolate milk." Spencer*

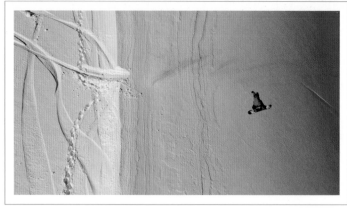

p.**148**
*rider:* HEIKKI SORSA
*location:* Methven, New Zealand
*photographer:* Jeff Curtes

*"One of my favorite shots of the 28 day shoot...dead above heli perspective, moonscape background texture, and classic Finnish style." Curtes*

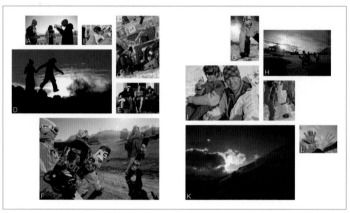

p.**152**
A: *rider:* MIKKEL BANG, LUKE MIRTANI, KEEGAN VALAIKA *location:* Snow Park, New Zealand *photographer:* Adam Moran
B: *rider:* HEIKKI SORSA *location:* Methven, New Zealand *photographer:* Jeff Curtes
C: *rider:* TREVOR ANDREW *location:* Snow Park, New Zealand *photographer:* Dean Blotto Gray
D: *rider:* SPENCER O'BRIEN AND VICTORIA JEALOUSE *location:* Termas De Chillan, Chile *photographer:* Jeff Curtes
E: *rider:* DANNY DAVIS, ROMAIN DE MARCHI, GIGI RUFF *location:* Methven, New Zealand *photographer:* Jeff Curtes
F: *rider:* DANNY DAVIS, ROMAIN DE MARCHI, GIGI RUFF *location:* Methven, New Zealand *photographer:* Dean Blotto Gray
G: *rider:* ROMAIN DE MARCHI *location:* Methven, New Zealand *photographer:* Jeff Curtes
H: *rider:* NICOLAS MULLER, HEIKKI SORSA, AND DCP *location:* Methven, New Zealand *photographer:* Jeff Curtes
I: *rider:* NICOLAS MULLER , DCP *location:* Methven, New Zealand *photographer:* Jeff Curtes
J: *rider:* SPENCER O'BRIEN AND VICTORIA JEALOUSE *location:* Termas De Chillan, Chile *photographer:* Jeff Curtes
K: *rider:* NICOLAS MULLER, JAKE BURTON, DCP, AND TERJE *location:* Methven, New Zealand *photographer:* Jeff Curtes
L: *rider:* MARKO GRILC AND BLOTTO *location:* Treble Cone, New Zealand *photographer:* Dean Blotto Gray

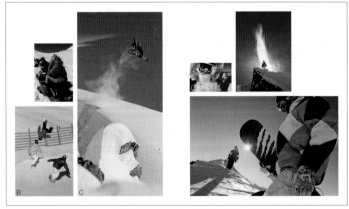

p.**154**
A: *rider:* ANNE-FLORE MARXER *location:* Chile *photographer:* Jeff Curtes
B: *rider:* LUKE MIRTANI, JACK MIRTANI, KEVIN PEARCE *location:* Snow Park, New Zealand *photographer:* Adam Moran
C: *rider:* HEIKKI SORSA *location:* Methven, New Zealand *photographer:* Jeff Curtes
D: *rider:* FREDERIK KALBERMATTEN *location:* Methven, New Zealand *photographer:* Jeff Curtes
E: *rider:* NICOLAS MULLER *location:* Methven, New Zealand *photographer:* Dean Blotto Gray
F: *rider:* DCP AND NICOLAS MULLER *location:* Methven, New Zealand *photographer:* Jeff Curtes

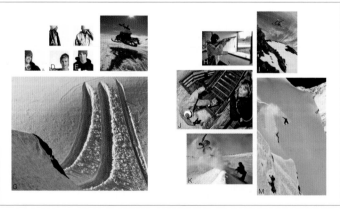

p.**156**
A: *rider:* KEIR DILLON *location:* Methven, New Zealand *photographer:* Jeff Curtes
B: *rider:* MARKO GRILC *location:* Wanaka, New Zealand *photographer:* Dean Blotto Gray
C: *rider:* DANNY DAVIS *location:* Wanaka, New Zealand *photographer:* Dean Blotto Gray
D: *rider:* MIKKEL BANG *location:* Wanaka, New Zealand *photographer:* Dean Blotto Gray
E: *rider:* KEVIN PEARCE *location:* Wanaka, New Zealand *photographer:* Dean Blotto Gray
F: *rider:* NATASZA ZUREK *location:* Termas De Chillan, Chile *photographer:* Jeff Curtes
G: *rider:* HEIKKI SORSA *location:* Methven, New Zealand *photographer:* Jeff Curtes
H: *rider:* MIKKEL BANG *location:* Snow Park, New Zealand *photographer:* Adam Moran
I: *rider:* SPENCER O'BRIEN *location:* Termas De Chillan, Chile *photographer:* Jeff Curtes
J: *rider:* ROMAIN DE MARCHI *location:* Mt. Hutt, New Zealand *photographer:* Dean Blotto Gray
K: *rider:* KEEGAN VALAIKA and MASON AGUIRRE *location:* Snow Park, New Zealand *photographer:* Adam Moran
M: *rider:* HEIKKI SORSA *location:* Methven, New Zealand *photographer:* Jeff Curtes

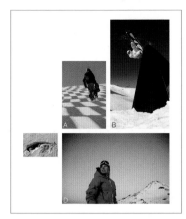

p. **158**

A: *rider:* KELLY CLARK *location:* Snow Park, New Zealand *photographer:* Dean Blotto Gray
B: *rider:* MOLLY AGUIRRE *location:* Snow Park, New Zealand *photographer:* Adam Moran
C: *rider:* NICOLAS MULLER *location:* Methven, New Zealand *photographer:* Jeff Curtes
D: *rider:* ANNE-FLORE MARXER *location:* Termas De Chillan, Chile *photographer:* Jeff Curtes

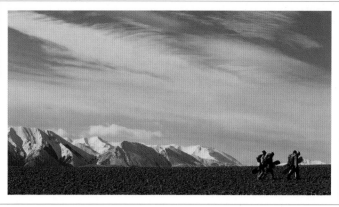

p. **174**
*rider:* NICOLAS MÜLLER, DCP, JAKE, AND TERJE
*location:* Methven, New Zealand
*photographer:* Jeff Curtes

*"Another day at the office."* Curtes

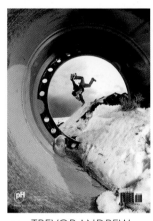

*rider:* TREVOR ANDREW
*location:* Snow Park, New Zealand
*photographer:* Dean Blotto Gray

*location:* Southern Alps, Methven, New Zealand
*photographer:* Jeff Curtes

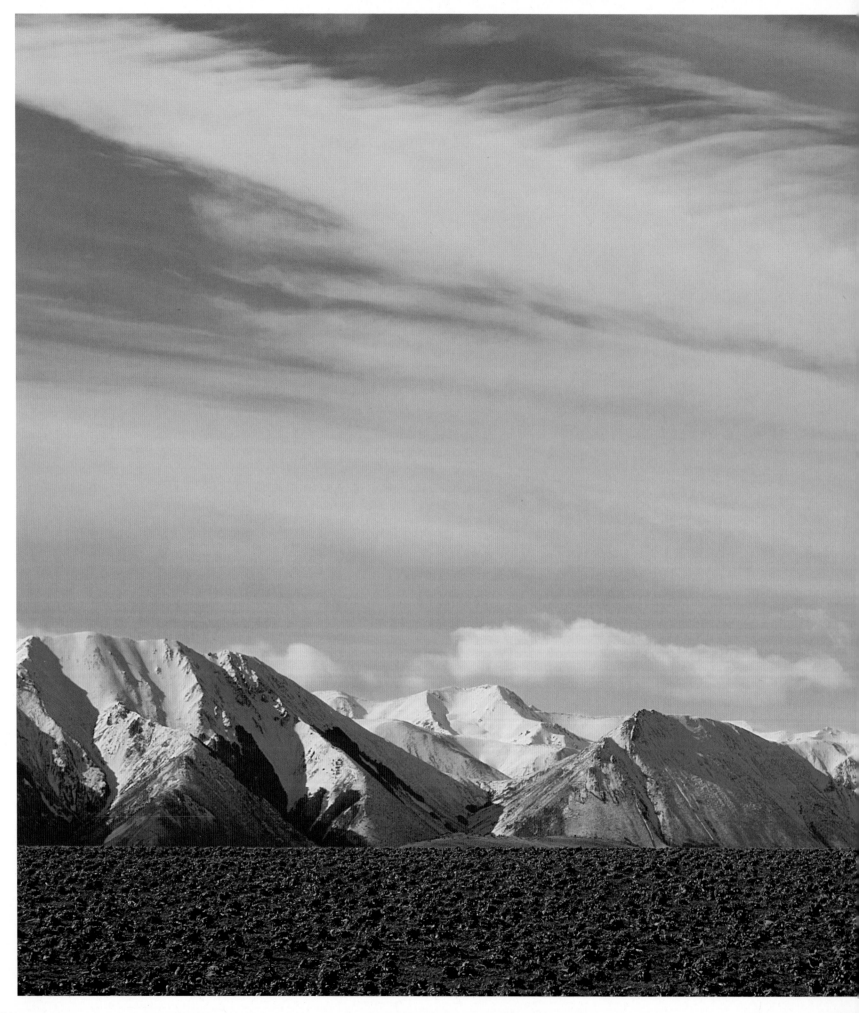

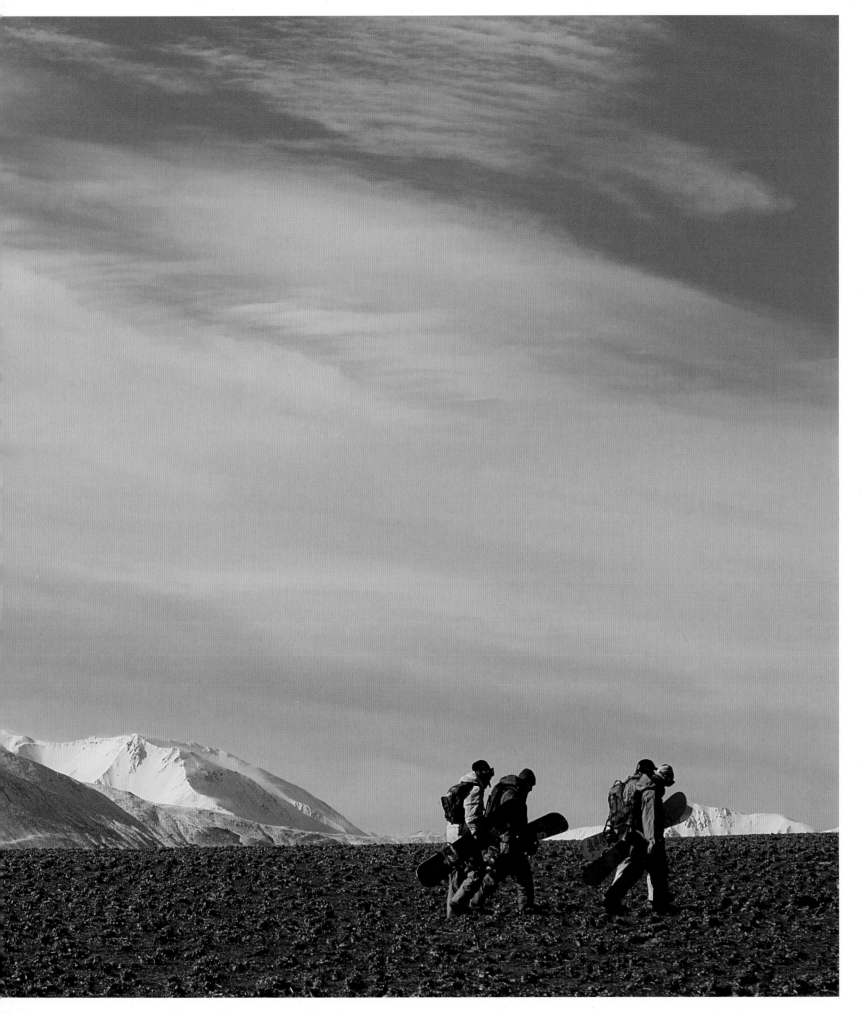

28 Day Winter
A Snowboarding Narrative

A Burton Snowboards Production

© 2007 powerHouse Cultural Entertainment, Inc.
Photographs © 2007 Jeff Curtes, Dean Blotto Gray, and Adam Moran

Published in the United States by powerHouse Books,
a division of powerHouse Cultural Entertainment, Inc.
37 Main Street, New York, NY 11201-1021
telephone 212 604 9074, fax 212 366 5247
e-mail: 28daywinter@powerHouseBooks.com
website: www.powerHouseBooks.com

First edition, 2007

Library of Congress Control Number: 2007934003

Hardcover ISBN 978-1-57687-418-9

Printing and binding by Midas Printing, Inc., China
Book design by PeetKegler

A complete catalog of powerHouse Books and Limited Editions is available upon request; please call, write, or visit our website.

10 9 8 7 6 5 4 3 2 1

Printed and bound in China